VINTAGE
MODERN
crochet

CLASSIC
CROCHET LACE
TECHNIQUES FOR
CONTEMPORARY STYLE

Robyn Chachula

INTERWEAVE.
interweave.com

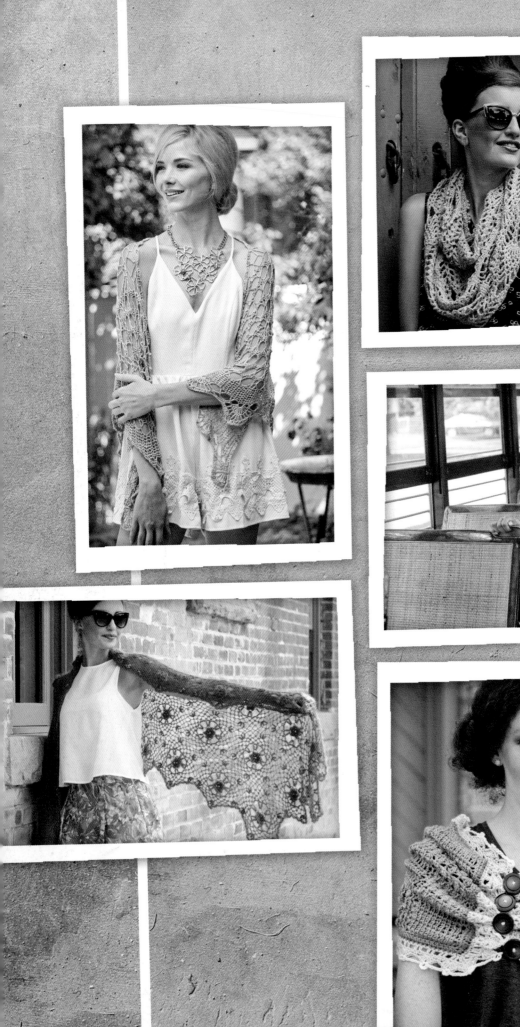
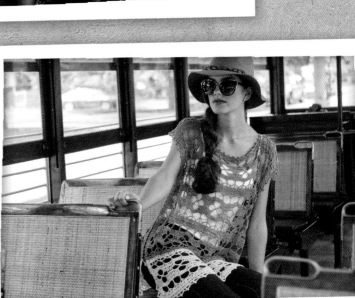
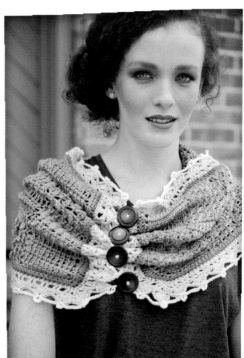

CONTENTS

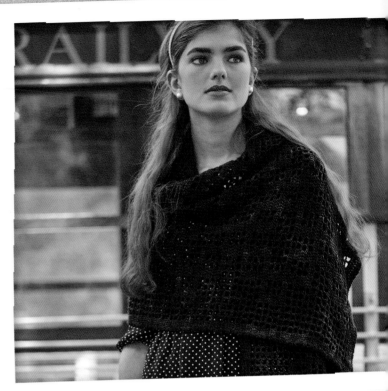

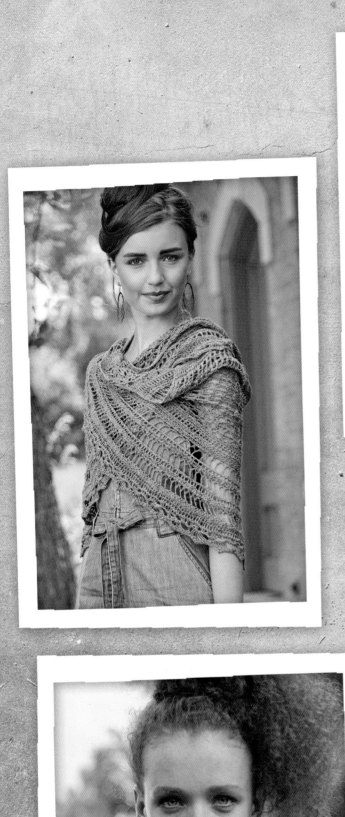

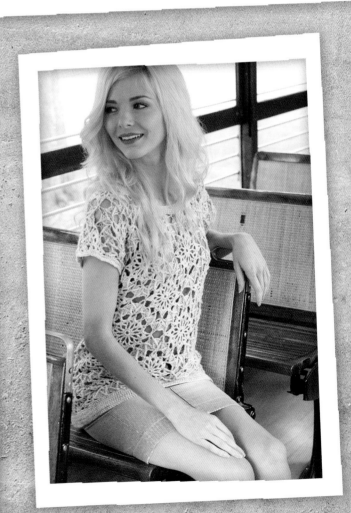

INTRODUCTION

Marrying vintage techniques with a modern sensibility has been a mission of mine for years. Crochet has a long history of exquisite patterns and motifs that are sparingly published, because they harken back to items that we deem dated. For me, I love all the doilies and tablecloths that might have been found in my grandmother's house. Sometimes I wish I could just toss a tablecloth on as a shawl to display all of its complex stitches. (Okay, so I have totally done that in real life more than once.)

Crochet is such a vibrant art form that the right design and designer can breathe new life into these techniques and reinvent them in beautiful, compelling ways. That is what brought this whole book about: the pure love of all crochet lace techniques and the desire to be able to wear those creations and look fabulous without looking dated.

It's my pleasure to showcase all of these lovely stitches in one book. I am proud to be joined by like-minded designers who also have that vision. Their designs are so amazing that I really wanted to grab some yarn and a hook to start many of them for myself.

You will notice that all the projects are fashion-forward and styled for today. This is done to help you, too. When you make that amazing top or scarf for your sister, niece, or granddaughter, you can show her how stylish it is. It will be our secret that you are using the very same techniques women from the 1850s used while crocheting for their loved ones. That connection to history is important, not just to me but to all of us in keeping our art form vibrant and alive by honoring techniques that our ancestors used. The only difference between our crochet and our ancestors' crochet is our modern yarn and thread. I know my grandmother crocheted with very vibrant colors for everything, but she had to dye it herself. We are lucky we don't have to invent our materials (unless we really want to), but instead we can focus on the great creations that come about.

The techniques we use throughout the book are only the tip of the iceberg of antique techniques. We will look at the modern retelling of Pineapple Lace, Bruges Crochet, Irish Crochet, Filet, and Tunisian Lace. All of our stitches are classics; only the way we are presenting them is modern. I can't tell you how much I enjoyed designing the pieces that use these fantastic techniques while making projects that could range from timeless cardigans to trendy accessories. I hope we inspire you to keep crocheting and to fall in love with all these impressive techniques.

I hope you truly have a wonderful time crocheting these beauties, and I can't wait to see your twist on our designs.

Robyn Chachula

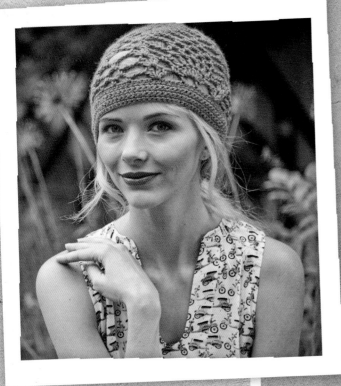

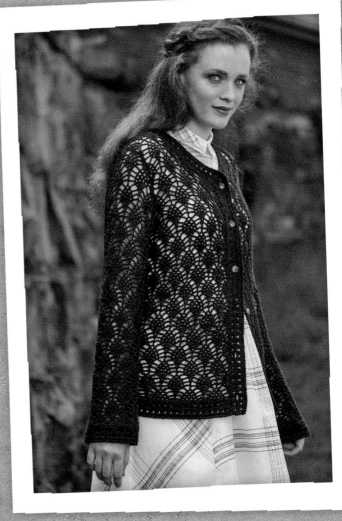

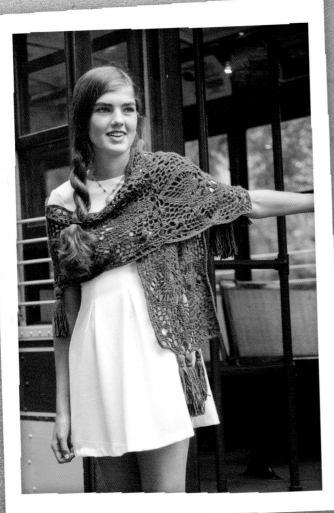

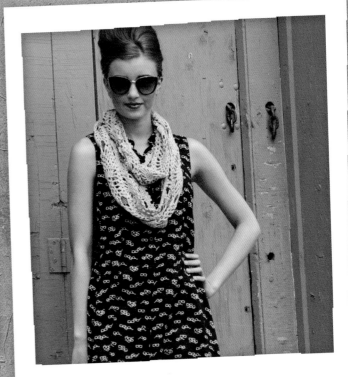

PINEAPPLE LACE

In Colonial America, the height of status and wealth was to have a pineapple on your table; it showed good taste and lavish wealth. It also demonstrated the impressive capabilities of the hostess to procure one (even if it was rented for the occasion!). Pineapples were so rare that King Charles II of England was painted in portrait, depicting him being given the golden fruit.

It only makes sense that the pineapple subsequently became a symbol of hospitality. With such a potent meaning attached to its image, the pineapple materialized in all crafts and handiwork, from tapestries to needlework, printings, and of course, crochet lace. Some of us romantically think back on our grandmothers' tables, with their pineapple lace doily and tablecloths; or fondly recall their elegant clothes with lace collars and trims. There never has been a time when pineapples weren't beloved. In the 1930s, they dominated fashion and needlework magazines. This makes sense, since during the Great Depression women were looking for inexpensive ways to brighten and refresh their wardrobe. All that you need for a lace collar is some thread, a hook, and know-how.

Even now, when doilies have lost favor and you rarely see a collar with tons of lace, we still love pineapple lace. We love it for its exquisite beauty and complex-looking patterns. Sure, we may not use it for the centerpiece of our table, but we would be thrilled to have a pineapple lace tunic, oversized cardigan, lightweight shawl, or silky cowl to wear.

The hidden beauty of pineapple lace is that even though the patterns are usually extremely long, they use classic stitches and are quite easy to "read" on the fabric. The projects in this book are stunning to start with and need a bit of concentration to follow. But the results are amazing.

If you have never picked up a pineapple lace crochet pattern before, I recommend the **Bromelia Infinity Cowl.** It is rectangular in shape, so you don't have to worry about any shaping along the way. If you are looking for the perfect present, you might want to try the **O'Hara Hat.** It is the perfect slouchy hat for cool days. **Zoe Cardigan** is the project that you can make now and wear for years. It is the classic lace cardigan that never goes out of style. The **Kidwell Garden Wrap** is a project that uses pineapple crochet in new ways, rotating how we see the motifs. No matter what you choose to crochet first, you will have a showstopper in the end.

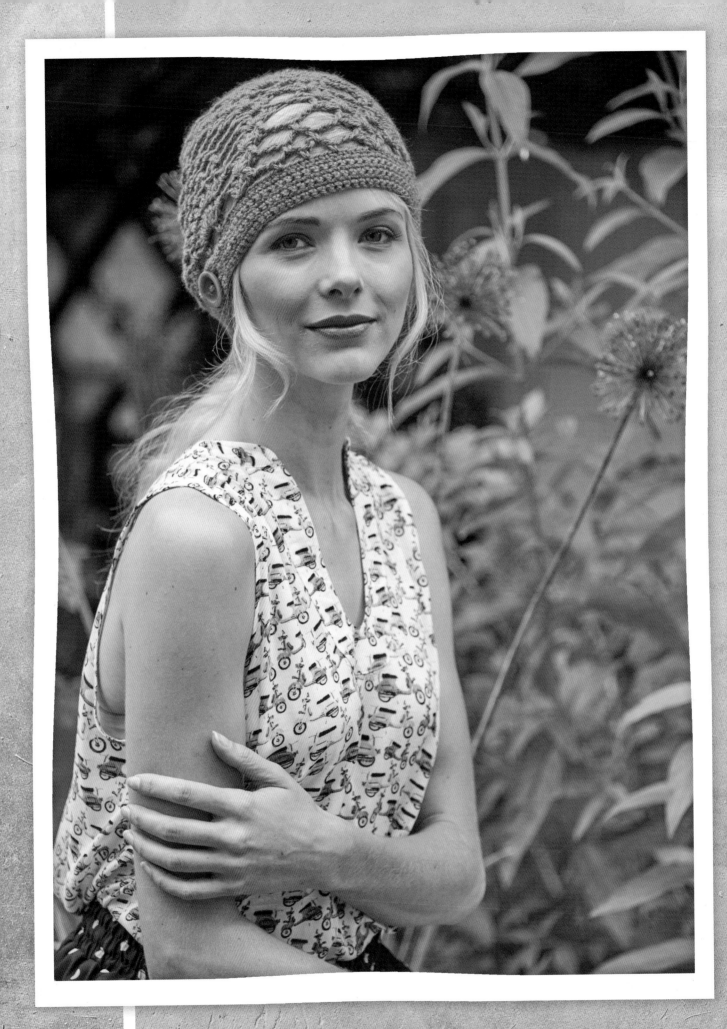

O'Hara hat

REBECCA VELASQUEZ

Typically, when you think of the pineapple motif, a doily or perhaps even a shawl comes to mind. I knew I wanted to try something a bit different; something fun and modern; something wearable by many women with many different styles. A hat!

FINISHED MEASUREMENTS

Fits average woman's head. Hat band circumference = 19" (48.5 cm).

YARN

DK Weight (#4 Medium).

Shown here: Berroco Vintage DK (50% acrylic 40% wool, 10% nylon; 288 yd [263 m]/3.5 oz [100 g]): #2192 Chana Dal, 1 hank.

HOOK

Sizes G-6 (4.25 mm) and H-8 (5.00 mm). *Adjust hook size if necessary to obtain the correct gauge.*

NOTIONS

Locking stitch markers; tapestry needle for assembly and weaving in ends; one 1" (2.5 cm) button.

GAUGE

16 sc by 20 rows= 4" × 4" (10 × 10 cm) with size G-6/4.25mm hook.

NOTE

The hat is worked from the bottom of the crown portion to the top, then the hat is turned and the band is added by stitching into the bottom loops of the foundation chain.

STITCH GUIDE

Shell (sh): (2 dc, ch 1, 2 dc) in indicated st or sp. When a shell is worked into the next shell, all sts are worked into the ch-1 sp of the indicated shell.

HAT

Row 1: (RS) For button on RIGHT side of hat, ch 28, pm in ch just created, ch 60, sc in 2nd ch from hook, pm in sc just made, sc in next ch and in ea across, do not turn—87 sc.

For button on LEFT side of hat, ch 60, pm in ch just created, ch 28, sc in 2nd ch from hook, pm in sc just made, sc in next ch and in ea across, do not turn—87 sc.

Rnd 2: Being careful not to twist your work, bring the ends together, with RS facing you, sc in the marked sc, remove marker, pm in sc just made, [ch 3, sk 4 sts, sh in next st, sk 4 sts, (ch 3, sc in next st, sk 2 sts) 3 times, sk 2 more sts, sh in next st, ch 3, sk 4 sts, sc in next st, ch 3, sk 2 sts**, sc in next st] around ending final rep at **, sl st into marked st, remove marker, do not turn.

Now working in rounds.

Rnd 3: Sl st in blp of next 2 chs, sc around next ch, pm in sc just made, [ch 3, sh in next shell, sk next ch-3 sp, (ch 3, sc in next ch-3 sp) twice, ch 3, sh in next shell, ch 3, sk in next ch-3 sp, 6 dc in next ch-3 sp**, sc in next ch-3 sp] around, ending final rep at **, sl st into marked st, remove marker, do not turn.

Rnd 4: Sl st in blp of next 2 chs, sc around next ch, pm in sc just made, [ch 3, sh in next shell, sk ch-3 sp, ch 3, sc in next ch-3 sp, ch 3, sh in next shell, ch 3, sc in next ch-3 sp, dc in next dc (ch 1, dc in next dc) 5 times**, sc in next ch-3 sp] around, ending final rep at **, sl st in marked st, remove marker, do not turn.

Rnd 5: Ch 4, pm in first ch just created, [(sh in next shell) twice, sk next ch-3 sp, (ch 3, sc in next ch-1 sp) 5 times**, ch 3] around, ending final rep at **, sl st in marked ch, remove marker, do not turn.

Rnd 6: Ch 4, pm in first ch just created, [sh in next shell, ch 1, sh in next shell, sk next ch-3 sp, (ch 3, sc in next ch-3 sp) 4 times**, ch 3] around, ending final rep at **, sl st in marked ch, remove marker, do not turn.

Rnd 7: Ch 4, pm in first ch just created, [sh in next shell, ch 3, sc in next ch-1 sp, ch 3, sh in next shell, sk next ch-3 sp, (ch 3, sc in next ch-3 sp) 3 times**, ch 3] around, ending final rep at **, sl st in marked ch, remove marker, do not turn.

Rnd 8: Ch 4, pm in first ch just created, [sh in next shell, ch 3, (sc in next ch-3 sp, ch 3) twice, sh in next shell, sk next ch-3 sp, (ch 3, sc in next ch-3 sp) twice**, ch 3] around, ending final rep at **, sl st in marked ch, remove marker, do not turn.

Rnd 9: Sl st in each of next 3 chs, sl st in blo of next 2 dc, sl st in ch-1 sp of shell, ch 3, (dc, ch 1, 2 dc) in same shell, [ch 3, sc in next ch-3 sp, 6 dc in next ch-3 sp, sc in next ch-3 sp, ch 3, sh in next shell, sk next ch-3 sp, ch 3, sc in next ch-3 sp, ch 3**, sh in next shell] around, ending final rep at **, sl st in top of beg ch-3, do not turn.

Rnd 10: Sl st in blp of next dc, sl st in next ch-1 sp, ch 3, pm in 3rd ch just created, (dc, ch 1, 2 dc) in same shell, [ch 3, sc in next ch-3 sp, dc in next dc, (ch 1, dc in next dc) 5 times, sc in next ch-3 sp, ch 3, shell in next shell**, shell in next shell] around, ending final rep at **, sl st in marked ch, remove m, do not turn.

Rnd 11: Sl st in blp of next dc, sl st in next ch-1 sp, ch 3, pm in 3rd ch just created, 3 dc in same shell, sk ch-3 sp, [(ch 3, sc in next ch-1 sp) 5 times, ch 3, 4 dc in next shell**, 4 dc in next shell] around, ending final rep at **, sl sl in marked ch, remove m, do not turn.

Rnd 12: Ch 2, pm in 2nd ch just created, dc in next dc, [sk (2 dc, ch 3), (ch 3, sc in next ch-3 sp) 4 times, ch 3, sk (ch 3, 2 dc), dc in next dc**, dc2tog in next 2 sts, dc in next dc] around, ending final rep at **, dc in next dc, sl st to marked ch, remove m, do not turn.

Rnd 13: Ch 2, pm in 2nd ch just created, dc in next dc, [sk ch-3, ch 2, sc in next ch-3 sp, (ch 3, sc in next ch-3 sp) 2 times, ch 2, sk ch-3 sp**, dc3tog in next 3 sts] around, ending final rep at **, dc in next dc, sl st to marked ch, remove m, do not turn.

Rnd 14: Ch 5, pm in 3rd ch just created, [sk ch-2 sp, sc in next ch-3 sp, ch 3, sc in next ch-3 sp, ch 2, sk ch-2 sp**, dc in next st, ch 2] around, ending final rep at **, sl st in marked ch, remove m, do not turn.

Rnd 15: Ch 4, pm in first ch just created, [sk ch-2 sp, sc in next ch-3 sp, ch 3, sk (ch-2 sp, dc)] around, sl st in marked ch, remove m. Fasten off.

HAT BAND

With RS facing you, turn hat so that you will now be working into the unworked loops of the foundation chain.

10

Work the following rows with a G/4.25mm hook.

Row 1: Ch 1, sc in same ch as sl st just made, remove m, sc in each ch around, ch 10, turn—87 sc, 10 ch.

Row 2: Sc in 2nd ch from hook and in each of next 8 ch, sc in each sc across, turn—96 sc.

Row 3: Ch 1, sc in first sc and in each of next 91 sc, ch 3, sk 3 sc, sc in next sc, 2 sc in last sc, turn.

Row 4: Ch 1, 2 sc in first sc, sc in each of next 2 sc, sc in each of next 3 ch, sc in each sc across, turn—97 sc.

Row 5: Ch 1, sc in each sc across, shift piece so that you are now working along the side of the buttonband, sc into the tch of row below, sc into side of next sc, sc into the tch of row below, shift piece so that you will now be working into the bottom loops of the button extension, 2 sc in first loop, sc into ea of next 8 loops, finish off. Weave in all the ends.

BLOCKING AND SEWING

Liberally spray crown portion of the hat with water. Partially blow up a balloon. Without stretching the hat

TECHNIQUE TIDBIT

For the most part, the basic pineapple lace is started with a half circle of a taller stitch, such as a double or treble crochet. On the next row, each tall stitch gets a single crochet and chain space. Then each row after has one less chain space than the previous one, which in the end makes up the pinecone shape of the pineapple motif. The fill around the motif is usually another chain space with either shells or V-sts that draw the eye to the pineapple. Once you can see the pattern, crocheting and finding mistakes become a tad easier to see.

band, insert the balloon into the hat. Continue to blow up the balloon until it lightly stretches the lace/crown of the hat. Tie the balloon closed and allow the hat to air-dry. When dry, pop and remove the balloon.

Using project yarn and a yarn needle, with the RS facing you, sew the button to the hat band opposite the buttonhole, weave in the ends.

- • slip stitch
- ⌒ back loop only
- + single crochet
- ⊤ double crochet
- ⋀ dc3tog

O'HARA HAT STITCH DIAGRAM

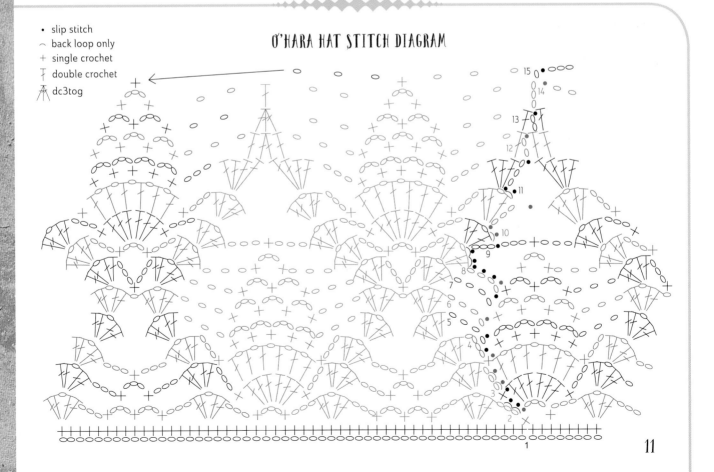

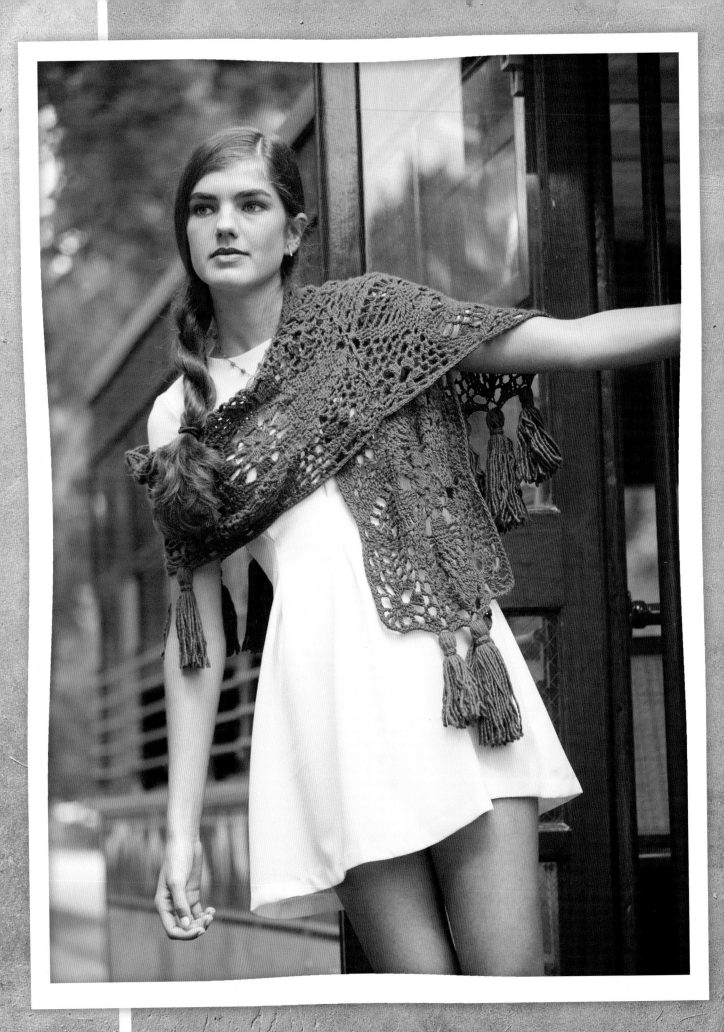

Kidwell Garden wrap

◆◆◆◆◆◆◆◆◆◆◆◆

SHELBY ALLAHO

Elegant pineapple motifs are crocheted and joined as you go. Bold tassels are added as the perfect finishing touch, giving the project a whimsical look! Once you learn how to make tassels, you won't want to stop!

FINISHED MEASUREMENTS

12½" (31.5 cm) wide × 71" (180 cm) long, not including the tassels.

YARN

Worsted weight (#4 Medium).

Shown here: Lorna's Laces Lion and Lamb (50% Silk, 50% Wool; 205 yd [187 m]/3.50 oz [100 g]): #60ns Waistcoat, 4 skeins.

HOOKS

Size G-6 (4 mm) and H-8 (5 mm). *Adjust hook size if necessary to obtain the correct gauge.*

NOTIONS

Yarn needle; rust-proof pins; 2 pieces of cardboard—one 4" (10 cm) wide × 7½" (19 cm) high and one 4" (10 cm) wide × 6" (15 cm) high. These will be templates for the large and small tassels.

GAUGE

First Motif = 13½" (34.5 cm) wide by 12" (30.5 cm) high with a size H-8/5mm hook.

STITCH GUIDE

Two treble crochet cluster (2tr-cl): [Yo twice, insert hook into indicated st, yo and pull through work, (yo and pull through 2 loops) twice] twice, yo and pull through rem 3 loops on hook.

Three treble crochet cluster (3tr-cl): [Yo twice, insert hook into indicated st, yo and pull through work, [yo and pull through 2 lps) twice] 3 times, yo and pull through rem 4 loops on hook.

Two double crochet cluster (2dc-cl): [Yo, insert hook into indicated st, yo and pull through work, yo and pull through 2 loops] twice, yo and pull through rem 3 loops on hook.

Invisible Fasten Off: Cut yarn, leaving a 3" (7.5 cm) tail, pull the yarn all the way through the loop on hook, as if to fasten off in the usual way. Insert hook in both lps of second st in rnd, yo with tail end and pull through st. Finally, insert the hook in the flp of the last st in rnd, yo, pull yarn through.

FIRST MOTIF

Rnd 1: Using hook size H-8/5mm, make an adjustable ring and ch 4, 2tr-cl, [ch 4, 3tr-cl in ring] 7 times, ch 4, sl st in first 2tr-cl to join—8 cl.

Rnd 2: Sl st in first ch sp, ch 4 (counts as first tr), 2 tr in the same sp, [ch 4, 5 tr in next sp, ch 4**, 3 tr in next sp] around, ending final rep at **, sl st in top of beg ch-4 to join—32 tr.

Rnd 3: Ch 3, dc in st at base of ch-3 (counts as first 2 dc), [(dc, ch 2, dc) in next tr, 2 dc in next tr, ch 4, sc in next 5 tr, ch 4**, 2 dc in next tr] around, ending final rep at **, sl st in top of beg ch-3 to join—24 dc, 20 sc.

Rnd 4: Ch 3 (counts as first dc here and throughout), [dc in next 2 dc, (dc, ch 2, dc) in next ch sp, dc in next 3 dc, ch 4, sc in next 5 sc, ch 4**, dc in next dc] around, ending final rep at **, sl st in top of beg ch-3 to join—32 dc, 20 sc.

Rnd 5: Ch 3, dc in next 2 dc, [ch 2, (2 dc, ch 2, 2 dc) in next ch sp, ch 2, dc in next 3 dc, ch 4, sc in next sc, (ch 4, sc in next sc) 4 times, ch 4**, dc in next 3 dc] around, ending final rep at **, sl st in top of beg ch-3 to join—40 dc, 20 sc.

Rnd 6: Ch 3, [dc in next 2 dc, (ch 2, [dc, ch 2, dc] in next ch sp) 3 times, ch 2, dc in next 3 dc, ch 4, sk (ch sp, 1 sc), sc in next ch-4 sp, (ch 4, sc in next ch-4 sp) 3 times, ch 4**, dc in next dc] around, ending final rep at **, sl st in top of beg ch-3 to join—48 dc, 16 sc.

Rnd 7: Ch 3, *dc in next 2 dc, [ch 2, dc in next ch sp] 3 times, ch 2, 4 dc in next ch sp, [ch 2, dc in next ch sp] 3 times, ch 2, dc in next 3 dc, ch 4, sk (ch sp, 1 sc), sc in next ch-4 sp, [ch 4, sc in next ch-4 sp] twice, ch 4**, dc in next dc; rep from * around, ending final rep at**, sl st in top of beg ch-3 to join—64 dc, 12 sc.

Rnd 8: Ch 3, [dc in next 2 dc, (ch 2, dc in next ch sp) 3 times, ch 2, 4 dc in next ch sp, ch 3, 4 dc in next ch sp, (ch 2, dc in next ch sp) 3 times, ch 2, dc in next 3 dc, ch 4, sk (ch sp, 1 sc), sc in next ch-4 sp, ch 4, sc in next ch-4 sp, ch 4**, dc in next dc] around, ending final rep at **, sl st in top of beg ch-3 to join—80 dc, 8 sc.

Rnd 9: Ch 3, [dc in next 2 dc, (ch 2, dc in next ch sp) 4 times, ch 2, 2dc-cl in next ch-4 sp, (ch 2, 2dc-cl in same ch-4 sp) 3 times, (ch 2, dc in next ch sp) 4 times, ch 2, dc in next 3 dc, ch 4, sk ch-4 sp, sc in next ch-4 sp, ch 4**, dc in next dc] around, ending final rep at **, sl st in top of beg ch-3 to join—56 dc, 16 cl, 4 sc.

Rnd 10: Sl st in first 2 dc, 2 sl st in first ch sp, (sl st, ch 3) in next dc, [2 dc in next ch sp, dc in next dc, ch 2, dc in next dc, 2 dc in next ch sp, dc in next dc, ch 2, dc in next cl, ch 2, sk next ch-2 sp, ([tr, ch 2] 3 times, tr) in next ch sp, ch 2, sk next ch-2 sp, dc in next cl, (ch 2, dc in next dc, 2 dc in next ch sp, dc in next dc) twice, ch 3, sk next ch sp, holding back the last lp of each of the next 6 dc, make a dc in each of the next 3 dc, sk 2 ch-4 sps, dc in each of the next 3 dc, yo and pull through all lps on hook, ch 3*, dc in next dc] around, ending final rep at **, sl st in top of beg ch-3 to join.

SECOND–FIFTH MOTIFS

Work first 9 rounds as in the First Motif. Then, you will work a partial round joining to the previous motif in the 3rd side of the motif by making sl sts into the previous motif as indicated.

Rnd 10: Sl st in next 2 dc, 2 sl st in next ch sp, sl st in next dc, ch 3, *2 dc in next ch sp, dc in next dc, ch 2, dc in next dc, 2 dc in next ch sp, dc in next dc, ch 2, dc in next cluster**, ch 2, sk next ch sp and cl, [(tr, ch 2) 4 times in next ch sp], sk next cl and ch sp, dc in next cluster, [ch 2, dc in next dc, 2 dc in next sp, dc in next dc] twice, ch 3, sk next ch sp, holding back the last lp of each of the next 6 dc, dc in each of the next 3 dc, sk 2 ch-4 sps, dc in each of next 3 dc, yo and pull through all lps on hook, ch 3, sk next sp, dc in next dc*; rep from * to * once; rep from * to ** once. Ch 2, [in next sp: (tr, ch 2) twice, tr, sl st in

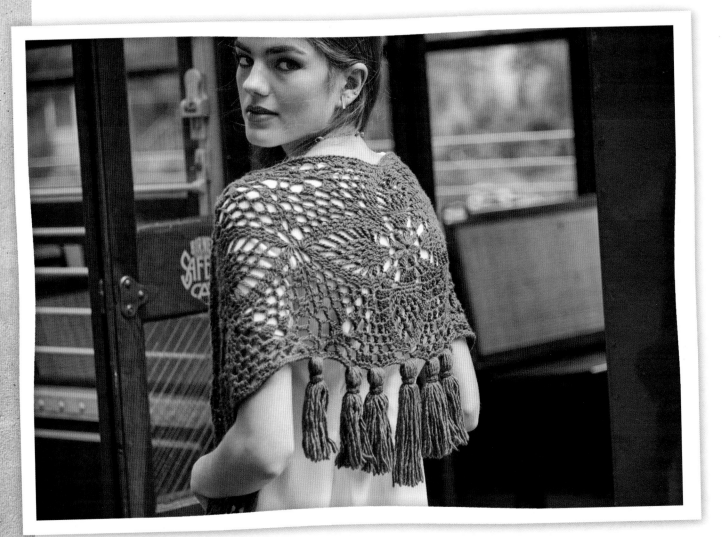

corresponding tr in previous motif, ch 2, tr, sl st in correspond-ing tr]. Ch 2, dc in top of next cluster, ch 2, ***dc in next dc, sl st in corresponding dc, 2 dc in next ch sp, dc in next dc, sl st in corresponding dc***, ch 2; rep from *** to *** once. Ch 3, sk next sp, holding back the last lp of each of the next 6 dc, make a dc in each of the next 3 dc, sk 2 ch-4 sps, dc in each of the next 3 dc, yo and pull through all lps on hook. Sl st in correspond-ing st in the middle of the joined 6 dc sts. Ch 3, rep from *** to *** once, ch 2, rep from *** to *** once more. Ch 2, dc in top of next cluster, ch 2, [in next sp: tr, sl st in corresponding tr, ch 2, tr,

sl st in corresponding tr, (ch2, tr) twice]. Ch 2, dc in top of next cluster, [ch 2, dc in next dc, 2 dc in next sp, dc in next dc] twice. Ch 3, sk next sp, holding back the last lp of each of the next 6 dc, make a dc in each of the next 3 dc, sk 2 ch-4 sps, dc in each of the next 3 dc that you made sl sts into to beg rnd, yo and pull through all lps on hook. Ch 3, sl st in top of beg ch-3 to join. Fasten off using the invisible method (see Stitch Guide).

EDGING

Using hook size G-6/4mm and beg on a short end of the wrap with the RS of work facing you, join with sl st in right-hand corner (the middle ch 2 between the tr's), ch 2, hdc in same sp, ****[hdc in next st, 2 hdc in next ch sp] 3 times, *hdc in each of next 4 dc, ch 3, hdc in each of next 4 dc*, 3 hdc in next ch-3 sp, ch 2, 3 hdc in next ch-3 sp, rep bet * and *, [2 hdc in next ch sp, hdc in next st] 3 times**, *****2 hdc in each ch-2 sp, hdc in each st and 3 hdc in each ch-3 sp across 2 motifs of long edge*****, across middle motif, ch 2, work between ** and **, ch 2,

KIDWELL GARDEN WRAP STITCH DIAGRAM

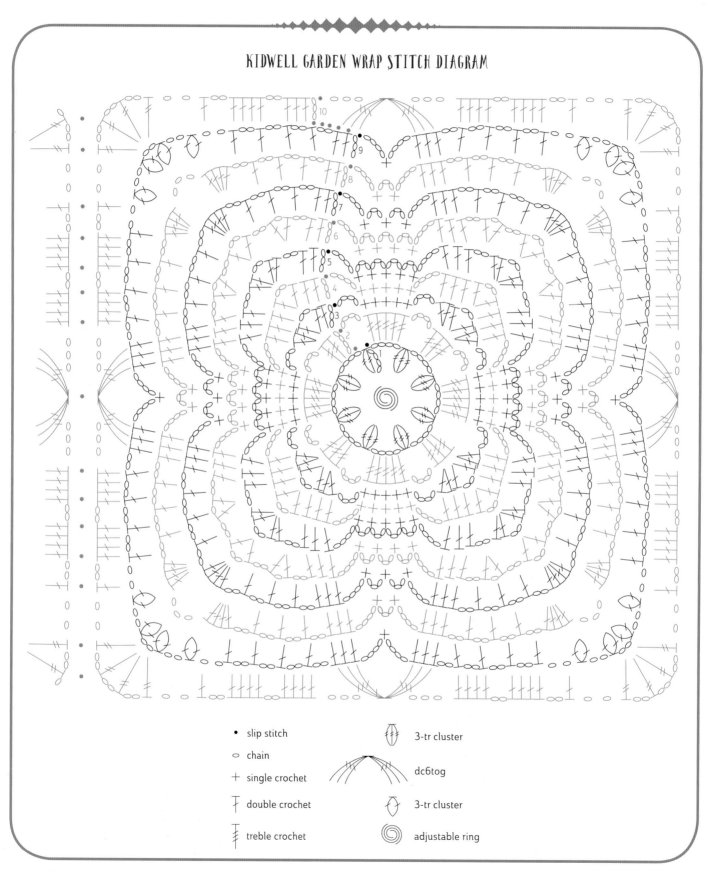

- • slip stitch
- ○ chain
- + single crochet
- ⊤ double crochet
- ⫟ treble crochet

- 3-tr cluster
- dc6tog
- 3-tr cluster
- adjustable ring

rep bet ***** and *****, 2 hdc in corner ch 2, rep from **** across second short edge and second long edge, sl st to join in first hdc. Fasten off using the invisible method.

TASSELS

LARGE (Make 3)
Using the large cardboard template, wrap the yarn around it 30 times, then cut it neatly across the end and set aside.

SMALL (Make 10)
Using the small cardboard template, wrap the yarn around it 25 times, then cut it neatly across the end and set aside.
Insert a large tassel into the middle ch 3 sp on each of the 3 sides of the wrap, and insert a small tassel into each of the rem ch 3 sps.

LARGE TASSEL BAND
Using a size G-6/4 mm hook, ch 10, then working into the ridges on the underside of the ch and beg in the second ridge from the hook, sc in each st. Wrap the tassel band around a large tassel, 1" (2.5 cm) from the top, sl st in beg sc. Fasten off using the invisible method. Rep for rem 2 large tassels.

SMALL TASSEL BAND
Using a size G-6/4 mm hook, ch 9, then working into the ridges on the underside of the ch, and beg in the second ridge from hook, sc in each st. Wrap the tassel band around a small tassel, 1" (2.5 cm) from the top, sl st in the beg sc. Fasten off using the invisible method. Rep for the rem 9 small tassels.

BLOCKING
Weave in all the loose ends with a yarn needle and then spray the wrap with water. Pin it out into shape on a blocking board. Straighten each tassel and trim the ends straight across the bottom. Allow the wrap to dry before removing the pins.

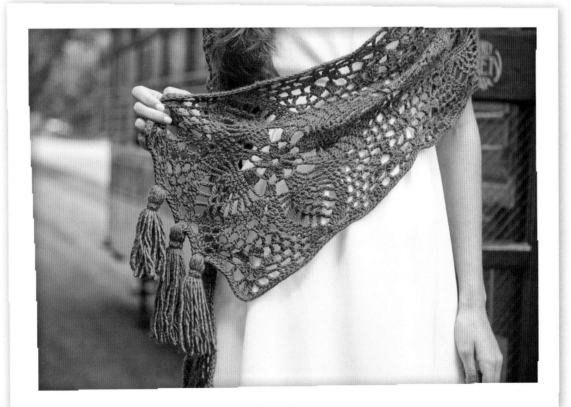

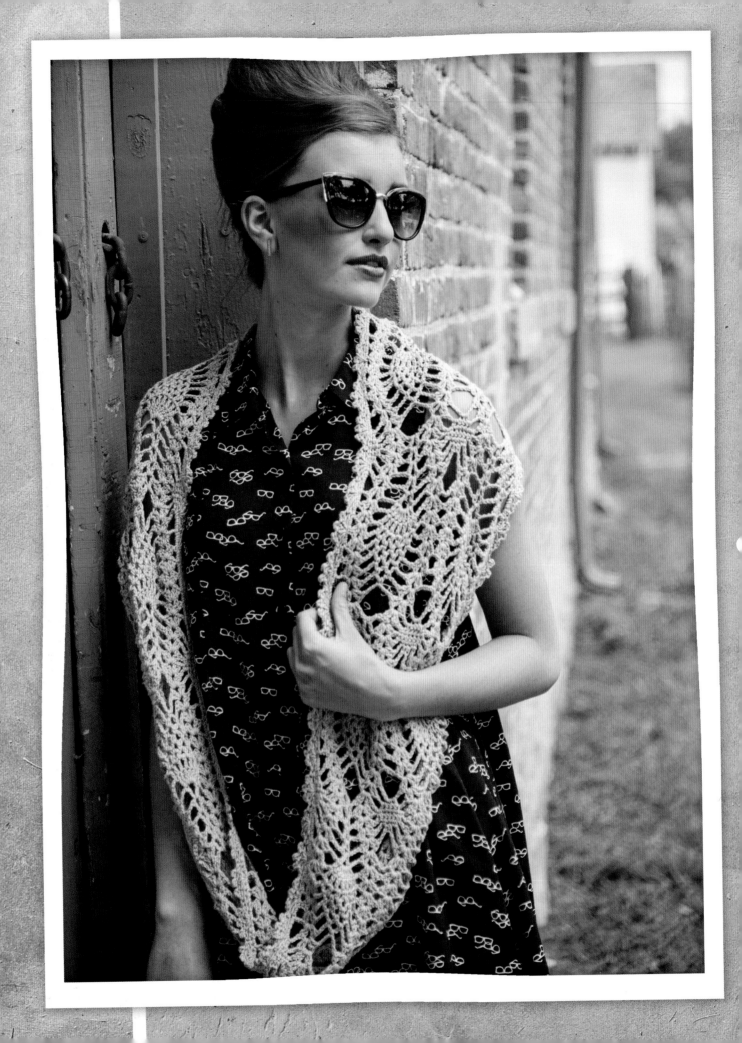

Bromelia Infinity scarf

Moon Eldridge

This infinity scarf uses a pattern that is a combination of the pineapple stitch and spider stitch. This design is a great piece for beginners!

FINISHED MEASUREMENTS

9½" (24 cm) wide and 62" (157.5 cm) circumference.

YARN

Sportweight (#2 Fine).

Shown here: Anzula Vera (65% silk, 35% linen; 365 yd [334 m]/4 oz [113 g]): Mauve, 2 skeins.

HOOK

Size G7 (4 mm). *Adjust hook size if necessary to obtain the correct gauge.*

NOTIONS

Tapestry needle for assembly and weaving in the ends.

GAUGE

22 starting chs × 14 rows in Pineapple Lace motif = 5" × 6¼" (12.5 × 16 cm) with size G-7 (4 mm) hook.

NOTES

Work to the desired length and then seam the ends together to make a ring. When you seam the ends, make sure to match the pattern stitches. The pattern should have a continuous flow after seaming. The fan pattern is worked along the edge after seaming.

STITCH GUIDE

Shell (sh): (2 dc, ch 2, 2 dc) in indicated st or sp.

V-st: (dc, ch 2, dc) in indicated st or sp.

COWL

Set-up row: (WS) Ch 45, sc in 2nd ch from hook, [sc in next 2 chs, ch 2, sk 3 chs, sh in next ch, sk 3 chs, dc in next ch, ch 2, dc in next ch, sk 3 chs, sh in next ch, sk 3 chs**, sc in next 4 chs] twice, ending final rep at **, sc in last 3 chs, turn.

Row 1: Ch 1, [sc in next 3 sc, ch 1, sh in next sh, ch 1, V-st in next ch-2 sp, ch 1, sh in next sh, ch 1, sc in next 3 sc] twice, turn.

Row 2: Ch 1, [sc in next 2 sc, ch 2, sh in next sh, ch 2, V-st in next V-st, ch 2, sh in next sh, ch 2, sk 1 sc, sc in next 2 sc] twice, turn.

Row 3: Ch 1, [sc in next sc, ch 2, sh in next sh, ch 3, V-st in next V-st, ch 3, sh in next sh, ch 2, sk 1 sc, sc in next sc] twice, turn.

Row 4: Ch 7, [sh in next sh, ch 3, V-st in next V-st, ch 3, sh in next sh**, ch 3] twice, ending final rep at **, trtr in last sc, turn.

Row 5: Ch 3, [sh in next sh, ch 3, dc in next dc, 5 dc in next ch-2 sp, dc in next dc, ch 3, sh in next sh] twice, dc in 6th ch of beg ch-7, turn.

Row 6: Ch 3, [sh in next sh, ch 1, sk ch-3 sp, (dc in next dc, ch 1) 7 times, sh in next sh] twice, dc in top of beg ch-3, turn.

Row 7: Ch 3, [sh in next sh, ch 3, sk (2 dc, ch 1, 1 dc), (sc in next ch-1 sp, ch 3) 6 times, sh in next sh] twice, dc in top of beg ch-3, turn.

Row 8: Ch 3, [sh in next sh, ch 3, sk ch-3 sp, (sc in next ch-3 sp, ch 3) 5 times, sh in next sh] twice, dc in top of beg ch-3, turn.

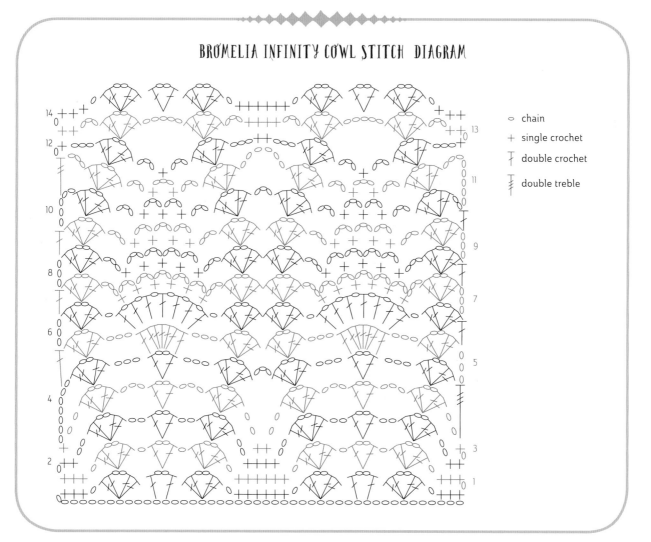

BROMELIA INFINITY COWL STITCH DIAGRAM

○ chain

+ single crochet

┬ double crochet

╪ double treble

Row 9: Ch 3, [sh in next sh, ch 3, sk ch-3 sp, (sc in next ch-3 sp, ch 3) 4 times, sh in next sh] twice, dc in top of beg ch-3, turn.

Row 10: Ch 6, [sh in next sh, ch 3, sk ch-3 sp, (sc in next ch-3 sp, ch 3) 3 times, sh in next sh**, ch 3] twice, ending final rep at **, ch 2, dc in top of beg ch-3, turn.

Row 11: Ch 8, [sh in next sh, ch 3, sk ch-3 sp, (sc in next ch-3 sp, ch 3) twice, sh in next sh**, ch 6] twice, ending final rep at **, ch 3, dtr in 3rd ch of beg ch-6, turn.

Row 12: Ch 1, sc in dtr, [ch 3, sh in next sh, ch 3, sk next ch-3 sp, sc in next ch-3 sp, ch 3, sh in next sh, ch 3**, 2 sc in next ch-6 sp] twice, ending final rep at **, sc in 6th ch of beg ch-8, turn.

Row 13: Ch 1, [sc in next sc, sc in next ch-sp, ch 3, sh in next sh, ch 5, sh in next sh, ch 3, sc in next ch-sp, sc in next sc] twice, turn.

TECHNIQUE TIDBIT

Try to think aboutr your rows as "working on the pineapple moti and "working on the background." Just separating the two in one's mind and eye, makes it easier to re-read when you make a mistake. I like to highlight the pinecone shape directions in my pattern, so I can keep track of where I am in the fabric.

Row 14: Ch 1, [sc in next 2 sc, sc in next ch-sp, ch 1, sh in next sh, V-st in next ch-5 sp, sh in next sh, ch 1, sc in next ch-sp, sc in next 2 sc] twice, turn.

Rep Rows 1–14 a total of 8 times; rep Rows 1 to 13 once. Fasten off.

ASSEMBLY

Sew the ends together with a mattress st seam (see page 156) with RS facing.

EDGING

With RS facing and the scarf turned sideways, rejoin the yarn to seamed st with sl st.

Rnd 1: Ch 1, [work 28 sc evenly across 14 rows of each patt rep] 8 times, work 27 sc evenly across final 13 rows—251 sts.

Rnd 2: Ch 1, sc in first sc, *sk next 2 sc, dc in next dc, [ch 3, sl st in top of dc just made, dc in same sc] 3 times, sk next 2 sc, sc in next sc; rep from * around, sl st in first ch. Fasten off.

Repeat edging on other side.

Weave in ends. Block.

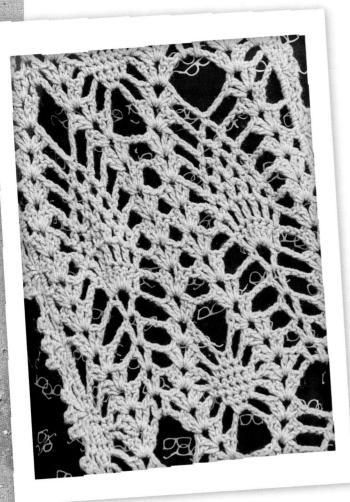

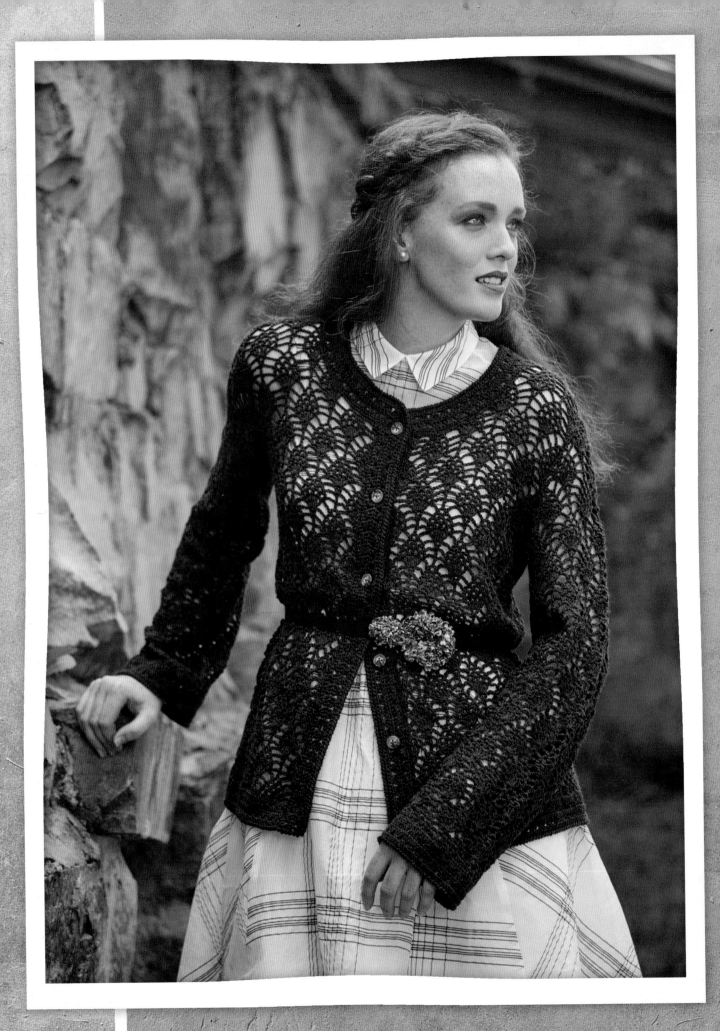

Zoe cardigan

Anastasia Popova

This cardigan is inspired by a piece my grandmother Zoe made over twenty years ago. I love the look and fit of it, and I especially love the edging. Pieces are made separately and sewn together; the set-in sleeves and waist shaping are accomplished by changing the stitch pattern.

FINISHED MEASUREMENTS

Bust measurement is 38¾ (48½, 57¾, 67½)" 98.5 [123, 146.5, 171.5] cm) with an oversized fit when buttoned. Sized for S (M, L, XL). Size shown is S.

YARN

Fingering weight (#1 Super fine).

Shown here: Berroco Ultra Alpaca Fine (50% superwash wool, 30% nylon, 20% superfine alpaca; 433 yd [396 m]/3.5 oz [100 g]): #1288, 4 (4, 5, 6) skeins.

HOOK

Size D-3/3.25mm.) *Adjust hook size if necessary to obtain the correct gauge.*

NOTIONS

Locking stitch markers; tapestry needle for assembly and weaving in the ends; six ⅝" (1.5 cm) buttons

GAUGE

SR = stitch repeat

RR = row repeat

2 SR by 16 rows (2 RR) = 4¾" × 4½" (12 cm × 11.5 cm) in Pineapple Lace Stitch Pattern One.

STITCH GUIDE

Pineapple Lace Stitch Pattern One
(Multiple of 16 sts + 1)

Row 1: (WS) Fsc 33, turn – 2 reps.

Row 2: Ch 1 (does not count as st), sc in next st, *ch 4, sk next 3 sts, sc in next st, [ch 3, sk next st, sc in next st] 4 times, ch 4, sk next 3 sts, sc in next st; rep from * across, turn.

Row 3: Ch 7, sc in next ch-3 sp, [ch 3, sc in next ch-3 sp] 3 times, ch 4, *dc in next sc, ch 4, sc in next ch-3 sp, [ch 3, sc in next ch-3 sp] 3 times, ch 4; rep from * across, dc in last sc, turn.

Row 4: (Ch 3, dc) in next st, ch 4, sk first ch-3 sp, *sc in next ch-3 sp, [ch 3, sc in next ch-3 sp] twice, ch 4**, (dc, ch 1, dc) in next dc; rep from * across to last dc working last rep to **, 2 dc in 3rd ch of ch-7, turn.

Row 5: (Ch 5, tr, ch 1, tr) in next dc, *ch 4, sc in next ch-3 sp, ch 3, sc in next ch-3 sp, ch 4, (tr, ch 1, tr, ch 1, tr**, ch 1, tr, ch 1, tr) in next ch-1 sp; ref from * across, ending last rep at **, turn.

Row 6: Ch 1, sc in next tr, [ch 3, sc in next tr] twice, ch 4, dc in next ch-3 sp, ch 4, *sc in next tr, [ch 3, sc in next tr] 4 times, ch 4, dc in next ch-3 sp, ch 4; rep from * across, [sc in next tr, ch 3] twice, sc in next ch-5 sp, turn.

Row 7: Ch 4, sc in next ch-3 sp, - ch 3, sc in next ch-3 sp, ch 4, dc in next dc, ch 4, *sc in next ch-3 sp, [ch 3, sc in next ch-3 sp] 3 times, ch 4, dc in next dc, ch 4; rep from * across, sc in next ch-3 sp, ch 3, sc in next ch-3 sp, ch 1, dc in last sc, turn.

Row 8: Ch 1, sc in next st, ch 3, sc in next ch-3 sp, ch 4, (dc, ch 1, dc) in next dc, ch 4, *sc in next ch-3 sp, [ch 3, sc in next ch-3 sp] twice, ch 4, (dc, ch 1, dc) in next dc, ch 4; rep from * across, sc in next ch-3 sp, ch 3, sc in last ch-4 sp, turn.

Row 9: Ch 4, sc in next ch-3 sp, ch 4, (tr, ch 1, tr, ch 1, tr, ch 1, tr) in next ch-1 sp, ch 4, *sc in next ch-3 sp, ch 3, sc in next ch-3 sp, ch 4, (tr, ch 1, tr, ch 1, tr, ch 1, tr) in next ch-1 sp, ch 4; rep from *

across, sc in next ch-3 sp, ch 1, dc in last sc, turn.

Row 10: Ch 7, sc in next tr, [ch 3, sc in next tr] 4 times, ch 4, *dc in next ch-3 sp, ch 4, sc in next tr, [ch 3, sc in next tr] 4 times, ch 4; rep from * across, dc in last ch-4 sp, turn.

Row 11: Ch 7, sc in next ch-3 sp, [ch 3, sc in next ch-3 sp] 3 times, ch 4, *dc in next dc, ch 4, sc in next ch-3 sp, [ch 3, sc in next ch-3 sp] 3 times, ch 4; rep from * across, dc in 3rd ch of ch-7, turn.

Rep Rows 4–11 for patt.

Pineapple Lace Stitch Pattern Two
(Multiple of 14 sts + 1)

Row 1: Fsc 29.

Row 2: Ch 1 (does not count as st), sc in next st, *ch 3, sk next 2 sts, sc in next st, [ch 3, sk next st, sc in next st] 4 times, ch 3, sk next 2 sts, sc in next st; rep from * across, turn.

Row 3: Ch 6, sk first ch-3 sp, sc in next ch-3 sp, [ch 3, sc in next ch-3 sp] 3 times, ch 3, sk next ch-3 sp, *dc in next sc, ch 3, sk next ch-3 sp, sc in next ch-3 sp, [ch 3, sc in next ch-3 sp] 3 times, ch 3, sk next ch-3 sp; rep from * across, dc in last sc, turn.

Row 4: (Ch 3, dc) in first st, ch 3, sk next ch-3 sp, *sc in next ch-3 sp, [ch 3, sc in next ch-3 sp] twice, ch 3, sk next ch-3 sp**, (dc, ch 1, dc) in next dc; rep from * across, ending last rep at **, 2 dc in 3rd ch of ch-6 sp, turn.

Row 5: (Ch 5, tr, ch 1, tr) in next dc, *ch 3, sk next ch-3 sp, sc in next ch-3 sp, ch 3, sc in next ch-3 sp, ch 3, sk next ch-3 sp, (tr, ch 1, tr, ch 1, tr**, ch 1, tr, ch 1, tr) in next ch-1 sp; rep from * across, ending last rep at **, turn.

Row 6: Ch 1, sc in next tr, [ch 3, sc in next tr] twice, ch 3, sk next ch-3 sp, dc in next ch-3 sp, ch 3, sk next ch-3 sp, *sc in next tr, [ch 3, sc in next tr] 4 times, ch 3, sk next ch-3 sp, dc in next ch-3 sp, ch 3, sk next ch-3 sp; rep from * across, [sc in next tr, ch 3] twice, sc in next ch-5 sp, turn.

Row 7: Ch 4, sc in next ch-3 sp, c -3, sc in next ch-3 sp, ch 3, sk next ch-3 sp, dc in next dc, ch 3, sk next ch-3 sp, *sc in next ch-3 sp, [ch 3, sc in next ch-3 sp] 3 times, ch 3, sk next ch-3 sp, dc in next dc, ch 3, sk next ch-3 sp; rep from * across, sc in next ch-3 sp, ch 3, sc in next ch-3 sp, ch 1, dc in last sc, turn.

Row 8: Ch 1, sc in next st, ch 3, sc in next ch-3 sp, ch 3, sk next ch-3 sp, (dc, ch 1, dc) in next dc, ch 3, sk next ch-3 sp, *sc in next ch-3 sp, [ch 3, sc in next ch-3 sp] twice, ch 3, sk next ch-3 sp, (dc, ch 1, dc) in next dc, ch 3, sk next ch-3 sp; rep from * across, sc in next ch-3 sp, ch 3, sc in last ch-4 sp, turn.

Row 9: Ch 4, sc in next ch-3 sp, ch 3, sk next ch-3 sp, (tr, ch 1, tr, ch 1, tr, ch 1, tr, ch 1, tr) in next ch-1 sp, ch 3, sk next ch-3 sp, *sc in next ch-3 sp, ch 3, sc in next ch-3 sp, ch 3, sk next ch-3 sp, (tr, ch 1, tr, ch 1, tr, ch 1, tr, ch 1, tr) in next ch-1 sp, ch 3, sk next ch-3 sp; rep from * across, sc in next ch-3 sp, ch 1, dc in last sc, turn.

Row 10: Ch 6, sc in next tr, [ch 3, sc in next tr] 4 times, ch 3, sk next ch-3 sp, *dc in next ch-3 sp, ch 3, sk next ch-3 sp, sc in next tr, [ch 3, sc in next tr] 4 times, ch 3, sk next ch-3 sp; rep from * across, dc in last ch-4 sp, turn.

Row 11: Ch 6, sk first ch-3 sp, sc in next ch-3 sp, [ch 3, sc in next ch-3 sp] 3 times, ch 3, sk next ch-3 sp, *dc in next dc, ch 3, sk next ch-3 sp, sc in next ch-3 sp, [ch 3, sc in next ch-3 sp] 3 times, ch 3, sk next ch-3 sp; rep from * across, dc in 3rd ch of ch-6 sp, turn.

Rep Rows 4-11 for patt.

Edging st patt (Multiple of 3 sts + 1), worked flat, [(multiple of 3 sts), worked in the round].

Ch 16 [15, sl st to form a ring].

Row 1 [Rnd 1]: (RS) Ch 2, dc in same st, *sk next 2 sts, 3 dc in next st, sk next 2 sts, rep from * across [around], 2 dc in last st [dc in same sp as first dc, join with sl st in top of ch-2 sp], turn—16 [15] sts.

Row 2 [Rnd 2]: Ch 1, sc in each st across [around, join with sl st in ch-1 sp], turn.

Row 3 [Rnd 3]: Ch 2 (does not count as st), dc in next st, ch 2, *dc3tog, ch 2; rep from * across to last 2 sts [around to last st], dc2tog [hdc in last st, join with sl st to first dc], turn.

Row 4 [Rnd 4]: Ch 1, *2 sc in next ch-2 sp, sc in next st, rep from * across [around, join with sl st in ch-1 sp], turn.

Row 5 [Rnd 5]: Rep Row 2 [rnd 2]. Do not turn.

Row 6 [Rnd 6]: Ch 1, reverse sc in each st across [around, join with sl st in ch-1sp]. Fasten off.

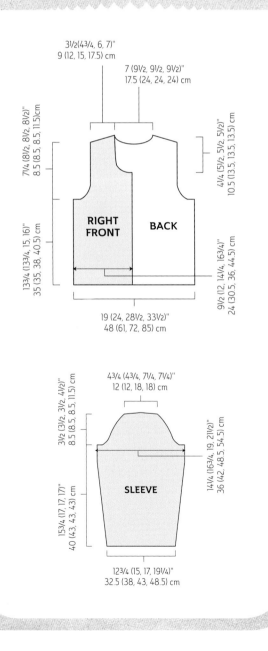

3½(4¾, 6, 7)"
9 (12, 15, 17.5) cm

7 (9½, 9½, 9½)"
17.5 (24, 24, 24) cm

7¼ (8½, 8½, 8½)"
8.5 (8.5, 8.5, 11.5)cm

4¼ (5½, 5½, 5½)"
10.5 (13.5, 13.5, 13.5) cm

RIGHT FRONT

BACK

13¾ (13¾, 15, 16)"
35 (35, 38, 40.5) cm

9½ (12, 14¼, 16¾)"
24 (30.5, 36, 44.5) cm

19 (24, 28½, 33½)"
48 (61, 72, 85) cm

4¾ (4¾, 7¼, 7¼)"
12 (12, 18, 18) cm

3½ (3½, 3½, 4½)"
8.5 (8.5, 8.5, 11.5) cm

14¼ (16¾, 19, 21½)"
36 (42, 48.5, 54.5) cm

SLEEVE

15¾ (17, 17, 17)"
40 (43, 43, 43) cm

12¾ (15, 17, 19¼)"
32.5 (38, 43, 48.5) cm

FRONT

Fsc 65 (81, 97, 113)—4 (5, 6, 7) reps.
Work Rows 2–11 of Pineapple Lace Stitch Pattern One, then work Rows 4–11 once.

WAIST SHAPING

Row 1: (Ch 3, dc) in next st, sk first ch sp, ch 3, [sc in next ch-3 sp, [ch 3, sc in next ch-3 sp] twice, ch 3, [(dc, ch 1, dc) in next dc, ch 3, sk next ch sp, sc in next ch-3 sp, (ch 3, sc in next ch-3 sp) twice, ch 3] across, 2 dc in 3rd ch, turn—4 (5, 6, 7) reps.
Work Rows 5–11 of Pineapple Lace Stitch Pattern Two, then Rows 4–10.

Next row: Ch 7, sc in next ch-3 sp, [ch 3, sc in next ch-3 sp] 3 times, ch 4, sk next ch-3 sp, [dc in next sc, ch 4, sk next ch-3 sp, sc in next ch-3 sp, (ch 3, sc in next ch-3 sp) 3 times, ch 4, sk next ch-3 sp] across, dc in last sc, turn.
Work Rows 4–11 of Pineapple Lace Stitch Pattern Two 1 (2, 2, 2) times.

Sizes S and XL only: Rep Rows 4–9 once.

Sizes M and L only: Rep Rows 4–5 once.

ARMHOLE SHAPING
Left Front

Row 1: (WS) Work in est patt to last (last, last, 2nd to last) tr group, sc in next tr, [ch 3, sc in next tr] twice, turn, leaving rem sts unworked.

Row 2: Ch 4, sc in next ch-3 sp, ch 3, sc in next ch-3 sp, cont in est patt.

Row 3: Work in est patt to last ch-3 sp, sc in last ch-3 sp, ch 2, dc in last ch-4 sp, turn.

TECHNIQUE TIDBIT

Because of the beautiful drape of the fabric, pineapple lace works beautifully for dresses, tunics, tops, afghans, blankets, throw pillows, hats, and even socks. It's usually a lot easier to crochet pineapples following a chart than by following written instructions. A unique symbol represents every stitch in the chart. Once you learn to recognize the symbols, "reading" your work becomes easier.

PINEAPPLE LACE STITCH PATTERN ONE

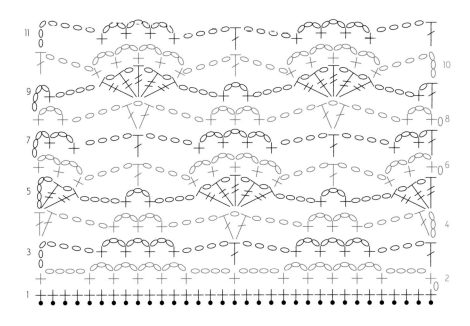

PINEAPPLE LACE STITCH PATTERN TWO

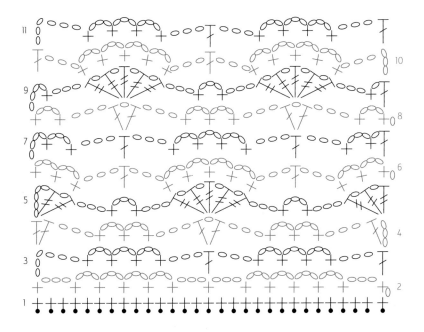

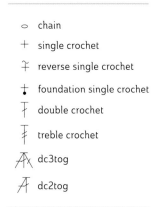

○ chain

+ single crochet

⨏ reverse single crochet

• foundation single crochet

Ŧ double crochet

⌇ treble crochet

⋏ dc3tog

⋏ dc2tog

FLAT EDGING STITCH PATTERN

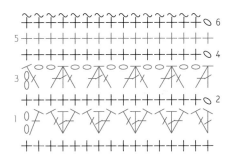

ROUND EDGING STITCH PATTERN

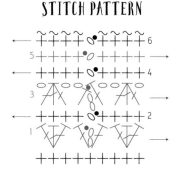

Row 4: Ch 4, (tr, ch 1, tr, ch 1, tr, ch 1, tr, ch 1, tr) in next ch-1 sp, cont in est patt.

Row 5: Work in est patt to last tr group, sc in next tr, [ch 3, sc in next tr] twice, ch 1, hdc in next tr, turn, leaving rem sts unworked. Work in Pineapple Lace Stitch Pattern One for 6 more rows.

Right Front

Row 1: (WS) Ch 1, sl st in each st across to 3rd tr of first (first, first, 2nd) tr group, sc in next tr, [ch 3, sc in next tr] twice, cont in est patt.

Row 2: Work in est patt to last sc, ch 1, dc in last sc, turn, leaving rem sts unworked.

Row 3: Ch 5, sc in next ch-3 sp, ch 4, cont in est patt.

Row 4: Work in est patt to last ch-1 sp, (tr, ch 1, tr, ch 1, tr, ch 1, tr, ch 1, tr) in last ch-1 sp, tr in last ch-5 sp, turn.

Row 5: Ch 1, sl st in next ch-1 sp, sl st in next tr, [ch 3, sc in next tr] 3 times, cont in est patt.

Row 6: Work in est patt to the last ch-3 sp, ch 2, dc in the last ch-3 sp.

Work in the Pineapple St Pattern One for 5 more rows.

NECK SHAPING

LEFT FRONT

Sizes S, M, and XL only:

Row 1: Work in est patt to last st, 2 dc in last st, turn.

Size L only:

Row 1: Work in est patt to last ch-1 sp, (dc, ch 1, dc, ch 1, dc) in next ch-1 sp, ch 4, cont in est patt.

All sizes:

Row 2: Ch 1, sl st in each st to next ch-3 sp, ch 1, sc in next ch-3 sp, ch 1, sl st in each of next 8 sts and chs, ch 3, sc in middle tr (tr, dc, tr) of group of 5, cont in est patt.

Row 3: Work in est patt to last ch-3 sp, ch 1, dc in last ch-3 sp, turn.

Row 4: Ch 3, sc in next ch-3 sp, ch 4, cont in est patt.

Row 5: Work in est patt to last ch-3 sp, tr in last ch-3 sp, turn.

Row 6: Ch 1, sl st in next ch sp, sl st in next tr, ch 3, sc in next tr, cont in est patt.

Row 7: Rep Row 3.

Sizes M and XL only:

Rep Rows 4–7 once.

All sizes:

Cont in Pineapple Lace Stitch Pattern One for 7 (7, 11, 7) more rows.

Last row: (Ch 2, sc) in each ch-3 sp across to last ch-3 sp of group, ch 2, dc in last ch-3 sp of group, [ch 1, (tr, ch 1, tr, ch 1, tr, ch 1, tr) in next dc, ch 1, (dc, ch 1, dc) in each rem ch-3 sp of group] across. Fasten off.

RIGHT FRONT

Sizes S, M, and XL only:

Row 1: (Ch 3, dc) in first st, ch 4, sc in next ch-3 sp, cont in est patt.

Size L only:

Row 1: Ch 4, sc in next ch-3 sp, ch 4, (dc, ch 1, dc, ch 1, dc) in next ch-1 sp, ch 4, cont in est patt.

All sizes:

Row 2: Work in est patt to 3rd tr (tr, dc, tr) of last tr (tr, dc, tr) group, ch 1, dc in next tr (tr, dc, tr), turn.

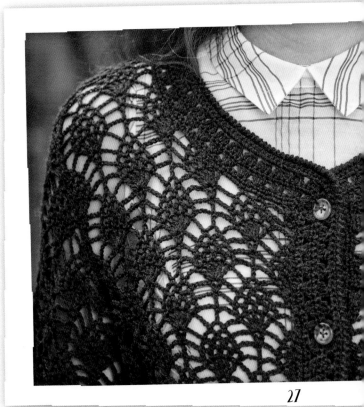

Row 3: Ch 3, sc in next ch-3 sp, ch 3, sc in next ch-3 sp, ch 4, cont in est patt.

Row 4: Work in est patt to last ch-3 sp, ch 1, dc in last ch-3 sp, turn.

Row 5: Ch 4, cont in est patt.

Rows 6 and 7: Rep Rows 2 and 3.

Sizes M and XL only: Rep Rows 4–7.

All sizes:

Cont in Pineapple Lace Stitch Pattern One for 7 (7, 11, 7) more rows.

Last row: Ch 4, dc in same sp, [(dc, ch 1, dc) in each ch-3 sp to next dc, ch 1, (tr, ch 1, tr, ch 1, tr, ch 1, tr) in next dc, ch 1] across to last ch-3 group, dc in next ch-3 sp, (ch 2, sc) in each rem ch-3 sp across and last st. Fasten off.

BACK

Fsc 129 (161, 193, 225)—8 (10, 12, 14) reps. Work as for front to armhole shaping. Working in est st patt, shape right back armhole as Left Front and left back armhole as Right Front. Work in Pineapple Lace Stitch Pattern One for 10 (14, 14, 14) more rows. Do not fasten off.

SHAPE RIGHT BACK SHOULDER

Row 1: Work in est patt to 2nd (3rd, 3rd, 4th) dc, dc in next dc, ch 4, sc in next ch-3 sp, ch 3, sc in next ch-3 sp, ch 1, dc in next ch-3 sp, turn, leaving rem sts unworked.

Row 2: Ch 4, sc in next ch-3 sp, cont in est patt.

Row 3: Work in est patt to last ch-4 sp, tr in last ch-4 sp, turn.

Row 4: Ch 1, sl st in next ch-1 sp, sl st in next tr, [ch 3, sc in next tr] 3 times, ch 4, dc in next ch-3 sp, ch 4, sc in next tr, [ch 3, sc in next tr] 4 times, ch 3, sc in last ch-4 sp.

Row 5: (Ch 2, sc) in each ch-3 sp across to last ch-3 sp of group, ch 2, dc in last ch-3 sp of group, [ch 1, (tr, ch 1, tr, ch 1, tr, ch 1, tr) in next dc, ch 1, (dc, ch 1, dc) in each rem ch-3 sp of group] across. Fasten off.

SHAPE LEFT BACK SHOULDER

Join yarn with sl st in 3rd ch-3 sp of 2nd (3rd, 3rd, 4th) tr group.

Row 1: Ch 4, sc in next ch-3 sp, ch 3, sc in next ch-3 sp, cont in est patt.

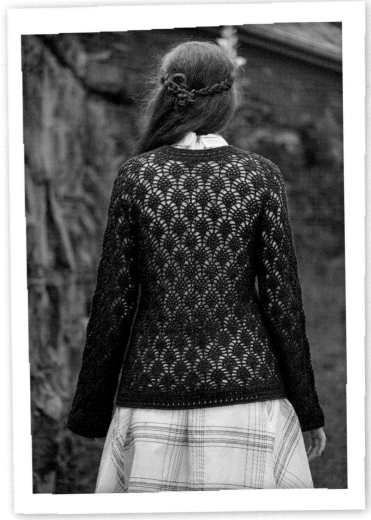

Row 2: Work in est patt to last ch-3 sp, sc in last ch-3 sp, ch 2, dc in last ch-4 sp, turn.

Row 3: Ch 4, (tr, ch 1, tr, ch 1, tr, ch 1, tr, ch 1, tr) in next ch-1 sp, cont in est patt.

Row 4: Ch 4, sc in next tr, [ch 3, sc in next tr] 4 times, ch 4, dc in next ch-3 sp, ch 4, sc in next tr, [ch 3, sc in next tr] twice, ch 1, hdc in next tr, turn.

Row 5: Ch 4, dc in same sp, [(dc, ch 1, dc) in each ch-3 sp to next dc, ch 1, (tr, ch 1, tr, ch 1, tr, ch 1, tr) in next dc, ch 1] across to last ch-3 group, dc in next ch-3 sp, (ch 2, sc) in each rem ch-3 sp across and last st. Fasten off.

SLEEVES

Note: Work sleeves in the round while turning every rnd and joining with sl st at the end of the rnd to the first st of the rnd. Fsc 85 (99, 113, 127). Work Rows 2–11 of Pineapple Lace Stitch Pattern Two, then work Rows 4–11 once, then work Rows 4–10.

Next row: Ch 7, sc in next ch-3 sp, [ch 3, sc in next ch-3 sp] 3 times, ch 4, sk next ch-3 sp, [dc in next sc, ch 4, sk next ch-3 sp, sc in next ch-3 sp, (ch 3, sc in next ch-3 sp) 3 times, ch 4, sk next ch-3 sp] across, dc in last sc, turn.

Work Rows 4–11 of Pineapple Lace Stitch Pattern One 3 (4, 4, 4) times, then Rows 4–9 (4–5, 4–5, 4–5).

SLEEVE CAP SHAPING

Row 1: Sl st in each st and ch to 3rd tr of next tr group, [ch 3, sc in next tr) twice, cont in est patt to last tr group, sc in first tr, dc in next tr, turn.

Row 2: Ch 3, (dc, ch 1, dc) in next dc, ch 4, cont in est patt to last dc, (dc, ch 1, dc) in last dc, tr in next ch-3 sp, turn.

Row 3: Ch 1, (dc, ch 1, dc) in next ch-1 sp, cont in est patt to last ch-1 sp, dc in last ch-1 sp, tr in last dc, turn.

Row 4: Ch 4, dc in next sc, ch 1, sc in next ch-3 sp, cont in est patt to last sc, ch 1, dc in last sc, tr in last ch-1 sp, turn.

Row 5: Ch 2, (dc, ch 1, dc) in next ch-3 sp, ch 4, cont in est patt to last ch-3 sp, dc in last ch-3 sp, dc in last ch-1 sp, turn.

Row 6: Rep Row 4.

Size XL only: Rep Rows 3–6.

Row 7: Ch 4, sc in next ch-3 sp, cont in est patt to last ch-3 sp, sc in last ch-3 sp, tr in last dc, turn.

Row 8: Ch 2, sc in next ch-3 sp, cont in est patt to last ch-3 sp, sc in last ch-3 sp, dc in last ch-4 sp, turn.

Row 9: Ch 2, dc in next ch-3 sp, cont in est patt to last ch-3 sp, dc in last ch-3 sp, dc in last ch-2 sp, turn.

Row 10: Ch 2, dc in next dc, ch 4, cont in est patt to last dc, tr in last dc, turn.

Row 11: Ch 3, sc in next ch-3 sp, cont in est patt to last ch-3 sp, sc in last ch-3 sp, sc in last ch-3 sp, ch 1, dc in last dc, turn.

Row 12: Ch 3, sc in next ch-3 sp, cont in est patt to last ch-3 sp, ch 3, sl st in last ch-3 sp.

Fasten off.

BLOCKING, SEAMING, AND EDGING

Block pieces to the measurements. Sew the shoulder and side seams.

SLEEVES EDGING

With WS facing, join the yarn in the first st, ch 1, *sc in next 20 (16, 22, 17) sts, sc2tog; rep from * 3 (5, 4, 6) more times, sc in rem sts, turn–81 (93, 108, 120) sts.

Work Rnds 1-6 of the Edging Stitch Pattern. Fasten off.

BOTTOM EDGING

With WS facing, join the yarn to the bottom right corner, ch 1 (counts as sc), work 243 (303, 363, 423) sc evenly along the Right Front, back, Left Front lower edge while decreasing 15 (19, 23, 27) sts evenly, turn. Work Rows 1–5 of Edging Stitch Pattern.

BUTTONBAND, BUTTONHOLE BAND, AND NECK EDGING

Row 1: With RS facing, cont with yarn from bottom edging, ch 1, work 114 (114, 123, 129) sc evenly along Right Front edge, 132 (165, 180, 198) sc around neck edge, 114 (114, 123, 129) sc along Left Front edge, turn.

Row 2: Ch 1, sc in each st across. Working 3 sc in neck opening corner sts, turn.

Row 3: Work Row 1 of Edging Stitch Pattern across, working (3 dc, ch 2, 3 dc) in center sc of each corner, turn.

Row 4: Work Row 2 of the Edging Stitch Pattern across the Left Front to the corner, 3 sc in corner ch-2 sp, cont in the patt along the neck opening edge, 3 sc in corner ch-2 sp, sc in next dc, *ch 3, sk next 3 sts, sc in next 18 (18, 19, 20) sts; rep from * 5 more times, sc in each rem st across, turn.

Row 5: Work Row 3 of Edging Stitch Pattern across, turn.

Rows 6–7: Ch 1, sc in each st across. Work 3 sc in the center corner st at each neck corner, turn.

With RS facing, work 1 row of reverse sc along both front edges, neck edge, and bottom edge. Fasten off.

Attach the sleeves to the armholes. Weave in all the loose ends.

BRUGES LACE

Bruges lace was at the height of fashion in the sixteenth and seventeenth centuries and brought renown to western Flandria, the region that contains the city for which this lace is named.

Fashion became an affordable luxury during this time period, mainly due to increased trade, and therefore increased wealth, of major European kingdoms. King Francis I of France was known for his lavish outfits and was accredited with adding lace to men's fashion. Even though most families would only have a handful of best gowns or outfits, it was considered rude not to embellish and essentially smarten up whenever you had company. Adding lace to your outfit was an easy way to do this.

True Bruges lace is a bobbin lace that uses many threads at once. A master craftsman will sketch a design on paper, use pins to act as location points, and weave 20 to 200 threads around them to make the design. Ever the innovators, crocheters found a way to mimic this look with just a trusty crochet hook and thread. Bruges crochet lace is made from tiny short-rows with one solid section of typically double crochet and one section of chains. The short-rows are stacked on top of each other to create a ribbon or column. The chains connect to other ribbons. The contrast of solid and open make the technique recognizable. The hardest aspect of Bruges is keeping track of when you want to turn your ribbon to go in another direction. I like to periodically lay out my work flat, and sometimes I even block it so I can see and check the direction in which I am curving my lace.

Amazingly, unlike a lot of lace techniques, Bruges crochet lace is still quite popular. We don't see a lot of it in the United States, but it is still incredibly vibrant in fashion designs from the Ukraine and Belguim. They have mastered using the ribbon portion of the lace to flow and twist into the most impressive and inspiring designs. We hope our projects will touch you in the same way and have you saying, "I didn't know it could look like that!" If you are new to Bruges crochet, you might want to try the **Zandstraat Jewelry.** You can get your feet wet by making the ribbon or column sections and learn how to join them. In the **Ter Berge Lace Shawl**, Kristin Omdahl uses the chain sections to stand out as large medallions. Lastly, the **Leopold Pullover** uses Bruges crochet as a joining strip between motifs. Bruges crochet is quite a rich lace technique. Don't be surprised if you find yourself googling Ukrainian designs after you have crocheted these.

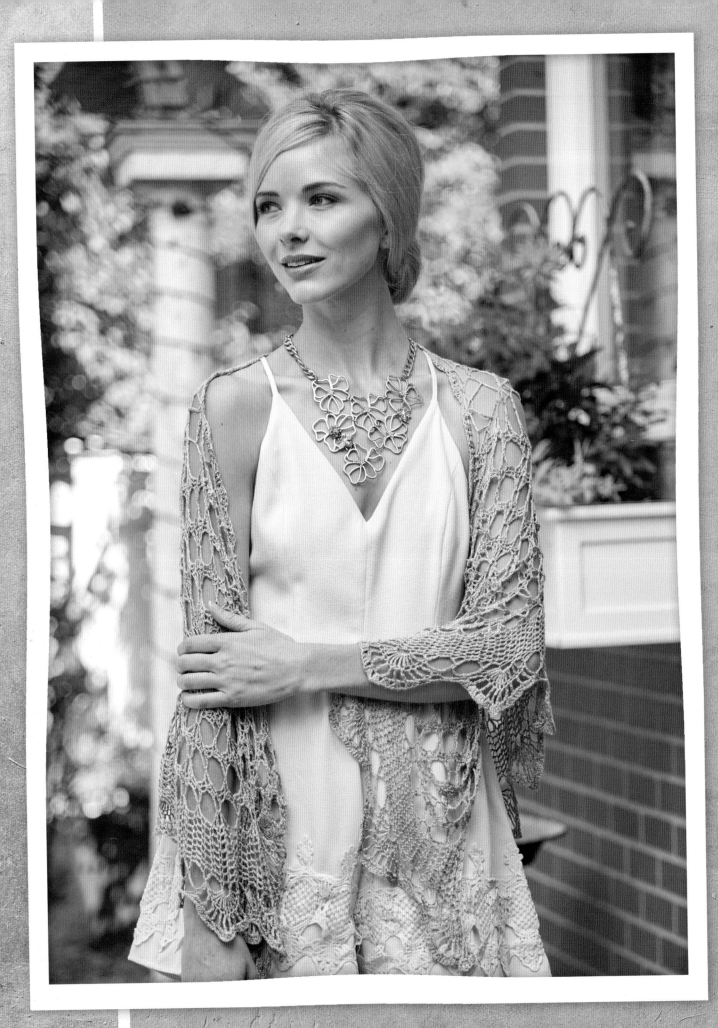

Ter Berge Lace shawl

Kristin Omdahl

Inspired by a photo of a swirling textile, this garment came to life when rendered in beautiful Bruges lace because there is so much control over the direction of your geometric shaping once you get the hang of it. Using the formulas of traditional crochet increases and applying them to the lace allows this spectacular vision of a spiral medallion to become a reality.

FINISHED MEASUREMENT

25" (63.5 cm) wide × 62" (157.5 cm) long.

YARN

Fingering weight (#1 Super fine).

Shown here: Kristin Omdahl Yarns Be So Fine (100% bamboo; 650 yd [594 m]/4 oz [113 g]): Lavender's First Romance, 1 skein.

HOOK

Size G-6 (4 mm). *Adjust hook size if necessary to obtain the correct gauge.*

NOTIONS

Split-ring stitch marker for end-of-round placement; tapestry needle for assembly and weaving in the ends.

GAUGE

4 dc and 2½ dc rows = 1 in (2.5 cm) blocked.

LARGEST MEDALLION

Set-up row: Ch 6 (counts as ch-5 center ring and ch-1 base for dc group), 3 dc in 6th ch from hook, turn.

FIRST SECTION

Row 1: Ch 5, 3 dc in center dc, turn.

Row 2: Ch 2, sl st in ch-5 center ring of set-up row, ch 2, 3 dc in center dc, turn.

Rows 3–16: [Rep Rows 1 and 2] 7 times—8 ch-5 sps around perimeter.

SECOND SECTION

Row 17: Rep Row 1.

Row 18: Ch 2, sl st in next ch-5 sp in preceding section, ch 2, 3 dc in center dc, turn.

Row 19: Rep Row 1.

Row 20: Ch 2, sl st in same ch-5 sp as in last sl st-, ch 2, 3 dc in center dc, turn.

Rows 21–48: [Rep Rows 17–20] 7 times—16 ch-5 sps around perimeter.

THIRD SECTION

Row 49: Rep Row 1.

Row 50: Ch 2, sl st in next ch-5 sp in preceding section, ch 2, 3 dc in center dc, turn.

Rows 51–54: Rep Rows 17–20 once.

Rows 55–96: [Rep Rows 49–54] 7 times—24 ch-5 sps around perimeter.

FOURTH SECTION

Rows 97–100: [Rep Rows 17–18] twice.

Rows 101–104: Rep Rows 17–20.

Rows 105–160: [Rep Rows 97–104] 7 times—32 ch-5 sps around perimeter.

FIFTH SECTION

Rows 241–248: [Rep Rows 17–18] 4 times.

Rows 249–252: Rep Rows 17–20.

Rows 254–336: [Rep Rows 241–252] 7 times—40 ch-5 sps around perimeter.

SIXTH SECTION

Rows 337–346: [Rep Rows 17–18] 5 times.

Rows 347–350: Rep Rows 17–20.

Rows 351–448: [Rep Rows 337–350] 7 times—48 ch-5 sps around perimeter.

SEVENTH SECTION

Rows 449–460: [Rep Rows 17–18] 6 times.

Rows 461–464: Rep Rows 17–20 once.

Rows 465–576: [RepRows 449–464] 7 times—56 ch-5 sps around perimeter.

Ch 2, sl st in next ch-5 sp on prev section, ch 2, sl st in ch-5 sp on last row of this section. Fasten off.

MEDIUM MEDALLION (Make 2)

Work the first 4 sections as for the Largest Medallion; do not fasten off—32 ch-5 sps around perimeter.

TECHNIQUE TIDBIT

Bruges lace is worked spirally in the round in this project and is a wonderful technique to add to your crochet repertoire. Marking the beginning/end of rounds with a split-ring stitch marker is a very handy tip when you get to the larger rounds.

JOINING

With first Medium Medallion, join the last 4 exterior ch-5 sps with the adjacent ch-5 sps of Large Medallion as follows: (ch 2, sl st to ch-5 sp, ch 2) in each corresponding ch-5 sp.

With second Medium Medallion, sk 18 ch-5 sps on Large Medallion from last join with first Medium Medallion, join the last 6 exterior ch-5 sps with the adjacent ch-5 sps of same Large Medallion as follows: (ch 2, sl st to ch-5 sp, ch 2) in each corresponding ch-5 sp. Fasten off.

SMALL MEDALLION (Make 2)

Work the first 2 sections as for largest Medallion; do not fasten off—16 ch-5 sps around perimeter.

JOINING

With first Small Medallion, join the last 4 exterior ch-5 sps to the 4 exterior ch-5 sps of Medium Medallion that are 6 ch-6 sps apart from the join of the Medium and

PARTIAL MEDALLION STITCH DIAGRAM

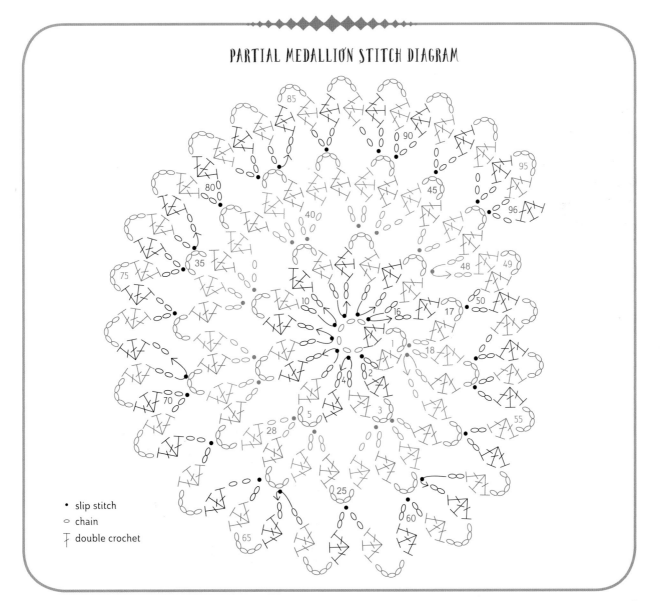

- • slip stitch
- ○ chain
- ⊤ double crochet

LAYOUT DIAGRAM

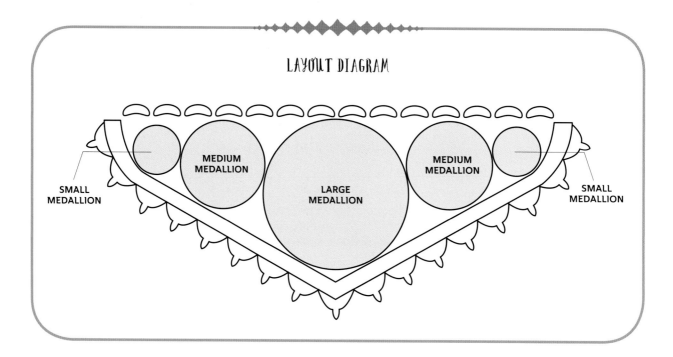

SMALL
MEDALLION

MEDIUM
MEDALLION

LARGE
MEDALLION

MEDIUM
MEDALLION

SMALL
MEDALLION

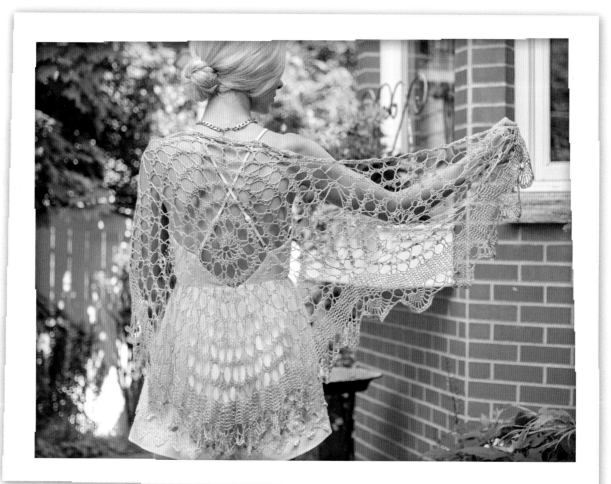

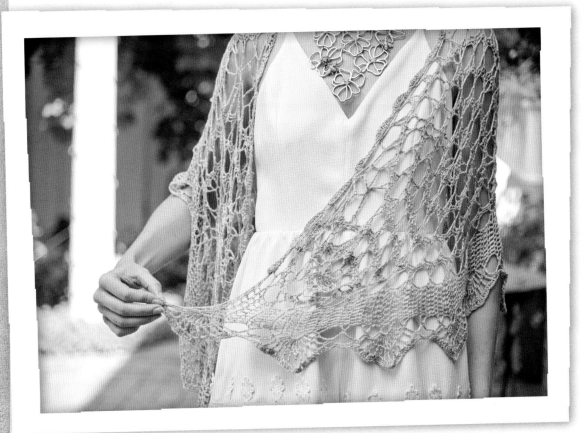

Large Medallions as follows: (ch 2, sl st to next ch-5 sp, ch 2) in each corresponding ch-5 sp. Fasten off. Repeat with second Small Medallion on opposite end in corresponding ch-5 sps of second Medium Medallion.

TOP EDGING

Row 1: Working across tops of Medallions, join with sl st in ch-5 sp of Small Medallion that is 4 ch-5 sps away from the Medium Medallion, ch 1, sc in same sp, *[ch7, sc in next ch-5 sp] across top edge to next gap between current and next Medallion. In the center 6 ch-5 sps in gap, work dc-tr-dtr-dtr-tr-dc cluster with one leg of b cluster in each ch-5 sp of gap; rep from * across top edge until 4th gap is filled with cluster, [ch 7, sc in next ch-5 sp] across to 4th ch-5 sp of second Small Medallion, ch 3, dc in last ch-5 sp, turn.

Row 2: Ch 1, sc in same st, *[ch 7, sc in next ch-7 sp] across to 2 ch-7 sps before next multi-stitch cluster, work dc-tr-tr-dc cluster with one leg of cluster in each of the next 4 ch-7 sps; rep from * across 4th gap, [ch 7, sc in next ch-7 sp] across, turn.

Row 3: Ch 1, 7 sc in each ch-7 sp across. Do not fasten off.

Note: Rotate piece 90 degrees and work the lower edging perpendicularly to the lower edge and joining edge.

LOWER EDGING

Row 1: Ch 13, dc in 6th ch from hook and each ch across, ch 2, sl st in next ch-5 sp on adjacent medallion, ch 2, turn.

Row 2: Dc in the next 8 dc, turn.

Row 3: Ch 5, dc in the next 8 dc, ch 2, sl st in next ch-5 sp on adjacent Medallion, ch 2, turn.

Rep Rows 2 and 3 across entire lower edge first ch-7 sp of Top Edging and ending with a Row 2.

Next row: Ch 5, dc in the next 8 dc, ch 2, sl st in first sc of Top Edging, ch 2, turn. Do not fasten off.

FAN EDGING

Set-up row: Dc in the next 8 dc.

Row 1: Ch 5, 11 dc in first ch-5 sp of Lower Edging, *sc in next ch-5 sp, [ch 7, sc in next ch-5 sp] twice, 11 dc in next ch-5 sp; rep from * across, dtr in last st from opposite side of starting ch of Row 1 of Lower Edging, turn.

Row 2: Ch 5 (counts as tr, ch1), [tr in next dc, ch 1] 10 times, *sc in next ch-7 sp, ch7, sc in next ch-7 sp, [tr in next dc, ch 1] 10 times, tr in last dc of group; rep from * across.

Row 3: Ch 3 (counts as dc), 2 dc in first ch-1 sp, 3 dc in each of the next 9 ch-1 sps, *sc in next ch-7 sp, 3 dc in the next 10 ch-1 sps; rep from * across. Fasten off.

Block to finished measurements.

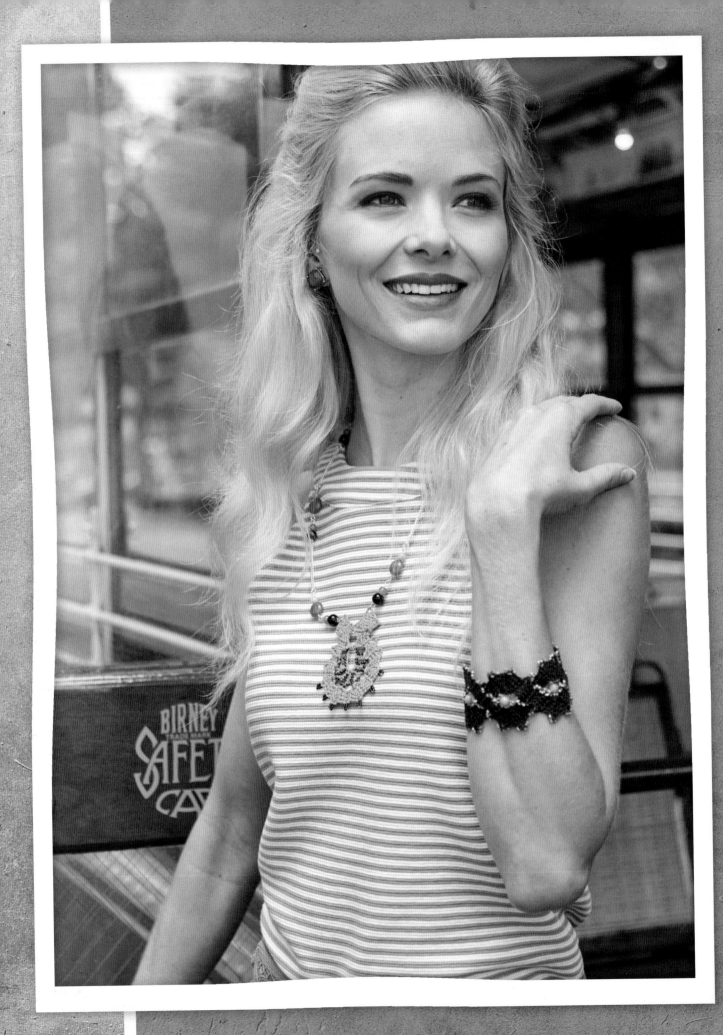

Zandstraat jewelry

ROBYN CHACHULA

Bruges crochet, with its tiny short-rows, transforms itself into any shape. Both the cuff and pendant necklace in this project use this to their advantage, coming to life in unique shapes. Creating this jewelry from thread is a great, inexpensive way to test out new techniques.

FINISHED MEASUREMENTS

Cuff is about 2" (5 cm) wide × 7" (18 cm) long. Pendant is about 3" (7.5 cm) wide × 4" (10 cm) tall.

YARN

Embroidery thread Size 10.

Shown here: Aunt Lydia's Classic 10 (100% mercerized cotton; 350 yd [320 m]/ 1¾ oz [50 g]): #154-420 Cream (cuff option 1), 150 yd [137 m]; #154-486 Navy (cuff option 2), 150 yd [137 m], #154-661 Frosty Green (Pendant option 1), 3 balls, #154-492 Burgundy (Pendant option 2), 100 yd [91 m].

HOOK

Size 7 (1.5 mm) steel hook. *Adjust hook size if necessary to obtain the correct gauge.*

NOTIONS

Cuff: (264) 11/0 golden seed beads (option 1); (528) 15/0 pink seed beads (option 2); fabric stiffener; rust-proof pins; five 6 mm round recycled glass beads light blue (option 1) or pink (option 2); five 1" (2.5 cm) open eye pins; twelve) 4 mm jump rings, one 19 mm bar and ring toggle clasp; needle-nose pliers.

Necklace: Eighty-four 11/0 blue seed beads (option 1); thirty-five 11/0 bronze seed beads (option 2); twenty 8/0 golden seed beads (option 2); fabric stiffener; rust-proof pins.

Option 1: Six 6 mm pink (A) and light blue (B) round beads; six 8 mm navy (C) beads; six 12 mm (D) orange beads; 12 open eye pins; eighteen 4 mm jump rings; needle-nose pliers; 20" (51 cm) chain link; wire cutters.

Option 2: Two 10 mm burgundy (E) beads; two 1" (2.5 cm) turquoise teardrop (F) beads; two (8 mm) light green (G) beads; 6 open eye pins; eight 4 mm jump rings; needle-nose pliers; 15" (38 cm) long chain.

GAUGE

3 dc = ½" (1.3 cm) and Rows 6–10 = 1" (2.5 cm).

STITCH GUIDE

Bead chain (bead ch): Slide 1 (option 1) or 2 (option 2) seed beads to hook, chain 1.

Bead dc: Yo, insert hook into ch sp indicated and pull up a loop, [slide bead to hook, yo and draw through 2 loops on hook] twice.

Treble crochet 2 together (Ttr2tog) option 1: Yo 4 times, insert hook into ch sp indicated and pull up a loop, [slide bead to hook, yo and draw through 2 loops on hook] twice, yo twice, insert hook into next ch sp indicated and pull up a loop, [slide bead to hook, yo and draw through 2 loops on hook] twice, slide bead to hook, yo and draw through 3 loops on hook, [slide bead to hook, yo and draw through 2 loops on hook] twice.

Treble crochet 2 together (Ttr2tog) option 2: Yo 4 times, insert hook into ch sp indicated and pull up a loop, [slide bead to hook, yo and draw through 2 loops on hook] twice, yo twice, insert hook into next ch sp indicated and pull up a loop, [slide bead to hook, yo and draw through 2 loops on hook] twice, yo and draw through 3 loops on hook, [yo and draw through 2 loops on hook] twice.

CUFF

FIRST SIDE

String on 148 seed beads (option 1) or string 296 seed beads (option 2). Ch 4.

Row 1: Four bead ch, turn, dc in last 4 ch.

Rows 2–3: Four bead ch, turn, dc in ea dc across.

Row 4: Two bead ch, 2 ch, turn, sc in next st, hdc, in next st, dc in next 2 st.

Row 5: Four bead ch, turn, dc in next 2 st, hdc in next st, sc in next st.

Row 6: Ch 5, turn, sc in next st, hdc in next st, dc in next 2 st.

Row 7: Rep Row 5.

Row 8: Ch 2, sl st through prev two ch sps below on same side, 2 bead ch, turn, sc in next st, hdc in next st, dc in next 2 sts.

Rows 9–12: Four bead ch, turn, dc in next 4 st.

Rep Rows 4–12 three times, rep Rows 4–11 once, fasten off. Weave in the ends.

SECOND SIDE

String on 116 seed beads (option 1) or string 232 seed beads (option 2). Ch 4, leave a long tail for seaming later.

Row 1: Four bead ch, turn, dc in last 4 ch.

Rows 2–3: Four bead ch, turn, dc in ea dc across.

Row 4: Two bead ch, 2 ch, turn, sc in next st, hdc in next st, dc in next 2 st.

Row 5: Four bead ch, turn, dc in next 2 st, hdc in next st, sc in next st.

Row 6: Ch 5, turn, sc in next st, hdc in next st, dc in next 2 st.

Row 7: Rep Row 5.

Row 8: Ch 2, sl st through prev 2 ch sps below on same side, 2 bead ch, turn, sc in next st, hdc in next st, dc in next 2 sts.

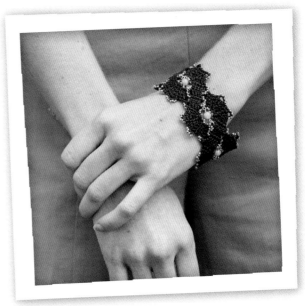

Row 9: Ch 1, sl st to ch sp of Row 12 on first side, ch 2, turn, dc in next 4 st.

Rows 10–11: Four bead ch, turn, dc in next 4 st.

Row 12: Ch 1, sl st to ch sp of Row 9 on first side, ch 2, turn, dc in next 4 sts.

Rep Rows 4–12 three times joining the second side to the first as you go; Rep Rows 4–11 once, leaving a long tail to fasten off.

Sew the ends of each side together.

CUFF ASSEMBLY
BLOCKING

Mix fabric stiffer with equal parts water. Dip the cuff into the solution. Pat off the excess and place the cuff on

CUFF STITCH DIAGRAM

FIRST SIDE

SECOND SIDE

PENDANT STITCH DIAGRAM

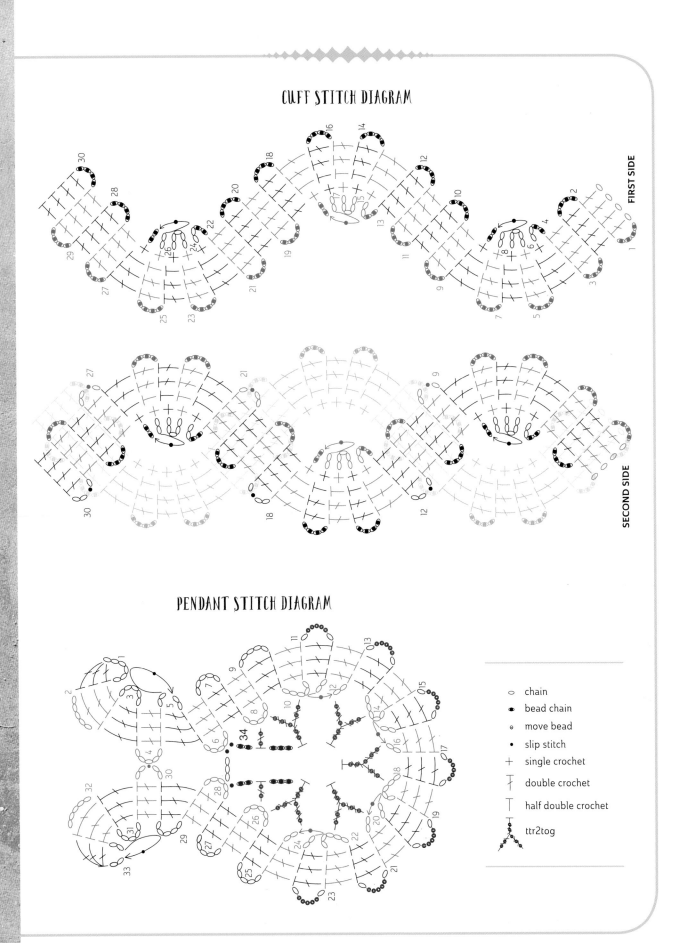

○	chain
●	bead chain
○	move bead
●	slip stitch
+	single crochet
⊤	double crochet
⊤	half double crochet
⋏	ttr2tog

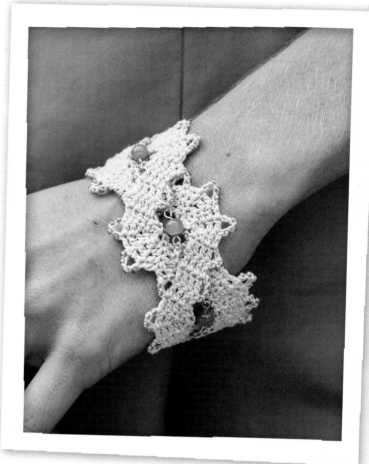

TECHNIQUE TIDBIT

The shapes into which Bruges fabric or motifs can be crocheted is limited only by your imagination. Around the world, crocheters have used the short-rows in Bruges crochet to curl, bend, and twist into the most creative shapes, from curling around flowers in a border to twisting around the collar of a garment.

parchment paper. Pin the cuff and chain spaces out to shape and allow to dry.

JEWELRY

Thread 1 recycled bead onto an open eye pin. Curl the end into a loop with pliers. Using pliers to twist open the jump rings, attach the bead to the cuff with a jump ring at each end of the eye pin in the center of the cuff. Attach the clasp to the cuff end with a jump ring.

PENDANT PATTERN

String on 35 seed beads.

Row 1: Ch 6, turn, sk 5 ch, 3 dc in last ch.

Rows 2–4: Ch 5, turn, dc in ea dc across.

Row 5: Ch 2, sl st to prev 2 ch sps below on same side, ch 2, turn, dc in ea dc across.

Rows 6–10: Ch 5, turn, dc in ea dc across.

Row 11: Ch 1, slide 5 beads onto hook, ch 1, turn, dc in ea dc across.

Row 12: Ch 2, sl st to prev ch sp below on the same side, ch 2, turn, dc in ea dc across.

Row 13: Rep Row 11.

Rep Rows 10–13 three times, Rep Rows 10–12 once.

Rows 25–29: Rep Row 6.

Row 30: Ch 2, sl st to ch sp on Row 4, ch 2, turn, dc in ea dc across.

Rows 31–32: Rep Row 6.

Row 33: Ch 2, sl st to prev 2 ch sps below on same side, ch 2, turn, dc3tog over all dc, fasten off, weave in the ends.

Row 34: String 49 11/0 (option 1) or 20 8/0 (option 2) seed beads, join yarn with sl st to the ch sp on Row 6, 2 bead ch, bead dc in ch sp on Row 8, 3 bead ch, ttr2tog in prev and next ch sp 5 times, 3 bead ch, bead dc in prev ch sp, 2 bead ch, sl st in next ch sp, ch 3, sl st to first ch sp, fasten off, weave in the ends.

PENDANT ASSEMBLY
BLOCKING

Dip the Pendant into fabric stiffener. Pat off the excess and place the Pendant on parchment paper. Pin the Pendant and chain spaces out to shape and allow to dry.

JEWELRY

Create bead charms. For option 1: Thread A and D or B and C on an eye pin. For option 2: Thread either a E, F, or G bead on an eye pin. Using wire cutters, trim off all but 1/2" (1.3 cm) of the eye pin. Using needle-nose pliers, bend the wire end back to 90 degrees, then curl the end back on itself to create a loop. (Option 1) Cut the chain into 2" (5 cm) lengths. Attach the bead charms to the Pendant, chain, and themselves with jump rings that you twist open to use. Use the photo as a guide to lay out the beads.

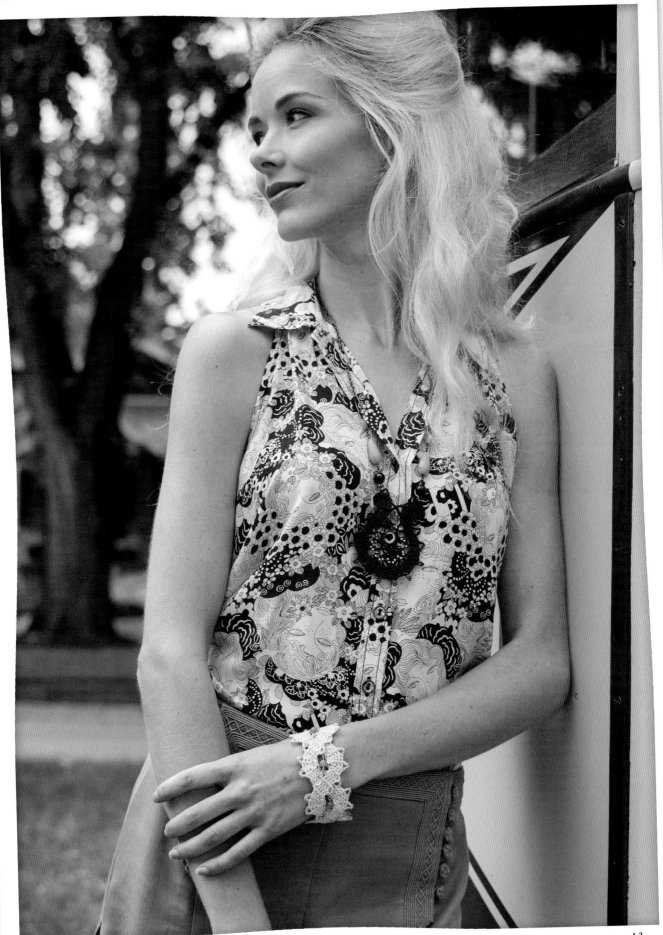

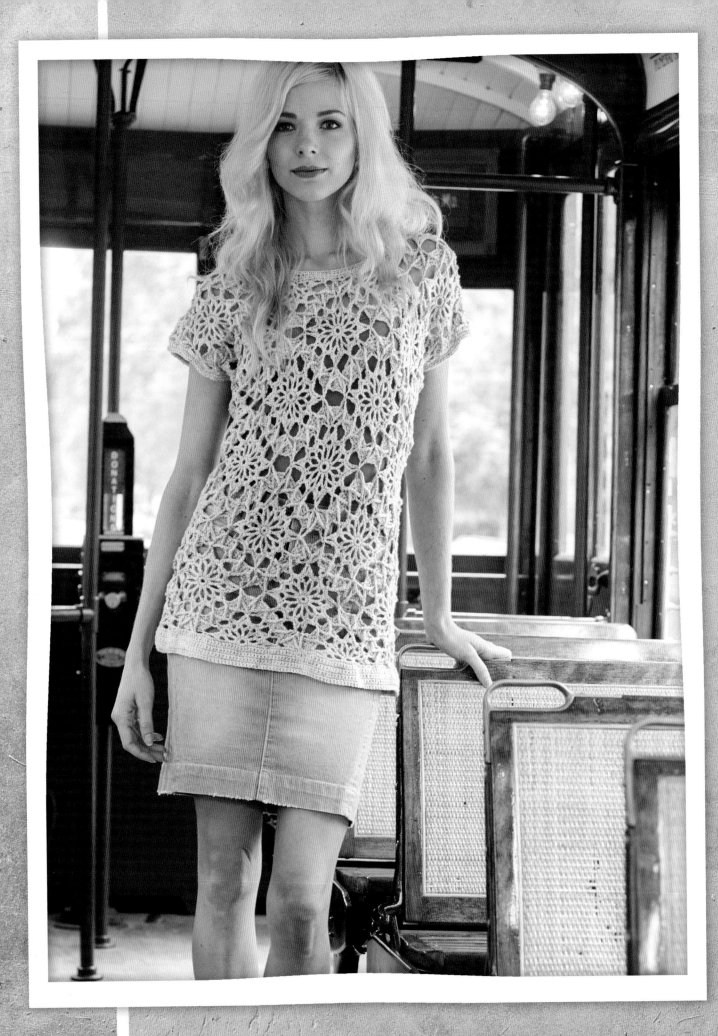

Leopold pullover

Robyn Chachula

Motif projects can make the most interesting lace fabric. When combining motifs with unusual joining methods, as done here, the results can be one of a kind. The tunic in this project is quite easy to wear. Relaxed in fit, this sweater can be customized to your size by going up a hook size when you want a bit more ease or by going down one when you don't.

FINISHED MEASUREMENTS

Bust measurement is 33¾ (37, 39¾, 44, 49, 53)" (85.6 [94, 101, 112, 124.5, 134.5] cm) with a relaxed fit. Sized for XS (S, M, L, XL, 2X). Size shown is S.

YARN

Sportweight (#2 Fine).

Shown here: Mrs Crosby Hat Box (75% superwash merino wool, 15% silk, 10% cashmere; 317 yd [290 m]/3.5 oz [100 g]): #African Grey, 4 (4, 5, 6, 6, 7) hanks.

HOOKS

Size G-6 (4 mm); G-7 (4.5 mm); H-8 (5 mm). *Adjust hook size if necessary to obtain the correct gauge.*

NOTIONS

Tapestry needle for assembly and weaving in the ends.

GAUGE

Diagonally across motif = 4 (4½, 5, 4, 4½, 5) 10 [11.5, 12.5, 10, 11.5, 12.5] cm with size G-6/4 mm (G-7 (4.5 mm), H-8 (5mm) hooks.

NOTE

Sizes XS and L use G-6 (4 mm) hook; S and XL use G-7 (4.5 mm) hook; M and 2X use H-8 (5 mm) hook.

STITCH GUIDE

Y-st: Dtr in next st indicated, ch 3, dc in middle of previous dtr post (through middle horizontal bar).

Ch-5 join: Ch 2, sl st to ch-sp indicated, ch 2.

Front post double treble crochet (Fpdtr): See Techniques

Back post double treble crochet (Bpdtr): See Techniques

CROSBY MOTIF

Make 32 (32, 32, 60, 60, 60).

Ch 6, join with sl st to form a ring.

Rnd 1: Ch 1, 12 sc in ring, sl st to first sc, do not turn—12 sc.

Rnd 2: Ch 6, y-st in ea sc around, dc in 3rd ch of tch, ch 3, sl st in top of tch, do not turn—12 y-sts.

Rnd 3: Ch 1, *(2 sc, ch 3, 2 sc) in each of next 2 ch-3 sps, (sc, hdc, dc, ch 5, dc, hdc, sc) in next ch-3 sp; rep from * around, sl st to first st, fasten off.

HALF MOTIF

Make 8 (8, 8, 16, 16, 16).

Ch 6, join with sl st to form a ring.

Rnd 1: Ch 1, 7 sc in ring, turn--12 sc.

Rnd 2: Ch 7, dc in 3rd ch of tch, y-st in ea sc around to last sc, dtr in last sc, ch 1, dc in middle of dtr post, turn—7 y-sts.

Rnd 3: Ch 9, (dc, hdc, sc) in ch-1 sp, (2 sc, ch 3, 2 sc) in each of next 2 ch-3 sps, (sc, hdc, dc, ch 5, dc, hdc, sc) in next ch-3 sp, (2 sc, ch 3, 2 sc) in next 2 ch-3 sps, (sc, hdc, dc) in tch-sp, ch 8, sl st in tch-sp, fasten off.

NECK MOTIF

Make 2 (2, 2, 0, 0, 0).

Ch 6, join with sl st to form a ring.

Rnd 1: Ch 1, 11 sc in ring, turn—11 sc.

Rnd 2: Ch 5, y-st in ea sc around to last sc, dtr in last sc, turn—9 y-sts.

Rnd 3: Ch 1, *(2 sc, ch 3, 2 sc) in next ch-3 sp, (sc, hdc, dc, ch 5, dc, hdc, sc) in next ch-3 sp, (2 sc, ch 3, 2 sc) in next ch-3 sp; rep from * around, sl st to top of tch, fasten off.

ARM MOTIF

Make 8 (8, 8, 0, 0, 0).

Ch 6, join with sl st to form a ring.

Rnd 1: Ch 1, 9 sc in ring, turn—9 sc.

Rnd 2: Ch 7, dc in 3rd ch of tch, y-st in ea sc around to last sc, dtr in last sc, turn—9 y-sts.

Rnd 3: Ch 1, *(2 sc, ch 3, 2 sc) in next ch-3 sp, (sc, hdc, dc, ch 5, dc, hdc, sc) in next ch-3 sp, (2 sc, ch 3, 2 sc) in next ch-3 sp; rep from * once, (2 sc, ch 3, 2 sc) in next ch-3 sp, (sc, hdc, dc) in tch-sp, ch 8, sl st in tch-sp, fasten off.

EDGE MOTIF

Make 4 (4, 4, 0, 0, 0).

Ch 6, join with sl st to form a ring.

Rnd 1: Ch 1, 6 sc in ring, turn—6 sc.

Rnd 2: Ch 5, y-st in ea sc around to last sc, dtr in last sc, ch 1, dc in middle of dtr post, turn—4 y-sts.

Rnd 3: Ch 9, (dc, hdc, sc) in ch-1 sp, (2 sc, ch 3, 2 sc) in each of next 2 ch-3 sps, (sc, hdc, dc, ch 5, dc, hdc, sc) in next ch-3 sp, (2 sc, ch 3, 2 sc) in next ch-3 sp, sl st to top of tch, fasten off.

JOINING STRIPS

Note: Motifs are joined with short-rows that create wavy stripes around the tunic. See stitch diagram on page 48 for guidance. Use layout as a guide for location of motifs.

Row 1: Join yarn to corner ch-5 sp of any motif at side seam with sl st, ch 6, sl st to next adjoining motif in its corner ch-5 sp, turn, sk 1 ch, dc in next 4 ch, dtr in sk ch.

Row 2: Ch-5, join to same corner ch-5 sp, turn, dc in ea dc across, bpdtr in dtr.

Row 3: Ch-5, join to next ch-3 sp on adjoining motif, turn, dc in ea dc across, fpdtr in dtr.

Row 4: Ch-5, join to next ch-3 sp on prev motif, turn, dc in ea dc across, bpdtr in dtr.

Rep Rows 3–4 once.

Row 7: Ch-5, join to corner ch-5 sp on adjoining motif, turn, dc in ea dc across, fpdtr in dtr.

Row 8: Ch-5, join to corner ch-5 sp on prev motif, turn, dc in ea dc across, bpdtr in dtr.

Row 9: Ch-5, join to same corner ch-5 sp on adjoining motif, turn, dc in ea dc across, fpdtr in dtr.

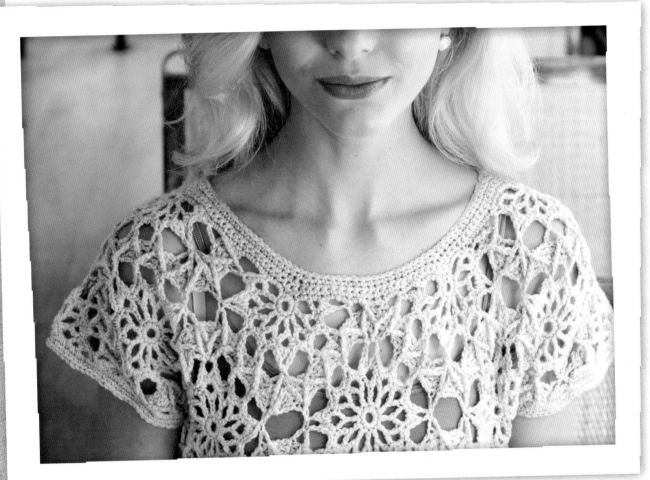

Row 10: Ch-5, join to corner ch-5 sp on next motif, turn, dc in ea dc across, bpdtr in dtr.

Row 11: Rep Row 9.

Row 12: Ch-5, join to next ch-3 sp on prev motif, turn, dc in ea dc across, bpdtr in dtr.

Row 13: Ch-5, join to next ch-3 sp on adjoining motif, turn, dc in ea dc across, fpdtr in dtr.

Rows 14–15: Rep Rows 12–13.

Row 16: Ch-5, join to corner ch-5 sp on prev motif, turn, dc in ea dc across, bpdtr in dtr.

Row 17: Ch-5, join to corner ch-5 sp on adjoining motif, turn, dc in ea dc across, fpdtr in dtr.

Row 18: Ch-5, join to same corner ch-5 sp on prev motif, turn, dc in ea dc across, bpdtr in dtr.

Row 19: Ch-5, join to corner ch-5 sp on next adjoining motif, turn, dc in ea dc across, fpdtr in dtr.

Rep Rows 2–19 around body; fasten off. Whipstitch first and last row together.

TECHNIQUE TIDBIT

Bruges lace is usually used on its own to make amazing fabric, but the clever short-rows are perfect for joining motifs together. This tunic shows that the chain spaces on the ends of typical Bruges stitch patterns are great for joining other crochet squares. Just think of the possibilities! You can use this technique to join granny squares together for a fun new twist on an old classic. Or, you could use this to join front and back panels together to give a bold side seam (as well as adding a bit of extra-wide seam for a bit more ease in your sweaters). I hope this gives you a bit of inspiration to try this technique on all your projects.

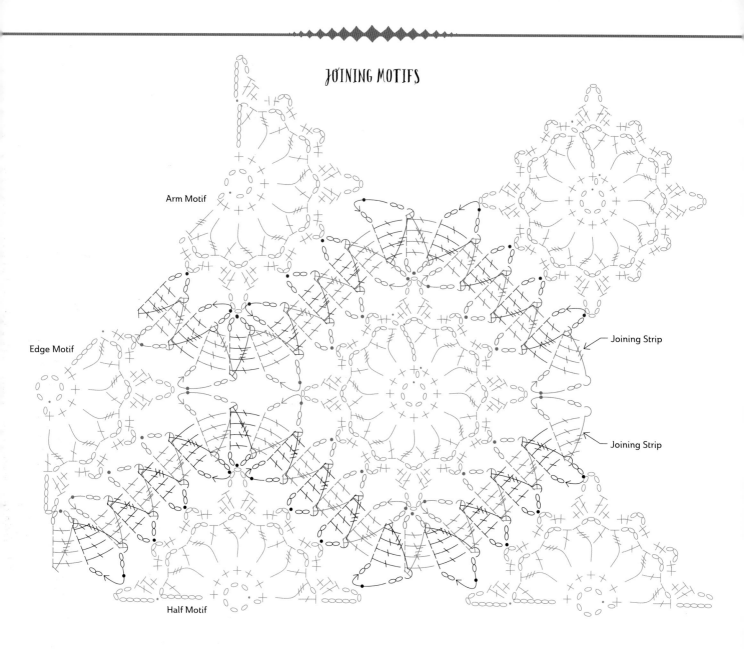

Arm Motif

Edge Motif

Joining Strip

Joining Strip

Half Motif

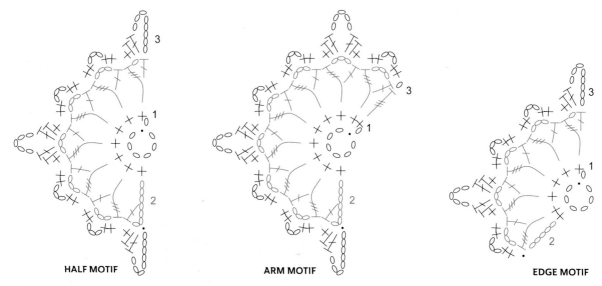

HALF MOTIF

ARM MOTIF

EDGE MOTIF

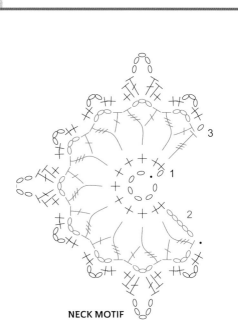

NECK MOTIF

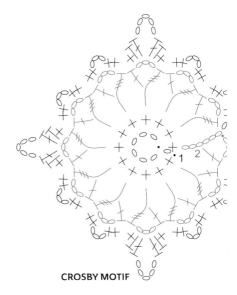

CROSBY MOTIF

○ chain
• slip stitch
+ single crochet
⊤ half double crochet
⊤ double crochet
⊤ treble crochet
⊤ double treble
⊤ front post double treble
⊤ back post double treble

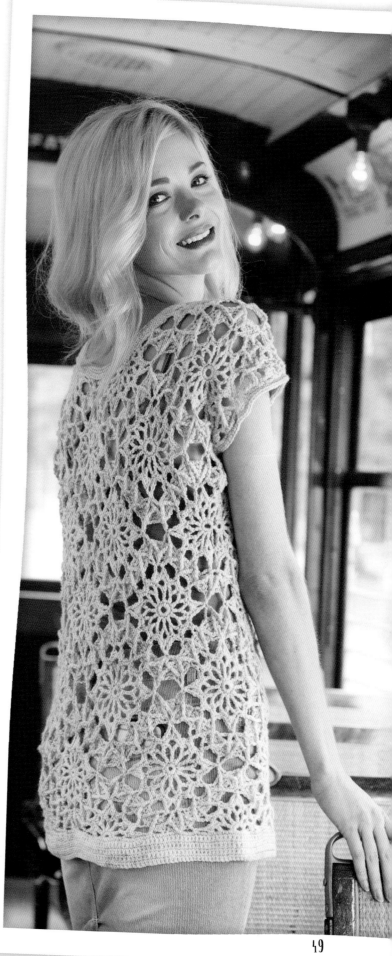

Rep joining stripe for all motifs across tunic. At arm openings and neck openings, end the joining strip at the edge of the motif.

BLOCKING AND SEAMING

Soak the tunic in a cool bath with a no-rinse gentle wash. Roll out the excess water in towels (do not wring out). Pin the tunic to the schematic size, allow to dry on one side, unpin, and flip to dry on the back side. For sizes XS, S, and M, whipstitch the edge and arm motifs together at the underarm seam.

EDGING
BOTTOM EDGING

Join yarn to the motif at the side seam with a sl st on the RS.

Rnd 1: Ch 1, *sc evenly across half motif, 3 sc in ch join, 3 sc around post of dc on joining stripe, 3 sc in ch join; rep from * around, sl st to first sc, turn.

Rnd 2: Ch 1, sc in ea sc around, sl st to first sc, turn.

Rep Rnd 2 six times;, fasten off. Weave in the ends.

CUFF EDGING

Join yarn to the edge of the motif at the side seam.

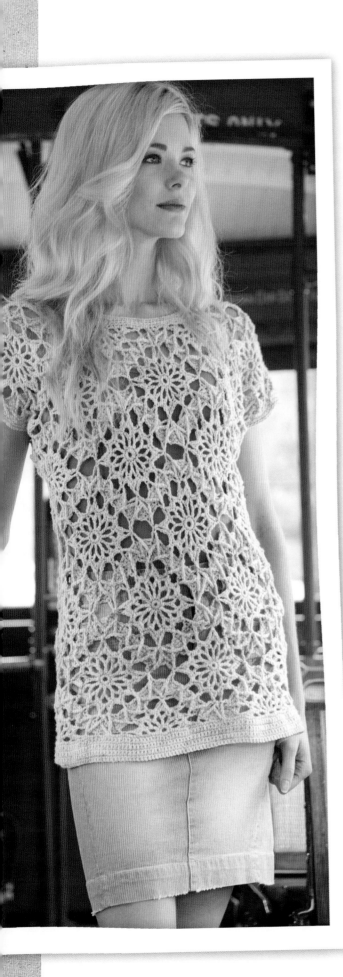

Rnd 1: Ch 1, *sc evenly across motif, sc evenly across joining stripe, ch 3, sc evenly across joining stripe; rep from * around, sl st to first sc, turn.

Rnd 2: Ch 1, sc in ea sc and ch around, sl st to first sc, turn.

Rnd 3: Sl st in ea sc around; fasten off.

COLLAR EDGING

Join yarn to the motif at the back neck.

Rnd 1: *Sc evenly across motif, 3 sc in ch join, 3 sc around post of dc on joining stripe, 3 sc in ch join; rep from * to shoulder; **sc evenly across motif, ch 3, sc evenly across joining stripe, ch 3; rep from ** across shoulder; cont around collar, sl st to first sc, turn.

Rnd 2: Sc in ea sc and ch around to corner, sk 1 sc at corner; rep from * around, sl st to first st, turn.

Rnds 3–4: Sc in ea sc around to corner, sk 1 sc at corner; rep from * around, sl st to first sc, turn.

Rnd 5: Sl st in ea sc around; fasten off.

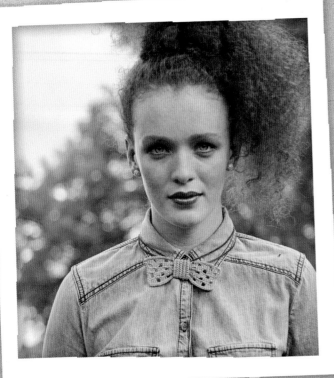

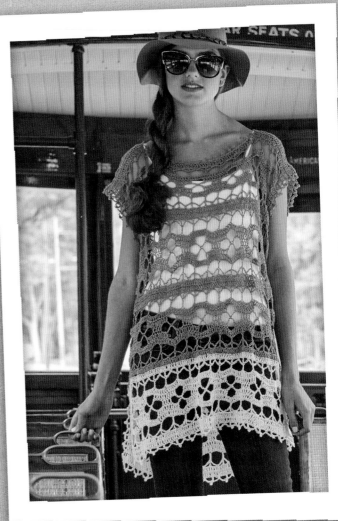

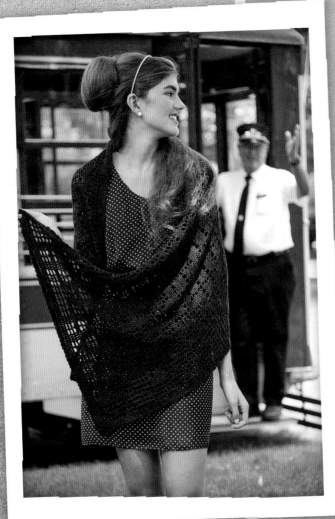

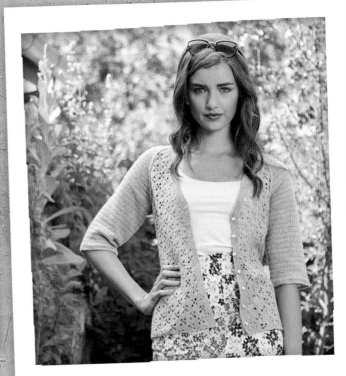

FILET LACE

Originally known as square crochet, filet lace was extremely popular in publications up until around the 1920s when machine lace became easy to mass produce. Filet crochet is made from open and filled-in spaces. The filled-in spaces are usually made from two to three double or treble crochet, and the open spaces are two to three chains with double or treble crochet on each side. Designs that are more extensive are made by combining single crochet, which can transform the blocks to curves. Popular patterns are Greek-inspired, nature themes, and simple sayings. To become the designer of these, you just mark off on graph paper the areas that you want to be solid. It is a bit like a pixelated picture but can be very enjoyable.

Filet crochet patterns are not classically hard to crochet. The hardest part is keeping your place in your pattern. Charts are made to make it even easier to follow since classic written directions can be extremely complex for just open and closed squares. I like to keep my place by high-lighting each complete row on my chart and placing a stitch marker at the beginning of that highlighted row. That way if I have to put down my work, I can pick it back up without having to start from the beginning counting each row up.

The patterns give a great array of filet lace projects, from classic to unusual. The **Celtic Cross Wrap** is a prime example of filet crochet. It is written in chart form, so the finished project and chart look exactly the same. The **Bow Tie Necklace** uses filet in a whimsical 1930s-inspired jewelry. The **Carefree Pullover** displays filet when it is combined with other stitches for an open and unique fabric. The **Field Cardigan** tests your chart capabilities. Field is crocheted on the bias, so naturally the chart is also on a diagonal.

But don't let our projects be the end. Use them as jumping-off points to create your own unique projects.

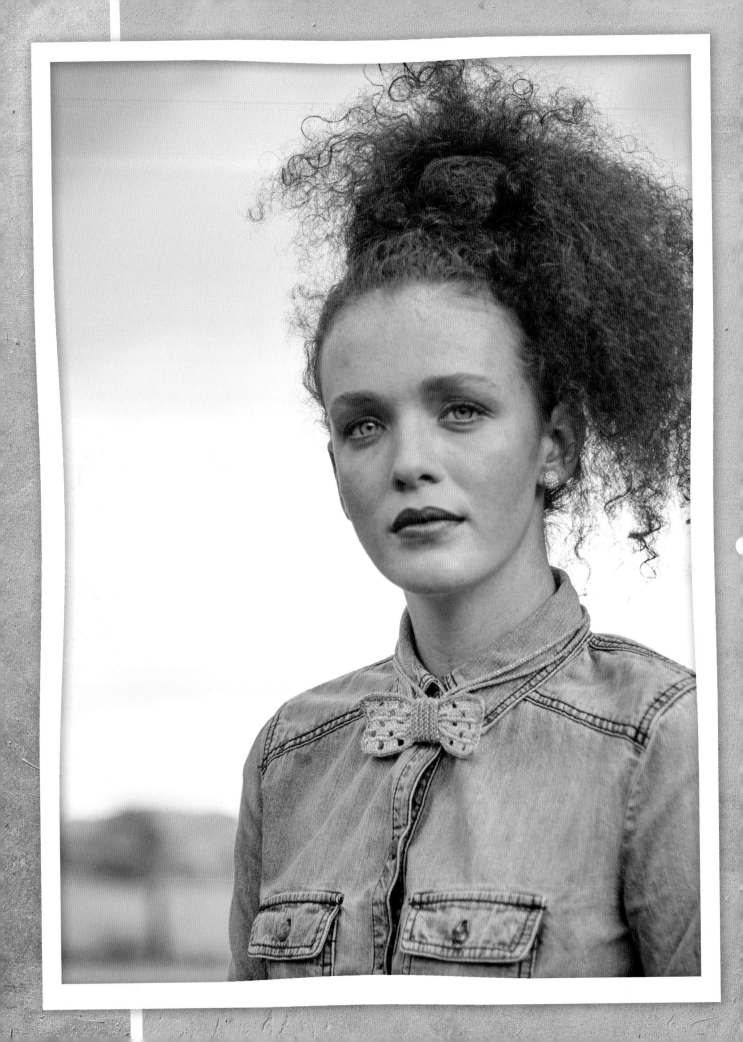

Bow Tie necklace

SHELBY ALLAHO

Add flair to any simple neckline with this modern interpretation of filet crochet. A fun and satisfying project for crocheters who are new to the filet technique, this project will also satisfy those who already love to crochet jewelry. Make a fully crocheted version or accent the bow with actual chains that are attached with jump rings.

FINISHED MEASUREMENTS
Bow measures 4³⁄8" (11.5 cm) wide × 1⁵⁄8" (4 cm) and 15½" (39.5 cm) around the neck.

YARN
Fingering weight (#1 Super fine).

Shown here: Red Heart Fashion Crochet Thread (93% mercerized cotton/7% metallic; 100 yd [91 m]): "Silver" (MC or CC), "Gold" (MC or CC), 1 skein of each color or 1 skein of either color.

HOOKS
Size 7 (1.50 mm) and Size 4 (1.75 mm) steel crochet hooks. *Adjust hook size if necessary to obtain the correct gauge.*

NOTIONS
Tapestry needle; rust-proof pins.

For the chain version: 30½" (77.5 cm) chain; six 6mm jump rings; necklace clasp; nail clippers for cutting chain, pliers to open and close the jump rings.

GAUGE
Gauge is not critical for this project.

STITCH GUIDE

Invisible Fasten Off: Cut yarn, leaving a 3" (8cm) tail, pull the yarn all the way through the loop on hook, as if to fasten off in the usual way. Insert hook in both lps of the second st in rnd, yo with tail end and pull through st. Finally, insert the hook in the flo of last st in rnd, yo, pull yarn down through.

BOW

With MC or CC, ch 39 sts.

Row 1: Working in back ridge of chs, beg in the 4th back ridge from hook, dc in first 3 chs, [ch 2, sk 2 chs, dc in next 4 chs] twice, sc in next 5 chs, dc in next 4 chs; rep bet [] twice, turn—37 sts.

Row 2: Ch 4 (counts as dc, ch 1), sk 2 dc, [dc in next st, 2 dc in ch-sp, dc in next st, ch 2, sk 2 sts] twice, dc in next st, sc in next 5 sts, dc in next st, ch 2, sk 2; rep bet [] once, dc in next st, 2 dc in ch-sp, dc in next st, ch 1, sk 2 sts, dc in last st, turn.

Row 3: Ch 3 (counts as dc), dc in first ch-sp, dc in next st, [ch 2, sk 2, dc in next st, 2 dc in ch- sp, dc in next st] twice, sc in next 5 sts, [dc in next st, 2 dc in ch-sp, dc in next st, ch 2, sk 2 sts] twice, dc in next st, dc in next ch-sp, dc in last st, turn—35 sts.

Row 4: Ch 5 (counts as dc, ch 2), sk 1 dc, dc in next, [2 dc in ch-sp, dc in next st, ch 2, sk 2 sts, dc in next st] twice, sc in next 5 sts, dc in the next st, [ch 2, sk 2 sts, dc in next st, 2 dc in ch-sp, dc in next st] twice, ch 2, sk 1 st, dc in last st, turn—37 sts.

Row 5: Ch 3 (counts as a st), [2 dc in ch-sp, dc in next st, ch 2, sk 2 sts, dc in next st] twice, 2 dc in ch-sp, dc in next st, sc in next 5 sts, dc in next st; rep bet [] twice, 2 dc in ch-sp, dc in last st. Fasten off.

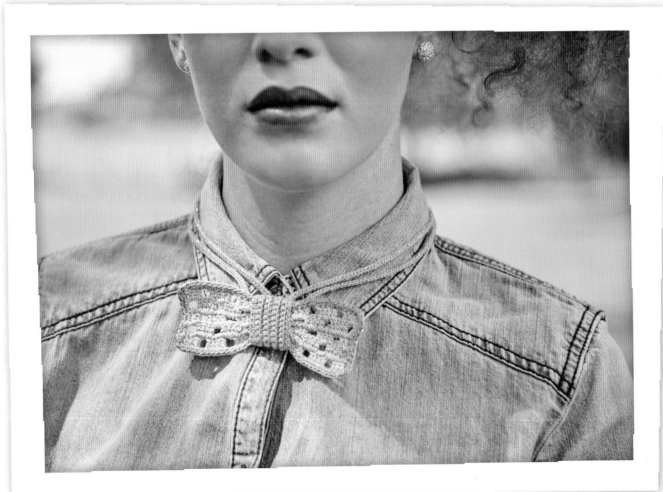

BOW TIE EDGING

Using hook size 4 (1.75 mm) and MC or CC, join with sl st in top right corner of Bow, ch 1, sc in same st, sc in each dc and 2 sc in each ch-sp across, *rotate to work down short side of the Bow, work 10 sc evenly across side of Bow*, rotate to work across starting ch, then sc in each st and 2 sc in each ch-sp across; rep from * to * once, join with sl st in blp of beg sc. Invisible fasten off.

MIDDLE BAND

With MC or CC and steel hook size 7 (1.50 mm), ch 20.

Row 1: Working in back ridge of each ch, sc in 2nd ch from hook and in each ch across, turn—19 sc.

Row 2: Ch 1, sc in blp of each st to end of row, turn.

Rows 3–9: Rep Row 2. Fasten off after last row.

CORDS (IF USING)

RIGHT SIDE

With MC or CC, ch 97, sl st in blp of each ch to end, ch 92, sl st in blp of each ch to end. Fasten off.

LEFT SIDE

With MC or CC, ch 97, sl st in blp of each ch to end, ch 8, then sl st in first ch to form the fastening loop, ch 92, sl st in blp of each ch to end. Fasten off.

CHAINS (IF USING)

Cut 2 lengths of chain 7³⁄4″ (19.5 cm) each, these will be the inner chains. Then, cut 2 lengths of chain 7¹⁄2″ (19 cm) each, these will be the outer chains. Link the top of sets of one inner and one outer chain together at the top with

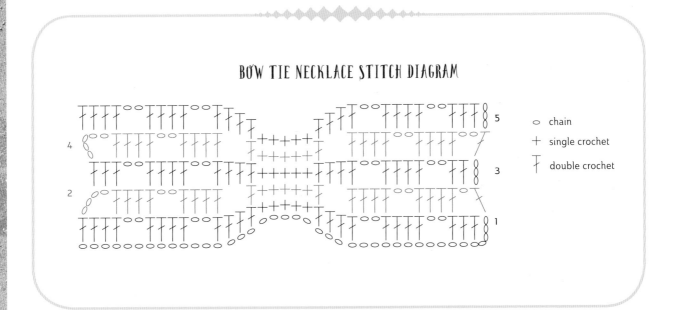

BOW TIE NECKLACE STITCH DIAGRAM

o chain
+ single crochet
† double crochet

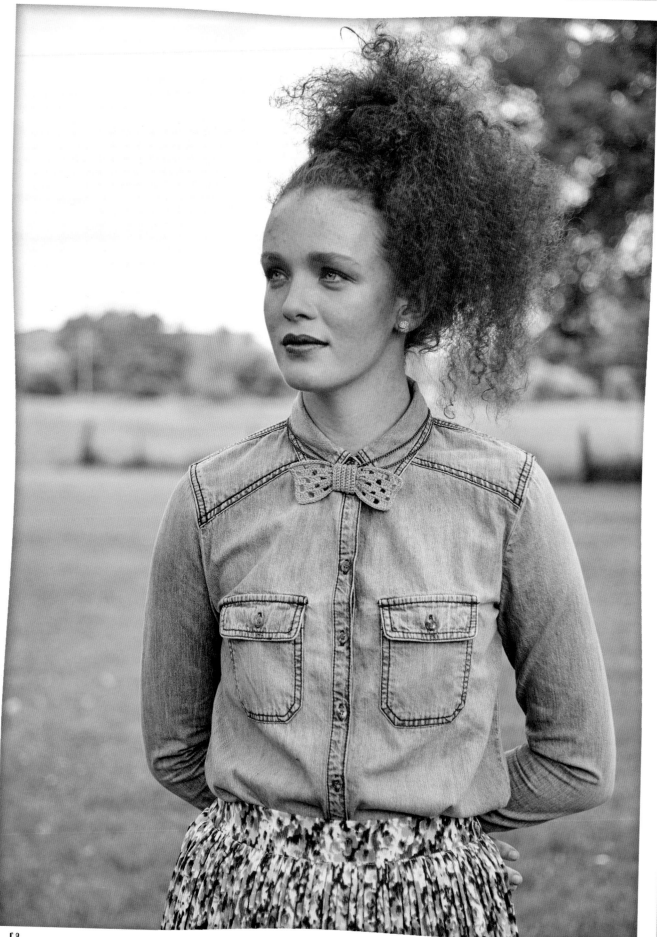

a jump ring. On the set that will be on the left side of the necklace, attach the necklace clasp to the jump ring. Put jump rings on the other end of each chain. Attach the outer chain jump rings to the Bow between the first 2 double crochet sts on either side of the middle 5 sc sts. Attach the inner chain jump rings, one on either side of the center ridge of the Middle Band, ⅛" (3 mm) down on the back side.

FASTENING DOME (FOR CROCHETED CORDS VERSION)

Rnd 1: With MC or CC, make adjustable ring; ch 3, work 12 dc into ring, sl st in first dc to close rnd.

Rnd 2: Sl st in every other st around to close up the dome. Fasten off.

ASSEMBLY

BLOCKING AND SEAMING

Wrap the Middle Band around the center of the Bow and stitch it together across the short end, securing it to the Bow as you do so, making sure the seam falls at the center back of the Bow.

CROCHET VERSION

Stitch the Fastening Dome to an end of the outer cord that has no fastening loop. Pin the Bow and Cords out into desired shape on a blocking board and wet-or steam-block. Stitch the two inner cords to the necklace behind the Middle Band, placing the ends of cords at the center seam of the Middle Band. Next, stitch the outer cords to the back of the necklace in the first blocks of dc on each side of the 5 single crochet stitches.

Neatly weave in all loose ends with a tapestry needle. Spray the Bow and Cords, if using, with water and pin out into shape on a blocking board. Allow to dry before removing pins.

Carefree pullover

Natasha Robarge

Enjoy traditional filet crochet at a modern speed! A "large print" stitch pattern and airy linen yarn create a bold statement fabric in this relaxed pullover.

FINISHED MEASUREMENTS
Bust measurement is 50 (64)" (127 [162.5] cm] blocked with an oversized fit. The pullover is sized for S/M (L/XL). Size shown is S/M.

YARN
Fingering weight (#2 Fine).

Shown here: Shibui, Linen (100% linen; 246 yd [225 m]/1. 76 oz [50 g]; #R 6913 caffeine (MC) 3 (5) skeins, #R 6902 ivory (CC) 1 (2) skeins.

HOOK
Size F-5 (3.75 mm). *Adjust hook size if necessary to obtain the correct gauge.*

NOTIONS
Locking stitch markers; tapestry needle for assembly and weaving in the ends.

GAUGE
15 sts × 11 rows = 3½ × 6" (9 × 15 cm) in stitch pattern.

STITCH GUIDE

Dc-picot, sc-picot: Complete indicated st, ch 3, sl st in side of st just made under both horizontal bars at the top of the post of the stitch.

Main body stitch patt (multiple of 30 sts + 22)
Note: Begining ch 3 counts as dc.

For swatch ch 52, turn.

Row 1: (RS) Dc in fifth ch from hook and each ch across—49 dc, turn.

Row 2: Ch 3, dc in next 3 dc, *ch 3, sk 2 dc, sc in next dc, ch 3, sk 2 dc, dc in next dc; rep from * across, dc in last 3 dc, turn.

Row 3: Ch 3, dc in next 3 dc, *ch 5, dc in next dc; rep from * across, dc in last 3 dc, turn.

Note: In next and subsequent rows, work in front loops of chains, unless otherwise indicated, and under both loops of dc/sc.

Row 4: Ch 3, dc in each st across, turn.

Row 5: Ch 3, dc in next 6 dc, ch 5, sk 5 dc, *dc in next 10 dc, ch 5, sk 5 dc; rep from * across, dc in last 7 dc, turn.

Row 6: Ch 3, dc in next 3 dc, *ch 5, sk 3 dc, sc in ch-5 sp, ch 5, sk 3 dc, dc in next 4 dc; rep from * across, turn.

Row 7: Ch 3, dc in next 3 dc, *dc in next 3 ch, ch 5, sk (2 ch, sc, 2 ch), dc in next 3 ch, dc in next 4 dc; rep from * across, turn.

Row 8: Ch 3, dc in each st across, turn.

Row 9: Ch 3, dc in next 3 dc, *ch 7, sk 5 dc, dc in next dc; rep from * across, dc in last 3 dc, turn.

Row 10: Ch 3, dc in next 3 dc, *ch 2, sc in ch-7 sp, ch 2, dc in next dc; rep from * across, dc in last 3 dc, turn.

Rows 11–12: Ch 3, dc in each st across, turn.

Repeat Rows 2–12 for patt.

NOTES

The front and back are worked separately in MC from the bottom up. Then the shoulders and sides are connected with filet mesh. CC stripes are worked from the bottom edge down ending with lace trim around the hem. The neck has a picot trim edge.

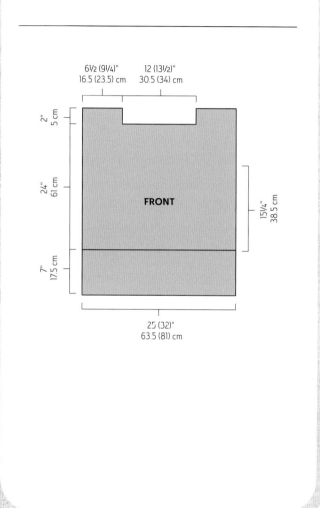

FRONT AND BACK

With MC, ch 112 (142) (multiple of 30 plus 22).

Row 1: (RS) Dc in fifth ch from hook and each ch across, turn—109 (139) dc.

For Back: Work Rows 2–12 of main pattern 3 times, then work Rows 2–4 once. Fasten off.

For Front: Work Rows 2–12 of main pattern 2 times, then work Rows 2–11.

FRONT RIGHT SHOULDER

Row 1: Ch 3, dc in next 27 (39) dc, turn, leaving rem sts unworked.

Row 2: Ch 6, sk 2 dc, sc in next dc, ch 3, sk 2 dc, dc in next dc, *ch 3, sk 2 dc, sc in next dc, ch 3, sk 2 dc, dc in next dc; rep from * across, dc in last 3 dc, turn.

Row 3: Ch 3, dc in next 3 dc, *ch 5, dc in next dc; rep from * across, working last dc in 3rd beg ch, turn.

Row 4: Ch 3, dc in each st across, ch 2. Continue with Shoulder Seam. (RS) Align Right Shoulder of Front with corresponding sts of (RS) Right Shoulder of Back edge to edge horizontally with Back closer to you, dc in first dc from right side of Back, *ch 2, sk 2 dc, dc2tog working first leg in next dc of Front and 2nd leg in next dc of Back; rep from * across Right Shoulder sts. Fasten off.

FRONT LEFT SHOULDER

Row 1: (WS) Attach yarn in 28th (40th dc from left side, ch 3, dc in next 27 (39) dc, turn.

Row 2: Ch 3, dc in next 3 dc, *ch 3, sk 2 dc, sc in next dc, ch 3, sk 2 dc, dc in next dc; rep from * across, turn.

Row 3: Ch 8, dc in next dc, *ch 5, dc in next dc; rep from * across, dc in last 3 dc, turn.

Row 4: Ch 3, dc in each st across, working last dc in 3rd beg ch, ch 2. Continue with Shoulder Seam. (RS) Align Left Shoulder of Front with (RS) Left Shoulder of Back edge to edge horizontally with Back closer to you, dc in 28th (52nd) dc from left side of Back, *ch 2, sk 2 dc, dc2tog working first

leg in next dc of Front and 2nd leg in next dc of Back; rep from * across. Fasten off.

Mark top of Row 22 for Front and Row 18 for Back from bottom on each side for armhole. Work side seams as follows:

Note: St between rows can be 3rd beg ch or top of first dc of row.

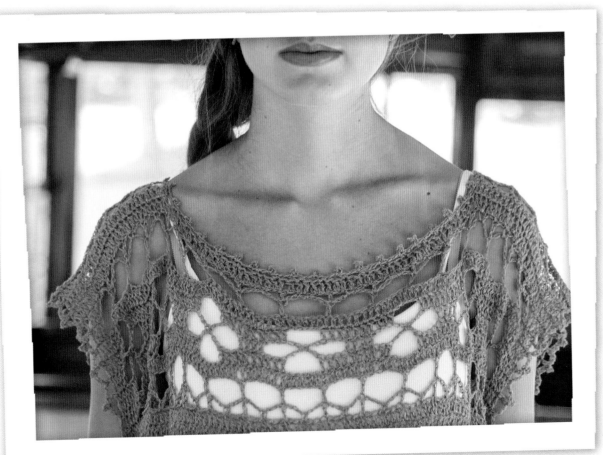

(RS) Align Front Side with (RS) Back Side edge to edge horizontally. Attach yarn to first ch of hem on the side closer to you, ch 2, dc in first ch of the opposite hem, *ch 2, sk the length of 1 dc, dc2tog with first leg in next st between rows of the side closer to you and 2nd leg in opposite st; rep from * to markers. Fasten off. Work the other side seam in the same manner.

Contrasting stripe: Work Back and Front separately.

Row 1: (WS) Join with dc in first ch (on unworked side of the chain) of bottom hem, dc in each st across, turn—109 (139) dc. Repeat Rows 2–12 of main pattern. Do not turn after Row 12.. Continue with trim around the hem.

HEM TRIM

Ch 1, [2 sc in corner st, ch 3, along the side sk the length of 1 dc, dc-picot in st between rows, *ch 3, sk the length of dc, sc in st between rows, ch 3, sk the length of 1 dc, dc-picot between rows, rep from * to end of stripe on the side, ch 3, sc in midseam, ch 3, dc-picot in st between next two rows of next stripe, *ch 3, sk the length of 1 dc, sc in st between rows, ch 3, skips the length of dc, dc-picot between rows, rep from * to last row of side, ch 3, 2 sc in corner st; continue along bottom hem: *ch 3, sk 2 dc, dc-picot in next dc, ch 3, sk 2 dc, sc in next dc; rep

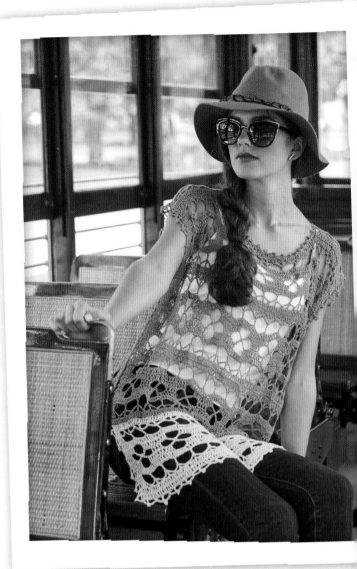

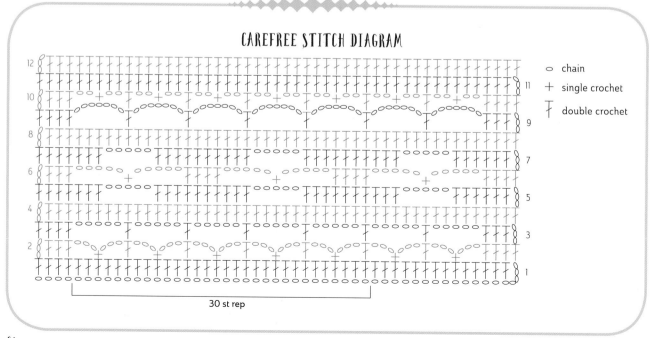

CAREFREE STITCH DIAGRAM

○ chain
+ single crochet
┬ double crochet

30 st rep

from * across hem omitting last sc in corner]. Rep bet [] once. Sl st in beg ch 1. Fasten off.

ARMHOLE TRIM

(RS) Attach yarn with sc in the center of seam at the bottom of armhole, ch 3, dc-picot in st between next 2 rows of armhole, *ch 3, sk the length of dc, sc in st between rows, ch 3, skip the length of dc, dc-picot between rows; rep from * to last row of armhole, ch 3, sl st in beg sc. Fasten off.

NECK TRIM

(RS) Attach yarn in the center of Right Shoulder seam along Neck, sc-picot in same st, ch 2, sc-picot in first open dc of Back neck, *ch 2, sk 2 dc, sc-picot in next dc; rep from * across open Back neck; dc, ch 2, sc-picot in center Shoulder Seam, [ch 2, sk the length of 1 dc, sc-picot in st between rows] 4 times, ch 2, sc-picot in first open dc of Front neck, *ch 2, sk 2 dc, sc-picot in next dc; rep from * across open Front neck dc, [ch 2, sk the length of 1 dc, sc-picot in st between rows] 4 times, ch 2, sl st in beg sc.

ASSEMBLY

Weave in the ends and iron the top on the cotton setting through wet cheesecloth.

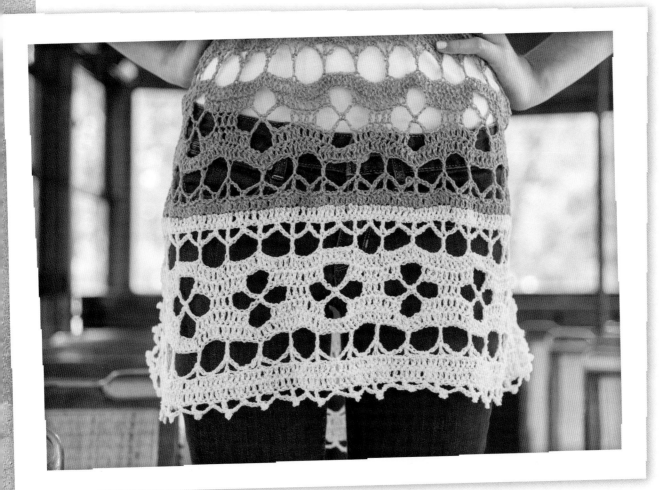

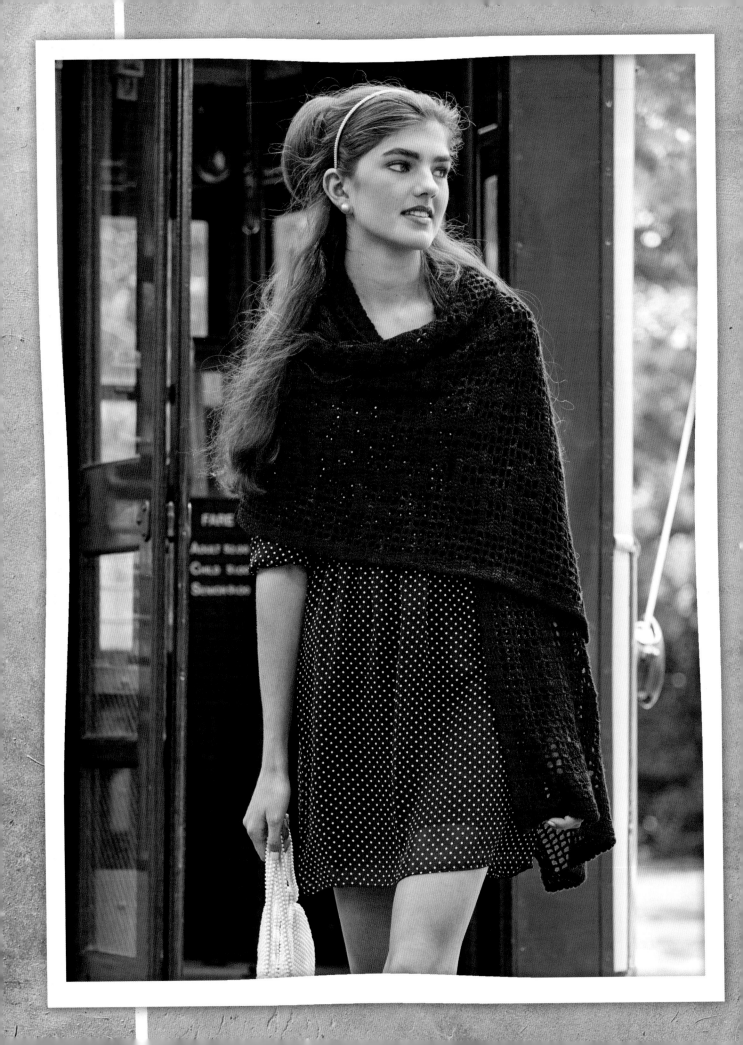

Celtic Cross wrap

LAURINDA REDDIG

Inspired by Celtic knotwork, this design of interconnected squares forms a pattern of crosses and blocks that make a gorgeous wrap.

FINISHED MEASUREMENTS

About 70" (1.8 m) wide and 24" (61 cm) long.

YARN

Fingering weight (#1 Super fine).

Shown here: Mrs. Crosby Loves to Play Satchel (100% superwash merino wool; 370 yd [338 m]/ 3.5 oz [100 g]): Hollywood Cerise, 4 hanks.

HOOK

Size F-5 (3.75 mm). *Adjust hook size if necessary to obtain the correct gauge.*

NOTIONS

Tapestry needle for weaving in the ends.

GAUGE

20 dc by 11 rows = 4" × 4" (10 × 10 cm) with size F-5 (3.75 mm) hook before blocking.

18 dc by 11 rows= 4" × 4" (10 × 10 cm) with size F-5 (3.75 mm) hook after blocking.

NOTES

Each square in the chart is formed with a ch-2 space for the open squares, represented by a white square, or 2 dc for the filled squares, represented by a gray square.

Read chart rows by beginning at the bottom right and following the chart from right to left for this row. For subsequent rows, read left to right and right to left in a zigzag manner.

Each block consists of 4 sts, but the edge stitches are shared with neighboring blocks.

WRAP

Ch 116, turn.

Row 1: Sc in 2nd ch from hook and next 114 chs, turn—115 sc.

Rows 2–3: Ch 3 (counts as first dc here and throughout), dc in each dc across and in top of turning ch, turn.

Rows 4–25: Work Rows 4–25 of Chart A.

Rows 26–121: [Work Rows 26–73 of Chart B] twice.

Rows 122–150: Work Rows 122–150 of Chart C.

Rows 151–152: Ch 3, dc in each dc across, turn.

Row 153: Ch 1, sc in each sc across. Do not finish off, turn.

EDGING

Working across top of Row 153, ch 1, dc in first st, *[sk next st, (sl st, ch 1, dc) in next st] across to end of row; turn to work down side, (sl st, ch 1, dc) in top of each st and turning ch, skipping over sides of sts; working in unused loops of beg ch; rep from *, join with sl st in corner. Fasten off and weave in all the loose ends.

TECHNIQUE TIDBIT

Filet crochet is an easy technique for creating images in yarn. By combining just double crochets and chain spaces to create a grid, you can fill in or leave open squares to create the design. Filet is often worked in thread to create lace silhouettes of simple shapes and even letters for monograms or phrases.

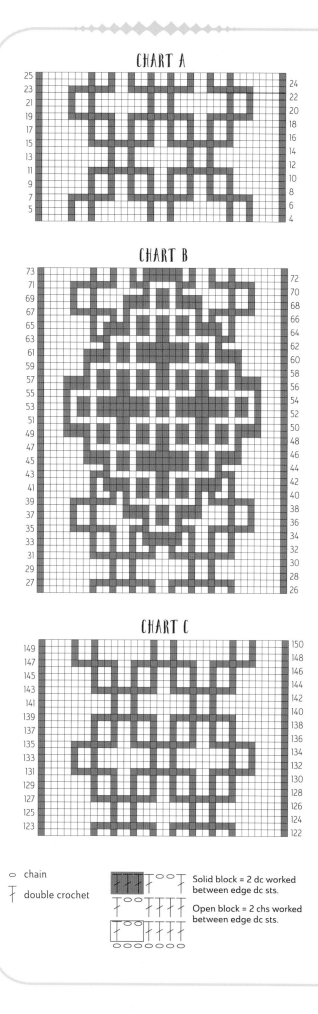

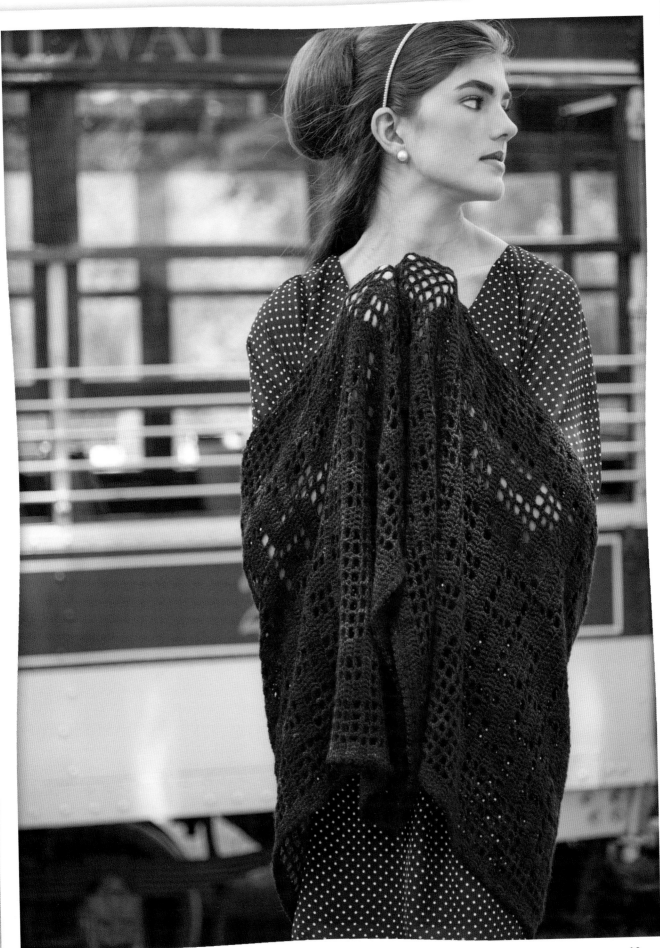

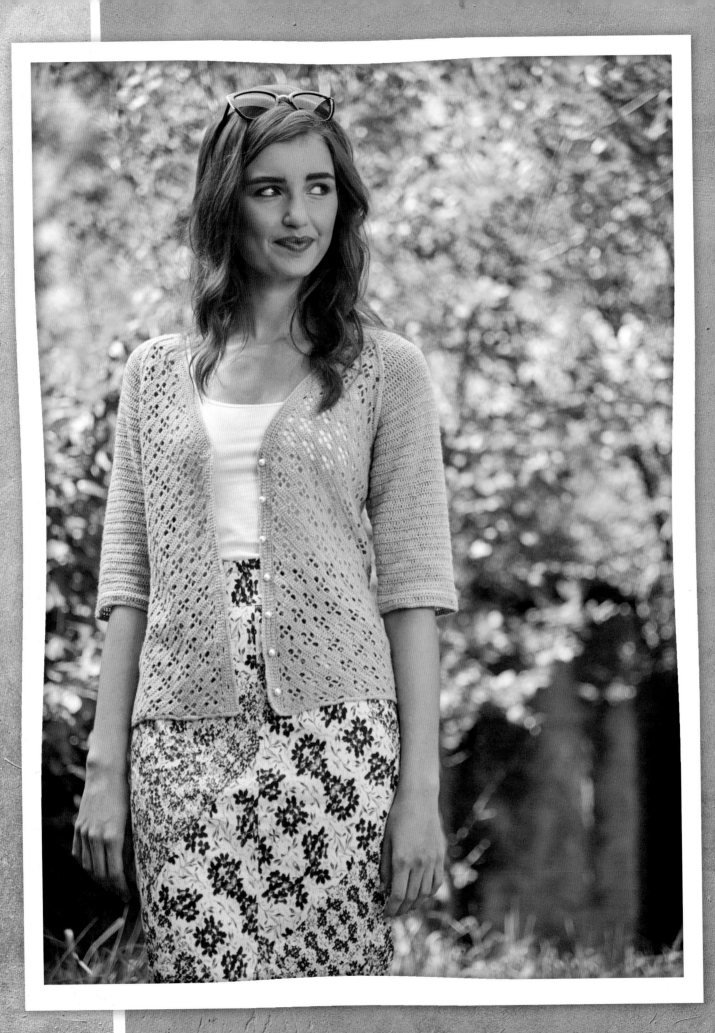

Field cardigan

ROBYN CHACHULA

This cardigan was born from one swatch many, many years ago. I was playing with filet stitch patterns and none ever seemed quite right, until I saw this abandoned swatch lying in my basket. Instead of the perfect boxes of crosses, the fabric looked like an abstract field of flowers. By just turning my swatch at a 45-degree angle, the voids created a whole new pattern. Working on the bias is worth the fun when you get to mix both a classic stitch pattern and a timeless silhouette with an interesting method.

FINISHED MEASUREMENTS

Bust measurement is 34½ (38, 41, 44)" (87.5 [96.5, 104, 112] cm) with a snug fit when buttoned. Sized for S (M, L, XL). Size shown is S.

YARN

Sock weight (#1 Super fine).

Shown here: Willow Yarns, Stream (70% wool, 30% silk; 437 yd [400 m]/ 1.75 oz [50 g]): #0006 Moors 4 (4, 5, 5) balls.

HOOK

Size D-3/3 mm. *Adjust hook size if necessary to obtain the correct gauge.*

NOTIONS

Locking stitch markers; tapestry needle for assembly and weaving in ends; 7 (7, 8, 8) ¼" (6 mm) pearl buttons.

GAUGE

28 dc by 14 rows= 4" × 4" (10 × 10 cm).

STITCH GUIDE

Beginning Decrease (beg dec): Ch 3, sk first st, *yo hook, insert hook into next st and pull up a loop, yo and draw through 2 loops on hook; rep from * once; yo and draw through 3 loops on hook.

End Decrease (end dec): *Yo hook, insert hook into next st and pull up a loop, yo and draw through 2 loops on hook; rep from * once, yo twice, insert hook into last st and pull up a loop, (yo and draw through 2 loops on hook) twice; yor and pull through remaining 4 loops on hook.

NOTES

Front and Back panels are crocheted on the bias, meaning they are crocheted from one corner to the opposite corner.

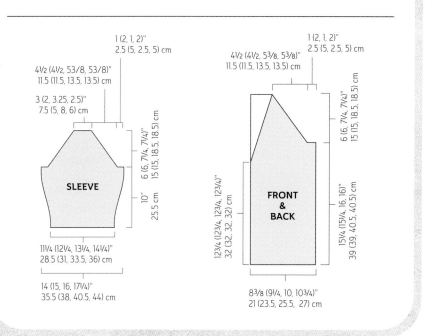

FRONT PANEL (Make 2)
BOTTOM EDGE

Ch 5.

Row 1: (3 dc, tr) in 5th ch from hook, turn—5 sts.

Row 2: Ch 4 (counts as tr throughout), 2 dc in first tr, dc in next 3 dc, (2 dc, tr) in top of tch, turn—9 sts.

Row 3: Ch 4, 2 dc in first tr, dc in next 2 dc, cont in filet chart to last 2 sts, dc in next dc, (2 dc, tr) in top of tch, turn—13 sts.

Row 4: Ch 4, 2 dc in first tr, cont in filet chart to last 2 sts, dc in next dc, (2 dc, tr) in top of tch, turn—17 sts.

Row 5: Ch 4, 2 dc in first tr, cont in filet chart to last 3 sts, dc in next 2 dc, (2 dc, tr) in top of tch, turn—21 sts.

Row 6: Ch 4, 2 dc in first tr, dc in next dc, cont in filet chart to last 3 sts, dc in next 2 dc, (2 dc, tr) in top of tch, turn—25 sts.

Row 7: Ch 4, 2 dc in first tr, dc in next dc, cont in filet chart to tch, (2 dc, tr) in top of tch, turn—29 sts.

Row 8: Ch 4, 2 dc in first tr, dc in next 2 dc, cont in filet chart to tch, (2 dc, tr) in top of tch, turn—33 sts.

Rep Rows 3–8 three (three, three, four) times.

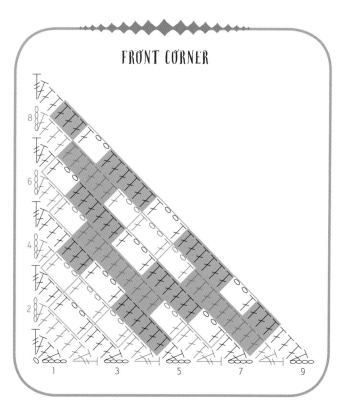

FRONT CORNER

Sizes S and XL: Rep Row 3 once—(109, 133 sts).
Size M: Rep Rows 3–5 once—(117 sts).
Size L: Rep Rows 3–7 once—(125 sts).

SIDE EDGE

Row 22 (24, 26, 28): Ch 4, 2 dc in first tr, dc in next 0 (1, 2, 0) dc, cont in filet chart to last 5 (3, 4, 5 sts), dc in next 2 (0, 1, 2) dc, end dec over last 3 sts, turn—109 (117, 125, 133 sts).

Row 23 (25, 27, 29): Ch 3, beg dec over next 2 sts, dc in next 0 (1, 2, 0) dc, cont in filet chart to last 3 (1, 2, 3) sts, dc in next 2 (0, 1, 2) sts, (2 dc, tr) in top of tch, turn.

Row 24 (26, 28, 30): Ch 4, 2 dc in first tr, dc in next 1(2, 0, 1) dc, cont in filet chart to last 4 (5, 3, 4 sts), dc in next 1 (2, 0, 1) dc, end dec over last 3 sts, turn.

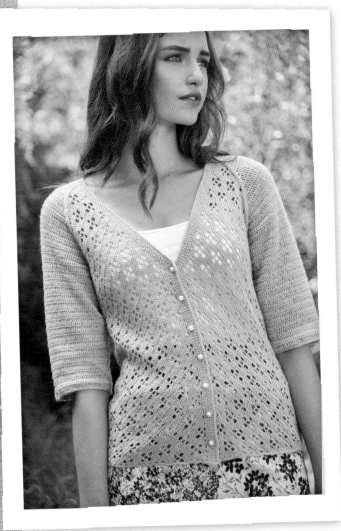

Row 25 (27, 29, 31): Ch 3, beg dec over next 2 sts, dc in next 2 (0, 1, 2) dc, cont in filet chart to last 1 (2, 3, 1) sts, dc in next 0 (1, 2, 0) sts, (2 dc, tr) in top of tch, turn.

Row 26 (28, 30, 32): Ch 4, 2 dc in first tr, dc in next 2 (0, 1, 2) dc, cont in filet chart to last 3 (4, 5, 3 sts), dc in next 0 (1, 2, 0) dc, end dec over last 3 sts, turn.
XL move to neck edge.

Row 27 (29, 31): Ch 3, beg dec over next 2 sts, dc in next 1 (2, 0) dc, cont in filet chart to last 2 (3, 1) sts, dc in next 1 (2, 0) sts, (2 dc, tr) in top of tch, turn.

Row 28 (30, 32): Ch 4, 2 dc in first tr, dc in next 0 (1, 2) dc, cont in filet chart to last 5 (3, 4 sts), dc in next 2 (0, 1) dc, end dec over last 3 sts, turn. L move to neck edge.

Row 29 (31): Ch 3, beg dec over next 2 sts, dc in next 0 (1) dc, cont in filet chart to last 3 (1) sts, dc in next 2 (0) sts, (2 dc, tr) in top of tch, turn.

Row 30 (32): Ch 4, 2 dc in first tr, dc in next 1 (2) dc, cont in filet chart to last 4 (5 sts), dc in next 1 (2) dc, end dec over last 3 sts, turn. M move to neck edge.

Row 31: Ch 3, beg dec over next 2 sts, dc in next 2 dc, cont in filet chart to last st, (2 dc, tr) in top of tch, turn.

Row 32: Ch 4, 2 dc in first tr, dc in next 2 dc, cont in filet chart to last 3 sts, end dec over last 3 sts, turn.

S/M BACK PANEL (UPPER HALF) FILET CHART

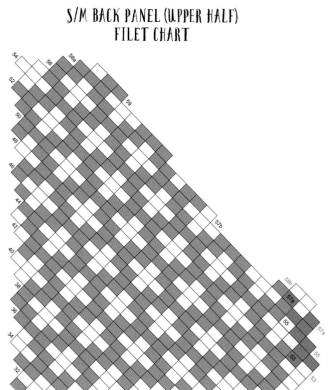

S/M FRONT PANEL FILET CHART

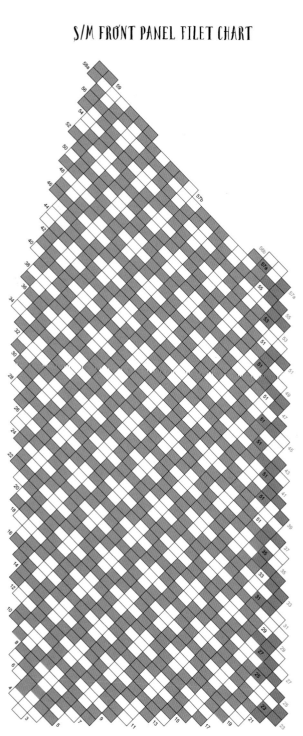

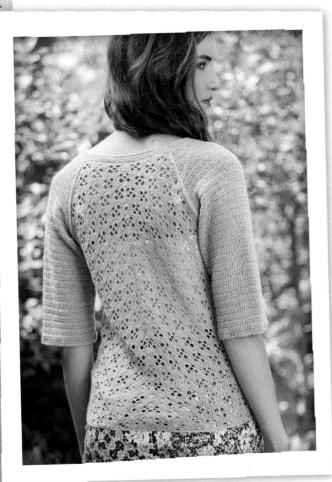

st in next 4 sts, ch 1, sk 1 st, sc in next 4 sts, hdc in next 4 st, dc in next 2 (2, 0, 0) dc, cont in filet chart across to last 2 sts, dc in next dc, 2 dc in top of tch, turn.

Row 58 (58, 64, 64)a: Ch 3, cont in filet chart for 7 (7, 12, 12) blocks, ch 2, hdc in next 4 sts, sc in next 4 sts, ch 1, sk 1 st, sl st in next 3 sts, fasten off.

Row 58 (58, 64, 64) b: Join yarn to top of ch 4 on prev row with sl st, ch 3, beg dec over next 2 sts, dc in next 1 (1, 1, 0) dc, (M/XL) cont in filet across to last (4, 5) sts, dc in next (1, 2) dc, (all) end dec over last 3 sts, turn.

Sizes S and XL, Row 59a (65a): Ch 1, sc3tog over 3 sts, fasten off.

Sizes M and XL, Row 59a (65a): Ch 3, beg dec over next 2 sts, dc in next 5 dc, end dec over last 3 sts, turn.

Sizes M and XL, Row 60a (66a): Ch 3, beg dec over next 2 sts, dc in next dc, end dec over last 3 sts, turn.

Sizes M and XL, Row 61a (67a): Ch 1, sc3tog over 3 sts, fasten off.

Sizes S and M, Row 59b: Join yarn with sl st 20 sts from end of Row 58, ch 1, sk 1 st, sc in next 4 sts, hdc in next 4 st, ch 2, sk 2 sts, dc in next 7 sts, 2 dc in top of tch, turn.

Sizes S and M, Row 60b: Ch 3, hdc in first dc, hdc in next dc, sc in next 3 sts, ch 1, sk 1 st, sl st in next st, fasten off.

Sizes L and XL, Row 65b: Join yarn with sl st 35 sts from end of Row 64 b ch 1, sk 1 st, sc in next 4 sts, hdc in next 4 sts, ch 2, cont in filet chart to last st, 2 dc in top of tch, turn.

Sizes M and XL, Row 66b: Ch 3, dc in first dc, dc in next 9 sts, hdc in next 4 sts, sc in next 4 sts, ch 1, sk 1 st, sl st in next st, fasten off.

Sizes M and XL, Row 67b: Join yarn with sl st 5 sts from end of Row 66 b ch 1, sk 1 st, sc in next 2 sts, hdc in top of tch, fasten off.

BACK PANEL (Make 2)

Rep directions for Front Panel through Row 26 (28, 30, 32) on Side Edge.

SIDE EDGE

Row 27 (29, 31, 33): Ch 3, beg dec over next 2 sts, dc in next 1 (2, 0, 1) dc, cont in filet chart to last 2 (3, 1, 2) sts, dc in next 1 (2, 0, 1) sts, (2 dc, tr) in top of tch, turn.

Rep prev 6 rows of side edge til 53 (53, 58, 58) rows.

NECK EDGE

Row 33: Ch 3, beg dec over next 2 sts, dc in next 1 (0, 2, 1), sts, cont in filet chart to last 2 sts, dc in next dc, 2 dc in top of tch, turn.

Row 34: Ch 3, cont in filet chart to last 5 (4, 3, 5) sts, dc in next 2 (1, 0, 2) sts, end dec over last 3 sts, turn.

Row 35: Ch 3, beg dec over next 2 sts, dc in next 0 (2, 1, 0), cont in filet chart to last st, 2 dc in top of tch, turn.

Row 36: Ch 3, dc in first dc, dc in next dc, cont in filet chart to last 4 (3, 5, 4) sts, dc in next 1 (0, 2, 1) sts, end dec over last 3 sts, turn.

Row 37: Ch 3, beg dec over next 2 sts, dc in next 2 (1, 0, 2), cont in filet chart across, 2 dc in top of tch, turn.

Row 38: Ch 3, dc in first dc, cont in filet chart to last 3 (5, 4, 3) sts, dc in next 0 (2, 1, 0) sts, end dec over last 3 sts, turn.

Rep Rows 33–38 three (three, four, four) times.

RAGLAN EDGE

Row 57 (57, 63, 63): Ch 3, beg dec over next 2 sts, dc in next 1 (0, 2, 1) dc, cont in filet chart for 1 (4, 1, 4) blocks, ch 4, sk 2 sts, sl

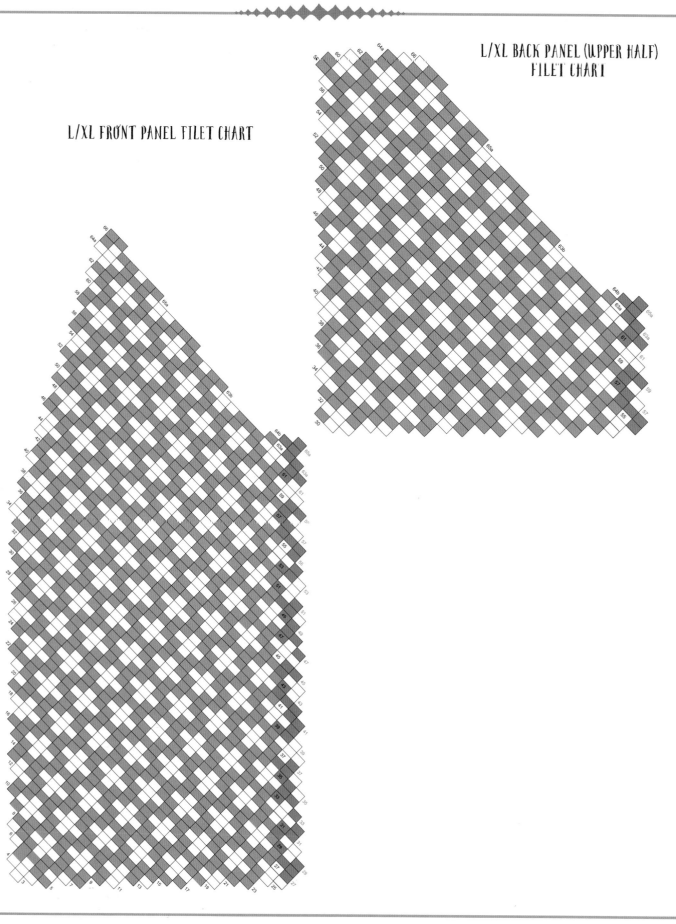

L/XL FRONT PANEL FILET CHART

L/XL BACK PANEL (UPPER HALF)
FILET CHART

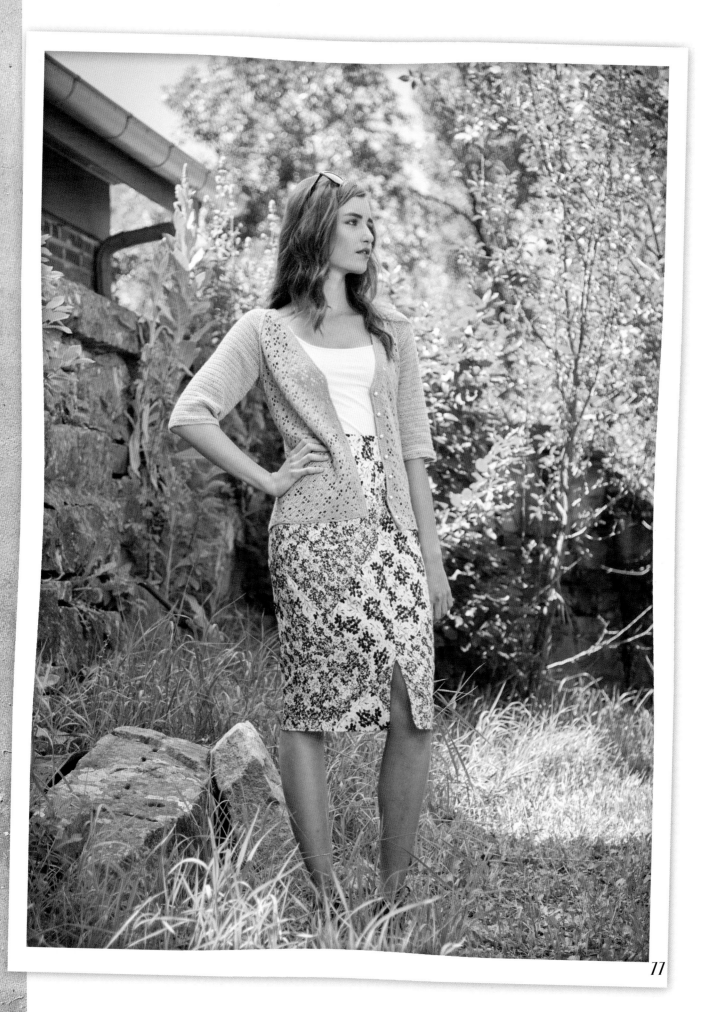

NECK EDGE

Sizes S and M:

Row 54: Ch 3, beg dec over next 2 sts, dc in next 2 dc, cont in filet chart to last (4, 3) sts, dc in next dc, end dec over last 3 sts—(105, 113 sts).

Row 55: Ch 3, beg dec over next 2 sts, dc in next 2 (1, 1, 0) dc, cont in filet chart to last 3 sts, end dec over last 3 sts—(101, 109 sts).

Row 56: Ch 3, beg dec over next 2 sts, dc in next dc, cont in filet chart to last 3 (5, 5, 4) sts, dc in next 0 (2, 2, 1) dc, end dec over last 3 sts—(97, 105 sts).

Row 57: Ch 3, beg dec over next 2 sts, dc in next (1, 0) dc, cont in filet chart for 1 (4) blocks, ch 4, sk 2 sts, sl st in next 4 sts, ch 1, sk 1 st, sc in next 4 sts, hdc in next 4 st, dc in next 2 dc, cont in filet chart across to last 3 sts, end dec over last 3 sts, turn.

Row 58a: Ch 3, beg dec over next 2 sts, cont in filet chart for 9 blocks, ch 2, sk 2 sts, hdc in next 4 sts, sc in next 4 sts, ch 1, sk 1 st, sl st in next 3 sts, fasten off.

Row 58b: Join yarn to top of ch 4 on prev row with sl st, ch 3, beg dec over next 2 sts, dc in next 1 dc, (m) cont in filet across to last (4) sts, dc in next dc, (all) end dec over last 3 sts, turn.

Size S, Row 59a: Ch 1, sc3tog over 3 sts, fasten off.

Size M, Row 59a: Ch 3, beg dec over next 2 sts, dc in next 5 dc, end dec over last 3 sts, turn.

Size M, Row 60a: Ch 3, beg dec over next 2 sts, dc in next dc, end dec over last 3 sts, turn.

Size M, Row 61a: Ch 1, sc3tog over 3 sts, fasten off.

Row 59b: Join yarn with sl st 26 sts from end of Row 58 b ch 1, sk 1 st, sc in next 4 sts, hdc in next 4 st, ch 2, sk 2 sts, cont in filet chart, dc in next dc, end dec over last 3 sts, turn.

Row 60b: Ch 3, sk next st, hdc in next 3 sts, sc in next 3 sts, ch 1, sk 1 st, sl st in next st, fasten off.

Sizes L and XL:

Row 59: Ch 3, beg dec over next 2 sts, dc in next (1, 0) dc, cont in filet chart to last 3 sts, end dec over last 3 sts—(121, 129 sts).

Row 60: Ch 3, beg dec over next 2 sts, dc in next dc, cont in filet chart to last (5, 4) sts, dc in next (2, 1) dc, end dec over last 3 sts—(117, 125 sts).

Row 61: Ch 3, beg dec over next 2 sts, dc in next (0, 2) dc, cont in filet chart to last 3 sts, end dec over last 3 sts—(113, 121 sts).

Row 62: Ch 3, beg dec over next 2 sts, cont in filet chart to last (4, 3) sts, dc in next (1, 0) dc, end dec over last 3 sts—(109, 117 sts).

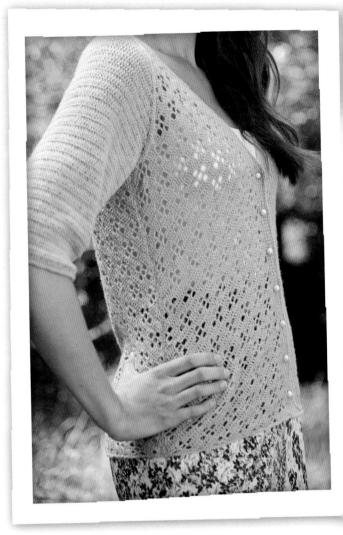

Row 63: Ch 3, beg dec over next 2 sts, dc in next (2, 1) dc, (XL) cont in filet chart for 3 blocks, (all) dc in next 2 dc, ch 4, sk 2 sts, sl st in next 4 sts, ch 1, sk 1 st, sc in next 4 sts, hdc in next 4 sts, cont in filet chart across to last 4 sts, dc in next dc, end dec over last 3 sts, turn.

Row 64a: Ch 3, beg dec over next 2 sts, cont in filet chart, ch 2, hdc in next 4 sts, sc in next 4 sts, ch 1, sk 1 st, sl st in next 3 sts, fasten off.

Row 64b: Join yarn to top of ch 4 on prev row with sl st, ch 3, beg dec over next 2 sts, dc in next (1, 0) dc, (XL) cont in filet across to last 5 sts, dc in next 2 dc, (all) end dec over last 3 sts, turn.

Size L, Row 65a: Ch 1, sc3tog over 3 sts, fasten off.

Size XL, Row 65a: Ch 3, beg dec over next 2 sts, dc in next 5 dc, end dec over last 3 sts, turn.

Size XL, Row 66a: Ch 3, beg dec over next 2 sts, dc in next dc, end dec over last 3 sts, turn.

Size XL, Row 67a: Ch 1, sc3tog over 3 sts, fasten off.

Sizes L and XL, Row 65b: Join yarn with sl st 43 sts from end of Row 64b ch 1, sk 1 st, sc in next 4 sts, hdc in next 4 sts, ch 2, cont in filet chart to last 3 sts, end dec over last 3 sts, turn.

Sizes L and XL, Row 66b: Ch 3, beg dec over next 2 sts, dc in next st, cont in filet chart, dc in next st, hdc in next 4 sts, sc in next 4 sts, ch 1, sk 1 st, sl st in next st, fasten off.

Sizes L and XL, Row 67b: Join yarn with sl st 7 sts from end of Row 66 b ch 1, sk 1 st, sc in next 2 sts, hdc in next st, dc in last st, fasten off.

SLEEVES (Make 2)

Ch 80 (88, 94, 102).

Row 1: Dc in 3rd ch from hook and each ch across, turn—(78, 86, 92, 100 dc).

Rows 2–3: Ch 3 (counts as dc throughout), dc in each dc across, dc in top of tch, turn.

Row 4: Ch 3, dc in first dc, dc in each dc across, 2 dc in top of tch, turn—(80, 88, 94, 102 dc).

Rep Rows 2–4 nine times, Rep Row 2 four times—(98, 106, 112, 120 dc).

CAP SHAPING

Row 1: Sl st in next 7 (14, 7, 14) sts, ch 2, sk next dc, dc in each dc across to last 9 (16, 9, 16) dc, dc2tog over next 2 dc, leave remaining sts unworked—(82, 76, 96, 90 sts).

Row 2: Ch 3, beg dec over next 2 dc, dc in ea dc across to last 3 sts, end dec over last 3 sts, turn—(78, 72, 92, 86 dc).

Row 3: Ch 2, dc in ea dc across to last 2 sts, dc2tog over last 2 sts, turn—(76, 70, 90, 84 sts).

Rep Rows 2–3 (nine, nine, eleven, eleven) times, fasten off—(22, 16, 24, 18 sts).

BLOCKING AND SEAMING

Pin panels to schematic size and spray with water and allow to dry. Pin back panels together with RS facing, whipstitch center seam. Pin back and front panels together with RS facing, whipstitch side seam. Join yarn to RS of Front Panel at Raglan Edge, sc across Raglan Edge of Front Panel, sc across underarm, sc across Raglan Edge of back, sc across back neck, sc across Raglan Edge, sc across underarm, sc across Raglan Edge of front, fasten off. Join yarn to RS of indent of cap shaping on the sleeve, sc evenly around cap shaping. Pin WS of Front Panel and sleeve together. Join yarn to Raglan Edge, sl st through both Front Panel and sleeve panel sts at the same time down Raglan Edge. Rep on all raglans. Whipstitch underarm seam of sleeves together.

CUFF EDGING

Rnd 1: Join yarn to edge, ch 1, sc around edge, sl st to first sc, do not turn.

Rnd 2: Ch 1, sc in each sc around, sl st to first sc, do not turn.

Rnd 3: Sl st in each sc around, fasten off.

BOTTOM EDGING

Row 1: Join yarn to edge, ch 1, sc across edge, fasten off.

COLLAR EDGING

Evenly space 7 (7, 8, 8) stitch markers up the Front Panel edge for buttonholes.

Row 1: Join yarn to bottom edge of Front Panel, ch 1, *sc across edge to outside corner, 2 sc in corner; rep from * around, sc evenly across edge to opposite bottom edge, turn.

Row 2: Ch 1, *sc in each sc across to outside corner, 2 sc in outside corner; rep from * around, sc in each sc to end, turn.

Row 3: Ch 1, *sc in each sc to 1 st before marker, ch 2, sk 2 sc; rep from * across Front Panel; sc in each sc across to end, turn.

Row 4: Ch 1, *sc in each sc to outside corner, 2 sc in outside corner; rep from * around, sc in each sc to ch-2 sp, 2 sc in each ch-sp, sc to end, turn.

Row 5: Ch 1, sc in each sc to end.

Row 6: Rep Row 2.

Row 7: Sl st in each sc around, fasten off.

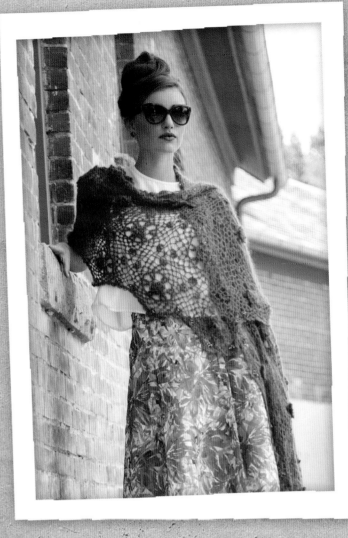

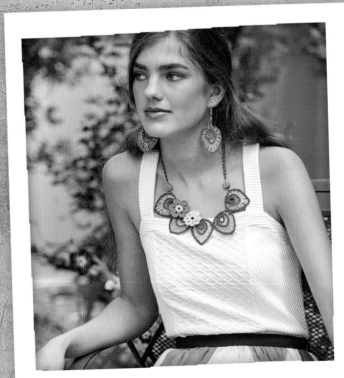

IRISH LACE

Irish crochet has been around for a long time, but it wasn't until the 1840s when it really gained traction. If you think of the time, it was the same era William Henry Harrison was president, the first telegraph from Washington, D.C., to Baltimore was sent, Elias Howe patented the sewing machine, and Elizabeth Blackwell was the first woman to receive her medical degree. To say the least, it was a different era. In Ireland, there was the terrible potato famine that killed nearly half the population since food was in such sort supply. The United States saw a huge influx of Irish immigrants trying to escape the harsh environment. Those who had to stay needed to find a new way to support their families. This is where crochet stepped in. Lace at the time was only affordable by the very wealthy. Therefore, when women learned how to master the stitches involved, they could support their families entirely with just their craft. They needed very little to start, just a bit of thread and a hook; it was very easy to enter the field.

The basics of Irish crochet are made up of floral motifs and lace netting. The motifs were crocheted first and then pinned to a muslin fabric to be held in place. Netting was freeform-crocheted to join the motifs together. Once all joined, the muslin fabric was removed and the amazing lace remained. Motifs highlighted nature that is seen readily in Ireland—roses, leaves, and shamrocks. Each village, town, or family mastered a certain set of motifs, and it was highly valued to be able to design and create new motifs. Even the netting would speak of where a lace was constructed. There was the standard netting with chain spaces, ones with picots, some with clusters or popcorn stitches, or a combination. Each was so individual that women would pride themselves on the exclusive lace designs that they wore.

Besides the nature themes of Irish motifs, they're renowned for the strong textured lines that make them stand out. The lines are made from crocheting over a padded cord or group of threads held over the stitches of the previous round. This gives weight and definition to each round and makes it all the more dramatic paired with the lace jewelry break down this process and honor each step along the way. The **Temperance Necklace and Earrings,** as well as the **Aine Fascinator and Headband,** takes the classic motifs, blasts them with color and separates them from their netting to highlight their own beauty. The **Fidelma Motif Shawl** uses only one motif, the rose, and makes Irish lace modular with rounds of chain netting that are easily joined together. Lastly, the **Guipure Top** takes what is usually in the background, the netting, to the forefront in a gorgeous lace top. Whichever one you chose to crochet first, you can feel that thrill of connection to an amazing group of female crocheters before you who came up with this incredible lace.

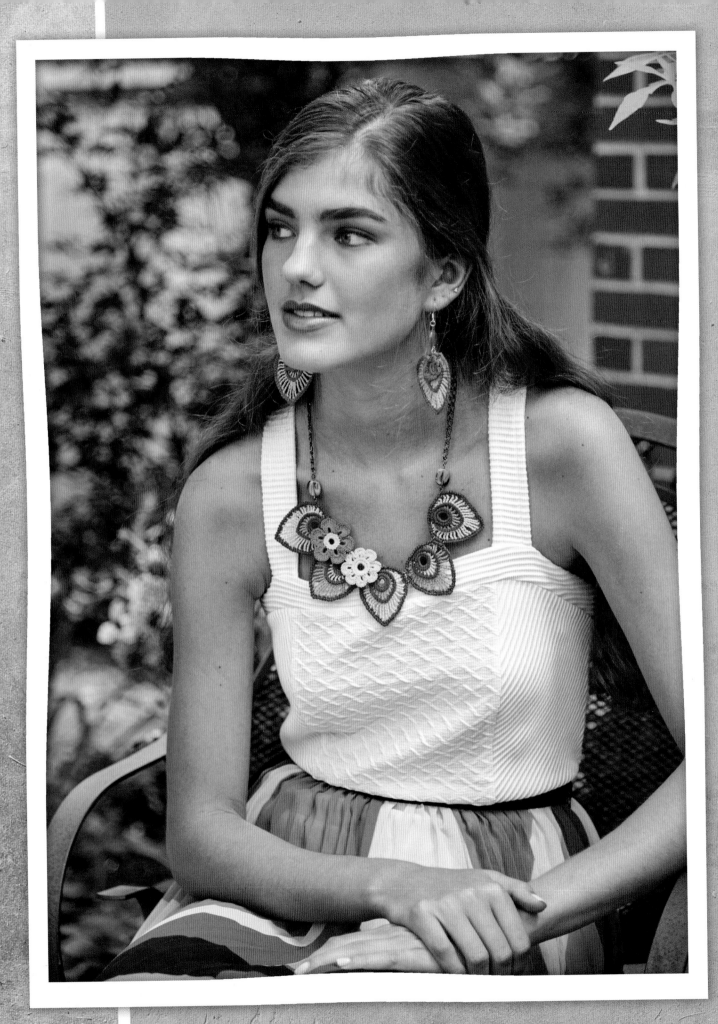

Temperance jewelry

Robyn Chachula

Often Irish crochet lace can look antique, but by using modern color combinations with contemporary materials, your projects will look anything but old. Try playing with color combinations for your perfect jewelry. Monochromatic motifs can bring out the texture and stitch definition of each stitch, and bold colors on the single crochet rounds can bring out the geometric shapes hidden in the motifs.

FINISHED MEASUREMENTS

Necklace: about 18" (45.5 cm) in circumference.

Earrings: about 3" (7.5 cm) in length.

YARN

Thread size 20.

Shown here: Lizbeth Size 20 Crochet Thread (100% Egyptian cotton; 210 yd [192 m]/ 0.88 oz [25 g]): #702 Coral Orange Med (A), #693 Linen Med (B), #630 Peach Lt (C), #686 Seagreen Lt (D), #688 Seagreen Dk, 1 ball ea.

HOOK

Size No. 6 (1 mm) steel hook. *Adjust hook size if necessary to obtain the correct gauge.*

NOTIONS

Sewing needle for weaving in ends; fabric stiffener; rust-proof pins; paper towels; aluminum foil or parchment paper; 4 mm black jump rings; needle-nose pliers; wire cutters; two ½" (12 mm) aqua beads; two 2" (5 cm) black open eye pins; two 12" (30.5 cm) lengths of black chain; 1 lobster clasp; 2 orange ½" (12 mm) beads; 2 gold open eye pins; four 0.16" (4 mm) gold jump rings; 2 earring hooks.

GAUGE

Leaf Motif = 1¾" (4.5 cm) wide × 2¼" (5.5 cm) long.

STITCH GUIDE

Beginning Ring: All the motifs begin with a traditional Irish crochet ring. Form this ring by wrapping yarn around a pencil or hook handle 10 times. Carefully slip the ring off the pencil and slip-stitch around all the threads to lock the ring in place.

Flp: Through the front loop.

Blp: Through the back loop.

Triple Treble (trtr): Yo hook 4 times, insert into st indicated and pull up a lp, [yo, and draw through 2 lps on hook] 5 times.

LEAF

Make 3 leaf motifs with B on Rnd 3 and C on Rnd 6, Make 2 with C on Rnd 3 and B on Rnd 6.

With A, form a beginning ring sl st to secure strands and ch 1.

Rnd 1: Twenty-four sc in ring, sl st flp in first sc, do not turn.

Rnd 2: (Ch 1, sl st flp) in ea sc around, do not turn.

Rnd 3: Join new color. Working in free back loop of ea sc on Rnd 1, ch 1, sc blp in next 3 sc, [ch 1, hdc blp in next sc] twice, [ch 1, dc blp in next sc] twice, [ch 1, tr blp in next sc] 4 times, [ch 1, dc blp in next sc] twice, [ch 1, hdc blp in next sc] twice, ch 1, sc blp in next 3 sc, sl st blp in last 6 sc, sl st to first sc, fasten off, do not turn.

Rnd 4: Join A, ch 1, sc in next 2 sc, sc in next ch-1 sp, 2 sc in next 11 ch-1 sps, sc in next ch-1 sp, sk next sc, sc in next 2 sc, sc in last 6 sl sts, sl st flp in first sc, do not turn—34 sc.

Rnd 5: (Ch 1, sl st flp) in ea sc around, ch 1, sl st to first sl st, do not turn.

Rnd 6: Join new color. Work in free back loop of ea sc on Rnd 4, ch 1, (sc blp, hdc blp) in first sc, ch 1, hdc blp in next sc, dc blp in next sc, [ch 1, tr blp in next 2 sc] twice, [ch 1, dtr blp in next 2 sc] twice, ch 1, trtr blp in next 2 sc, [ch 1, 2 trtr blp in next 2 sc] twice, ch 1, trtr blp in next 2 sc, [ch 1, dtr blp in next 2 sc] twice, [ch 1, tr blp in next 2 sc] twice, ch 1, dc blp in next sc, hdc blp in next sc, ch 1, (hdc blp, sc blp) in next sc, sl st blp in last 6 sc, sl st to first sc, fasten off, do not turn.

Rnd 7: Join A, ch 1, sc in sc, sc in hdc, 2 sc in next ch-1 sp, 3 sc in next 2 ch-1 sps, 2 sc in next 3 ch-1 sps, 3 sc in next ch-1 sp, 4 sc in next ch-1 sp, 3 sc in next ch-1 sp, 2 sc in next 3 ch-1 sps, 3 sc in next 2 ch-1 sps, 2 sc in next 2 ch-1 sps, sc in next hdc, sc in next sc, sc in last 6 sl st, do not turn—48 sc.

Rnd 8: (Ch 1, sl st) in ea sc around, fasten off, weave in the ends.

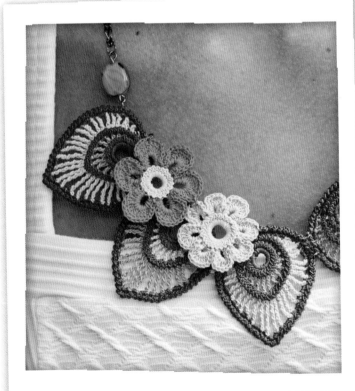

TECHNIQUE TIDBIT

Irish crochet lace is all about using texture and weight to add drama to your fabric. This is traditionally achieved by padding out rounds by crocheting over cords or several strands of thread held together. In our simplified motifs, only the beginning ring uses this technique, but I challenge you to try it on others. To do so, you only need to add in a thicker weight cotton thread or cord and place it on top of the stitches you will be crocheting around. For our motifs, add a cord around Rnd 3 or 6 before doing the single crochet on the next rounds. You will be amazed at the neat results.

LEAF

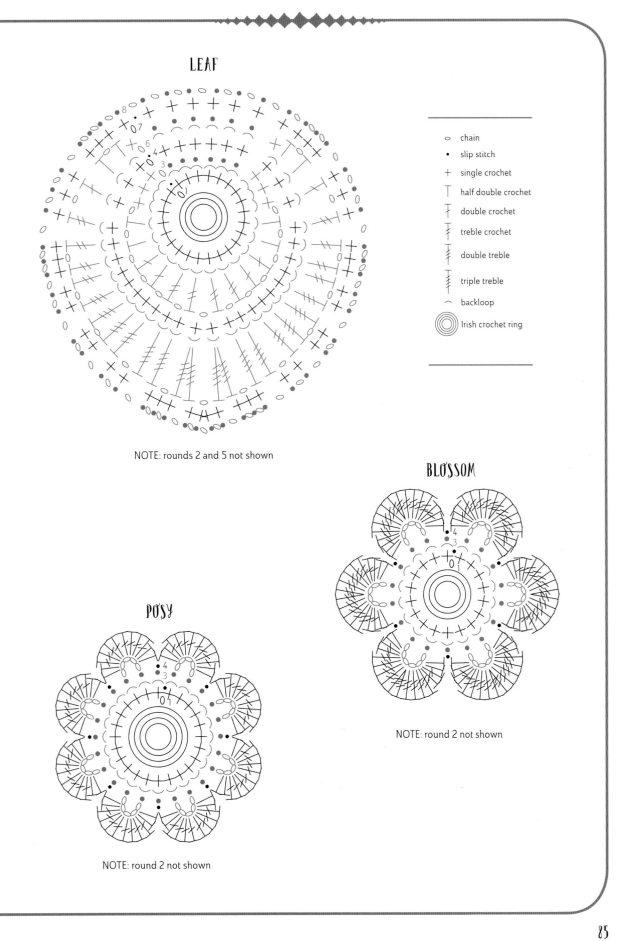

LEGEND

- ○ chain
- • slip stitch
- + single crochet
- T half double crochet
- ⊤ double crochet
- ⊤ treble crochet
- ⊤ double treble
- ⊤ triple treble
- ⌒ backloop
- ◎ Irish crochet ring

NOTE: rounds 2 and 5 not shown

BLOSSOM

NOTE: round 2 not shown

POSY

NOTE: round 2 not shown

POSY (Make 1)

With D, form a beginning ring, sl st to secure strands and ch 1.

Rnd 1: Twenty-four sc in ring, sl st flp in first sc, do not turn.

Rnd 2: (Ch 1, sl st flp) in ea sc around, do not turn.

Rnd 3: Work in free back lp of ea sc on Rnd 1, [sl st blp in next 2 sc, ch 5, sl st blp in next sc] 8 times, do not turn.

Rnd 4: *Sl st in next sl st, (2 hdc, 8 dc, 2 hdc) in ch-5 sp, sk next sl st; rep from * around, sl st to first sl st, fasten off and weave in the ends.

BLOSSOM (Make 1)

With D, form a beginning ring, sl st to secure strands and ch 1.

Rnd 1: Eighteen sc in ring, sl st flp in first sc, do not turn.

Rnd 2: (Ch 1, sl st flp) in ea sc around, fasten off, do not turn.

Rnd 3: Join E, work in free back lp of ea sc on Rnd 1, [sl st blp in next 2 sc, ch 6, sl st blp in next sc] 6 times, do not turn.

Rnd 4: *Sl st in next sl st, (2 hdc, 2 dc, 10 tr, 2 dc, 2 hdc) in ch-6 sp, sk next sl st; rep from * around, sl st to first sl st, fasten off and weave in the ends.

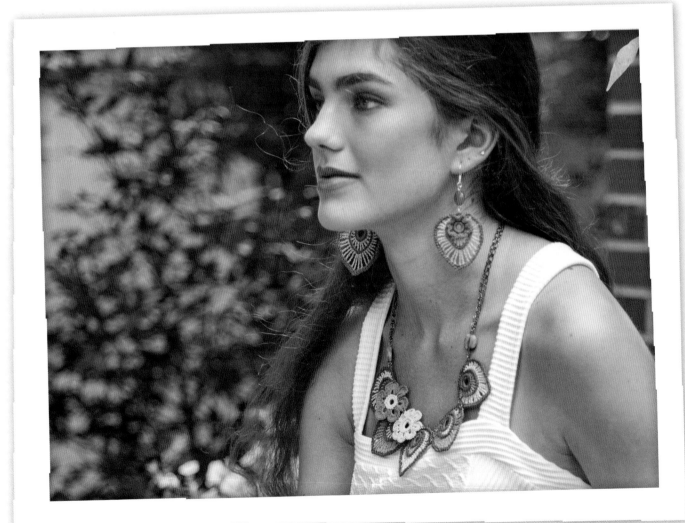

EARRINGS

(Make 2 with D on Rnd 3 and C on Rnd 6)

With E, form a beginning ring, sl st to secure strands and ch 1.

Rnd 1: Twenty-four sc in ring, sl st flp in first sc, do not turn.

Rnd 2a: Ch 3, sl st flp in next 3 sc; rep from * around, do not turn.

Rnd 2b: Sl st in next sl st, 7 hdc in ch-3 sp, sk 1 sl st; rep from * around, do not turn.

Rep directions for leaf to the end, fasten off.

BLOCKING

Immerse all motifs in fabric stiffener. Gently pat off excess with paper towels. Place blossom and posy to dry on aluminum foil or parchment paper. Pin leaf and earring motifs to shape and allow to dry.

JEWELRY

Make bead pendants by stringing 1 bead onto open eye pin. Snip off end to ½" (1.3 cm) left, bend wire to 90 degrees. Curl the end into a loop. Using needle-nose pliers, open the jump ring and thread it on 1 earring motif and bead; close the jump ring. Connect the bead to the earring hook with a jump ring. Cut the metal necklace chain in half with wire cutters. Connect the lobster clasp and bead metal necklace chain with the jump rings. Using the picture as a guide, connect the leaf motifs, blossom, and posy with the jump rings. Connect the motifs to the necklace with jump rings.

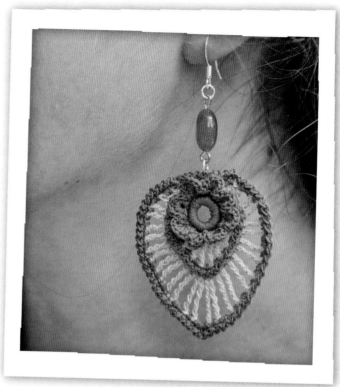

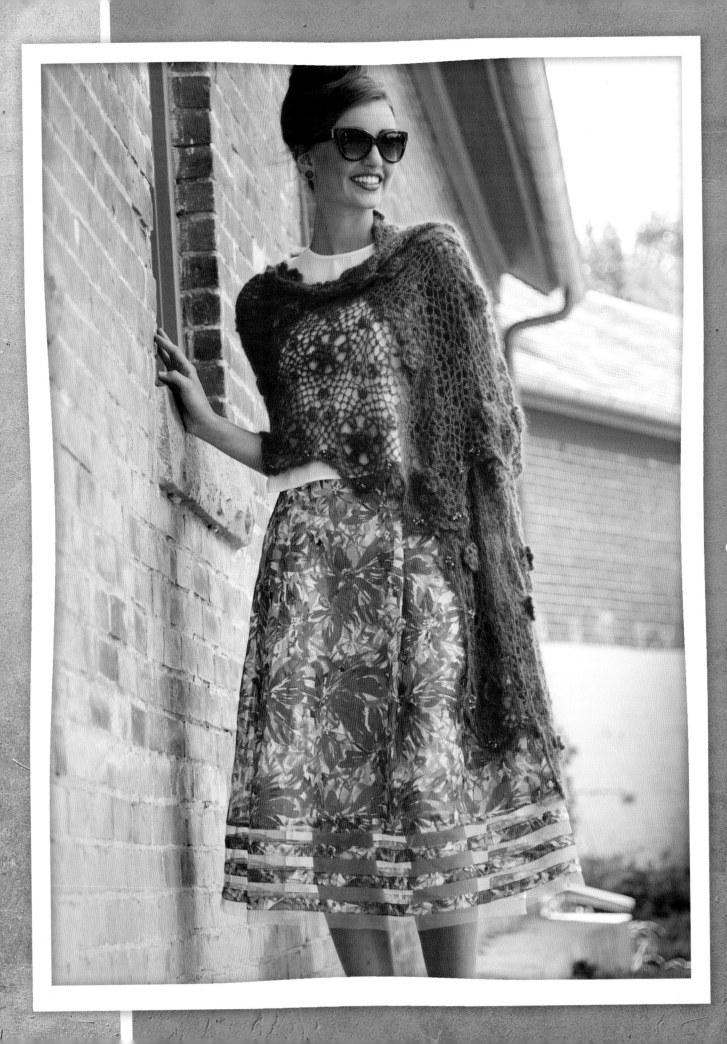

Fidelma Motif shawl

CRISTINA MERSHON

This is a modern interpretation of the classic Irish lacy rose. A hexagon motif featuring flowers and leaves combined with picots and arches. The kid mohair yarn makes it feel like you're wearing a cloud over your shoulders, and the glass beads along the edges give it the perfect amount of sparkle for a special occasion.

FINISHED MEASURMENTS
About 24" (61 cm) wide and 70" (178 cm) long.

YARN
Laceweight (#1 Super fine).

Shown here: ShiBui Silk Cloud (60% kid mohair, 40% silk; 300 yd [275 m]/.88 oz [25 g]): #2031 Poppy, 5 skeins.

HOOK
Size B-1 (2.25 mm). *Adjust hook size if necessary to obtain the correct gauge.*

NOTIONS
One 3.5 oz bag Size 6/0 glass beads (shown here: Seed Mix Tropical Garden by Hobby Lobby); tapestry needle.

GAUGE
Across widest point of motif = 8" (20 cm) with size B-1 (2.25 mm) hook.

Gauge is not essential for this pattern.

NOTES
The wrap consists of 44 hexagon motifs that are joined while they are crocheted. A final border is added around the entire wrap. Small glass beads are sewn around the edges of the wrap for weight and shine. Some rounds end with a dc in the first st; these count as ch 3 and finish the final ch-6 sp of a round.

STITCH GUIDE

Popcorn (pc): Work 6 dc in same st, drop live lp from hook, insert hook from front to back under the top 2 lps of the first dc made and back into the live lp, pull live lp through first dc.

Beginning popcorn (beg-pc): Ch 3, work 5 dc in same st, drop live lp from hook, insert hook from front to back under the top 2 lps of the first dc made and back into the live lp, pull live lp through first dc.

2 treble cluster (2tr-cl): [Yo twice, insert hook indicated st or sp, yo, draw up lp, {yo, draw through 2 lps} twice] twice, yo, draw through all lps on hook.

3 treble cluster (3tr-cl): [Yo twice, insert hook indicated st or sp, yo, draw up lp, {yo, draw through 2 lps} twice] 3 times, yo, draw through all lps on hook.

Shell: (3tr-cl, ch 3, 3tr-cl) in indicated st or sp.

Double Shell (dbl-sh): (3tr-cl, ch 2, 3tr-cl, ch 2, 3tr-cl) in indicated st or sp.

Picot: Ch 3, sl st in first ch made.

FIRST HEXAGON MOTIF

Rnd 1: Ch 6, sl st in first ch to close ring, beg-pc in ring, [ch 3, pc in ring] 5 times, ch 3, sl st in top of beg ch-3—6 pc.

Rnd 2: Ch 1, [sk pc, (sc, dc, tr, picot, tr, dc, sc) in next ch-3 sp] 6 times, sl st in first ch—6 petals.

Rnd 3: Ch 1, [sc in blp of next pc from rnd 1, fold petal forward, ch 6] 5 times, sc in blp of next pc from rnd 1, fold petal forward, ch 3, dc in first ch-1—6 ch-6 sps behind petals.

Rnd 4: Ch 1, sc around last dc made, [ch 6, sc in next ch-6 sp] 5 times, ch 3, dc in first ch-1—6 sc.

Rnd 5: Ch 3, ch 3, 2tr-cl around dc just made, ch 3, 3tr-cl around same dc, [ch 7, shell in next ch-6 sp] 5 times, ch 7, sl st in top of beg ch-3—6 shells.

Rnd 6: Ch 1, [4 sc in next ch-3 sp, 8 sc in next ch-7 sp] 6 times, sl st in first ch-1—72 sc.

Rnd 7: Ch 1, (sc, ch 3, sc) in first sc, *ch 6, sk 3 sc, (sc, ch 3, sc) in next sc; rep from * around to last 3 sc, ch 3, dc in first ch-1—18 ch-6 sps.

Rnd 8: Ch 1, (sc, ch 3, sc) in same ch-sp, [ch 6, sk (sc, ch 3, sc), (sc, ch 3, sc) in next ch-6 sp] 17 times, ch 3, dc in first ch-1.

Rnd 9: Ch 4, 2tr-cl around dc just made, ch 2, 3tr-cl around same dc, *[ch 6, (sc, ch 3, sc) in next ch-6 sp] twice, ch 6**, dbl-sh in next ch-6 sp; rep from * around, ending final rep at **, 3tr-cl in same sp as first 2tr-cl, ch 2, sl st in top of beg ch-4.

Rnd 10: (Sl st, ch 1, sc) in first ch-2 sp, *[ch 6, sc in next ch-6 sp] 3 times, ch 6, sc in next ch-2 sp, ch 3, picot, ch 3**, sc in next ch-2 sp; rep from * around, ending final rep at **, sl st in first sc. Fasten off.

SINGLE SIDE JOIN HEXAGON MOTIF

Referring to Assembly diagram, join Motifs 2–10 on one side of adjacent motifs.

Rnds 1–9: Rep Rnds 1–9 of First Hexagon Motif.

Rnd 10: (Sl st, ch 1, sc) in first ch-2 sp, [ch 6, sc in next ch-6 sp] 3 times, ch 6, sc in next ch-2 sp, **ch 4, sl st in picot of adjacent motif, ch 1, sl st in 4th ch just made, ch 3, sc in next ch-2 sp of current motif**, [ch 3, sl st in corresponding ch-6 sp of adjacent motif, ch 3, sc in next ch-6 sp on current motif] 3 times, ch 3, sl st in corresponding ch-6 sp of adjacent motif, ch 3, sc in next ch-2 sp on current motif, rep bet ** and **, *[ch 6, sc in next ch-6 sp] 3 times, ch 6, sc in next ch-2 sp, ch 3, picot, ch 3***, sc

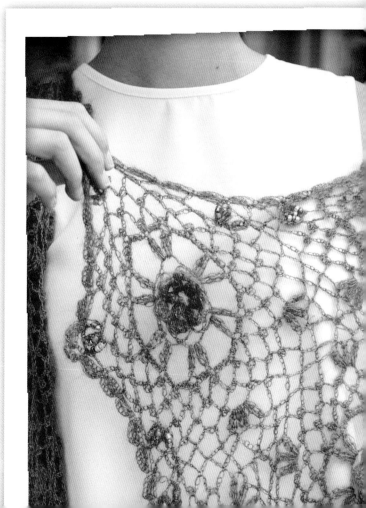

FIDELMA MOTIF SHAWL STITCH DIAGRAM

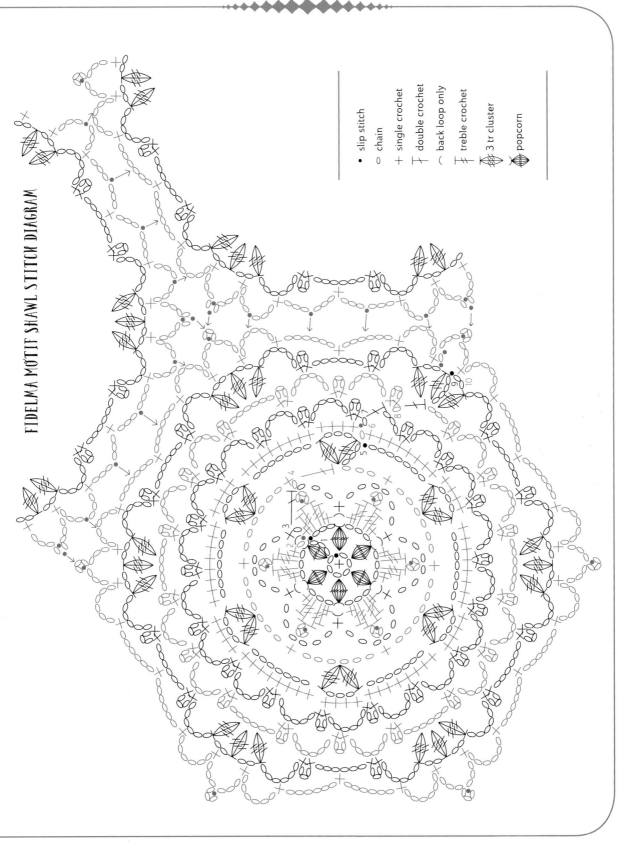

slip stitch
chain
single crochet
double crochet
back loop only
treble crochet
3 tr cluster
popcorn

91

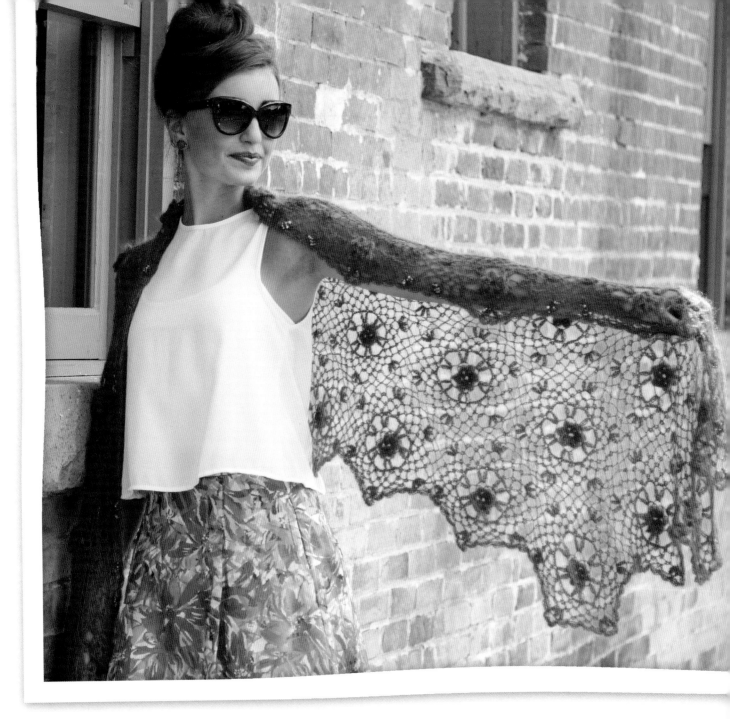

in next ch-2 sp; rep from * around, ending final rep at ***, sl st in first sc. Fasten off.

THREE-SIDED JOIN HEXAGON MOTIF

Referring to Assembly diagram, join Motifs 11–18 on three sides of adjacent motifs.

Rnds 1–9: Rep Rnds 1–9 of First Hexagon Motif.

Rnd 10: (Sl st, ch 1, sc) in first ch-2 sp, [ch 6, sc in next ch-6 sp] 3 times, ch 6, sc in next ch-2 sp, ◊**ch 4, sl st in picot of adjacent motif, ch 1, sl st in 4th ch just made, ch 3, sc in next ch-2 sp of current motif **, [ch 3, sl st in corresponding ch-6 sp of adjacent motif, ch 3, sc in next ch-6 sp on current motif] 3 times, ch 3, sl st in corresponding ch-6 sp of adjacent motif, ch 3, sc in next ch-2 sp on current motif; rep from ◊ twice, rep bet ** and **, *[ch 6, sc in next ch-6 sp] 3 times, ch 6, sc in next ch-2 sp, ch 3, picot, ch 3***, sc in next ch-2 sp; rep from * around, ending final rep at ***, sl st in first sc. Fasten off.

sl st in corresponding ch-6 sp of adjacent motif, ch 3, sc in next ch-2 sp on current motif; rep from ◊ once, rep bet ** and **, *[ch 6, sc in next ch-6 sp] 3 times, ch 6, sc in next ch-2 sp, ch 3, picot, ch 3***, sc in next ch-2 sp; rep from * around, ending final rep at ***, sl st in first sc. Fasten off.

TWO-SIDED JOIN OUTSIDE MOTIF

Referring to Assembly diagram, join Motif 20 on two sides of adjacent motifs.

Rnds 1–9: Rep Rnds 1–9 of First Hexagon Motif.

Rnd 10: (Sl st, ch 1, sc) in first 2tr-cl, ch 3, picot, ch 3, sc in first ch-2 sp, [ch 6, sc in next ch-6 sp] 3 times, ch 6, sc in next ch-2 sp, ◊**ch 4, sl st in picot of adjacent motif, ch 1, sl st in 4th ch just made, ch 3, sc in next ch-2 sp of current motif **, [ch 3, sl st in corresponding ch-6 sp of adjacent motif, ch 3, sc in next ch-6 sp on current motif] 3 times, ch 3, sl st in corresponding ch-6 sp of adjacent motif, ch 3, sc in next ch-2 sp on current motif; rep from ◊ once, rep bet ** and **, *[ch 6, sc in next ch-6 sp] 3 times, ch 6, sc in next ch-2 sp, ch 3, picot, ch 3, sc in next ch-2 sp. Leaving rem sides unworked, fasten off.

THREE-SIDED JOIN OUTSIDE MOTIF

Referring to Assembly diagram, join Motifs 21–28 on three sides of adjacent motifs.

Rnds 1–9: Rep Rnds 1–9 of First Hexagon Motif.

Rnd 10: (Sl st, ch 1, sc) in first 2tr-cl, ch 3, picot, ch 3, sc in first ch-2 sp, [ch 6, sc in next ch-6 sp] 3 times, ch 6, sc in next ch-2 sp, ◊**ch 4, sl st in picot of adjacent motif, ch 1, sl st in 4th ch just made, ch 3, sc in next ch-2 sp of current motif **, [ch 3, sl st in corresponding ch-6 sp of adjacent motif, ch 3, sc in next ch-6 sp on current motif] 3 times, ch 3, sl st in corresponding ch-6 sp of adjacent motif, ch 3, sc in next ch-2 sp on current motif; rep from ◊ twice, rep bet ** and **. Leaving rem sides unworked, fasten off.

OUTSIDE CORNER MOTIF

Referring to Assembly diagram, join Motifs 29 and 30 on two sides of adjacent motifs.

TWO-SIDED JOIN HEXAGON MOTIF

Referring to Assembly diagram, join Motif 19 on two sides of adjacent motifs.

Rnds 1–9: Rep Rnds 1–9 of First Hexagon Motif.

Rnd 10: (Sl st, ch 1, sc) in first ch-2 sp, [ch 6, sc in next ch-6 sp] 3 times, ch 6, sc in next ch-2 sp, ◊**ch 4, sl st in picot of adjacent motif, ch 1, sl st in 4th ch just made, ch 3, sc in next ch-2 sp of current motif **, [ch 3, sl st in corresponding ch-6 sp of adjacent motif, ch 3, sc in next ch-6 sp on current motif] 3 times, ch 3,

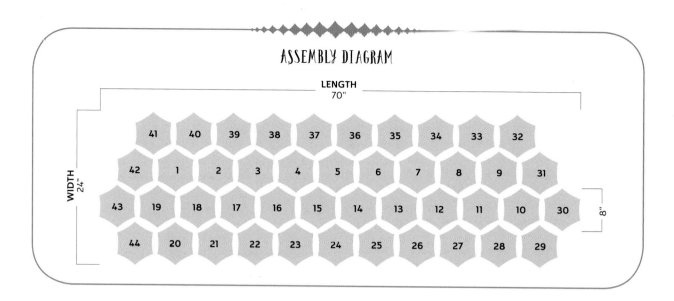

ASSEMBLY DIAGRAM

LENGTH
70"

WIDTH
24"

8"

(Hexagon motifs numbered: 41, 40, 39, 38, 37, 36, 35, 34, 33, 32; 42, 1, 2, 3, 4, 5, 6, 7, 8, 9, 31; 43, 19, 18, 17, 16, 15, 14, 13, 12, 11, 10, 30; 44, 20, 21, 22, 23, 24, 25, 26, 27, 28, 29)

Rnds 1–9: Rep Rnds 1–9 of First Hexagon Motif.

Rnd 10: (Sl st, ch 1, sc) in first 2tr-cl, ch 3, picot, ch 3, sc in first ch-2 sp, [ch 6, sc in next ch-6 sp] 3 times, ch 6, sc in next ch-2 sp, ◊**ch 4, sl st in picot of adjacent motif, ch 1, sl st in 4th ch just made, ch 3, sc in next ch-2 sp of current motif **, [ch 3, sl st in corresponding ch-6 sp of adjacent motif, ch 3, sc in next ch-6 sp on current motif] 3 times, ch 3, sl st in corresponding ch-6 sp of adjacent motif, ch 3, sc in next ch-2 sp on current motif; rep from ◊ once, rep bet ** and **. Leaving rem sides unworked, fasten off.

Referring to Assembly diagram throughout:
Join Motif 31 with Three-Sided Join Outside Motif;
join Motif 32 with Outside Corner Motif;
join Motifs 33–40 with Three-Sided Join Outside Motif;
join Motif 41 with Three-Sided Join Outside Motif;
join Motif 42 with Outside Corner Motif;
join Motif 43 with Three-Sided Join Outside Motif.

OUTSIDE END MOTIF

Referring to Assembly diagram, join Motif 44 on three sides of adjacent motifs.

Rnds 1–9: Rep Rnds 1–9 of First Hexagon Motif.

Rnd 10: (Sl st, ch 1, sc) in first 2tr-cl, ◊**ch 4, sl st in picot of adjacent motif, ch 1, sl st in 4th ch just made, ch 3, sc in next ch-2 sp of current motif **, [ch 3, sl st in corresponding ch-6 sp of adjacent motif, ch 3, sc in next ch-6 sp on current motif] 3 times, ch 3, sl st in corresponding ch-6 sp of adjacent motif, ch 3, sc in next ch-2 sp on current motif; rep from ◊ twice, rep bet ** and **. Leaving rem sides unworked, fasten off.

EDGING

Sl st to join in any sc on outside edge, ch 1, (sc, ch 5, 2tr-cl) in same st as join, [sk ch-6 sp, (sc, ch 5, 2tr-cl) in next sc] around, sl st in first ch-1 to join.

ADDING BEADS (OPTIONAL)

Note: Add beads only to the double shells around the outer edge of the shawl. This will add the right amount of sparkle and weight to the shawl's edges. Add 3 beads per treble cluster (there are 3 clusters on one double shell), beads per cluster. Make sure to use a thin- enough needle to go through the small beads.

Thread some yarn through the needle, attach it to the bottom part of the first outer cluster, then add 3 beads through the needle; sew the beads in place to cover the cluster. Repeat this step twice more to finish one full outer double shell. Fasten off and weave in the ends. Repeat this step in every outer double shell around the perimeter of the shawl.

BLOCKING

Pin shawl to size; spray with water and allow to dry.

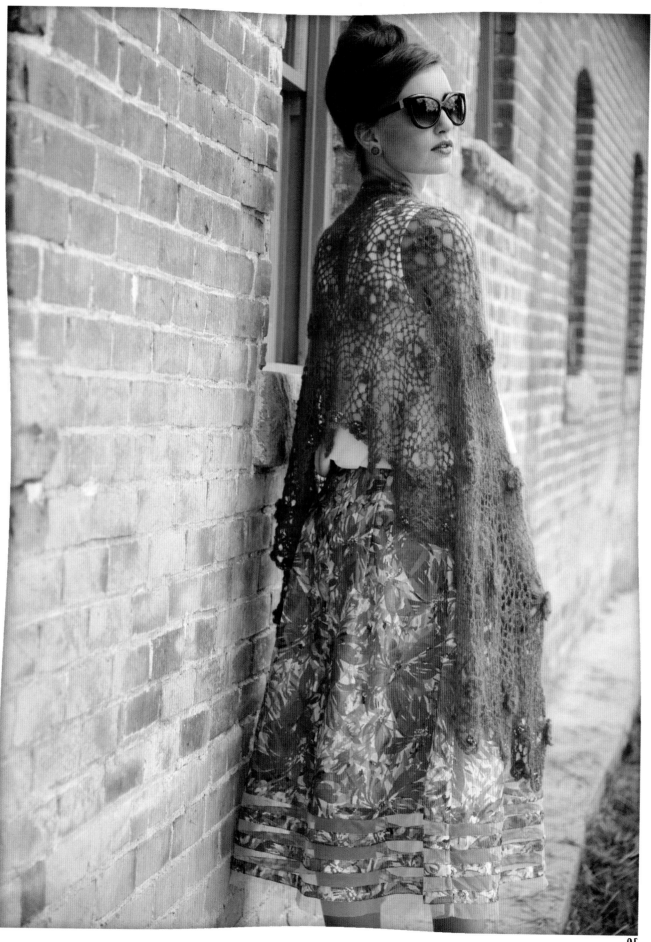

Aine Fascinator and Headband

BRENDA K. B. ANDERSON

◆◆◆◆◆◆◆◆◆◆◆◆◆◆

Sometimes you need a quick fix of lace crochet. This project is fast but makes a big impact! Made in white, this statement piece would be perfect for a bride. If you are looking for a more subtle look, try the headband version instead.

FINISHED MEASUREMENTS

Flower on fascinator: 5" (12.5 cm) in diameter.

Flower on headband: 3½" (9 cm) in diameter.

YARN

DK weight (#3 Light).

Shown here: Nazli Gelin Garden 3 (100% cotton; 1,362/3 yd [125 m]/1.76 oz [50 g]): #300-07 cabernet (MC), #300-25 black (CC); 1 ball each color.

YARN FOR HEADBAND

Fingering weight (#0 Lace).

Shown here: Nazli Gelin Garden 10 (100% cotton; 136.2 yd [125 m]/1.76 oz [50 g]): #700-37 light pink (MC); 1 ball.

HOOK

Hook for Fascinator: Size C-2 (2.75 mm). *Adjust the hook size if necessary to obtain the correct gauge.*

Hook for Headband: Steel Size 6 (1.6 mm). *Adjust hook size if necessary to obtain the correct gauge.*

NOTIONS

Yarn needle; sewing pins; fabric stiffener; paintbrush with stiff bristles; plastic wrap; balloon inflated to a 4" (10 cm) diameter; mug to rest balloon on (for blocking); craft glue. See page 98 for more notions required.

GAUGE

Fascinator: after working Round 3 with size 3 thread and size C (2.75 mm) hook, Flower should measure about 2½" (6.35 cm) in diameter.

Headband: after working Round 3 with size 10 thread and steel size 6 (1.6 mm) hook, Flower should measure about 15/8" (4 cm).

STITCH GUIDE

Back post slip stitch (bpslst): Insert hook from back to front in the space just before the post of the indicated stitch, then to the back space just after post of same stitch, yo, bring through (around the front of the post) to back, and pull through loop on hook.

NOTES

Rounds 1–7 are worked in the round. The next "round" of lacy petals is actually worked back and forth (in turned rows) one petal at a time, from the base of the petal to the tip. You will need to join a new piece of thread for each petal, but you can crochet over all of the yarn tails on the last edging round so you don't have so many ends to weave in. After you finish making the motif, it is stiffened using fabric stiffener and left to dry while resting upside down on a balloon. This gives the flower its curved shape.

Additional notions for Fascinator

One lightweight button 1¼" (3.2 cm) in diameter; 2 circles of pre-stiffened black felt cut to a 2½" (6.5 cm) diameter using larger circular template; two 6" (15 cm) pieces of 20-gauge black-colored copper wire; 5–7 black goose biot feathers; 1 comb or alligator clip for attaching in hair; one 26" (66 cm) piece of 8" (20.5 cm) wide French netting (also called birdcage or millinery netting) in black; sewing needle; and black thread.

Additional notions for Headband

One button ¾" (2 cm) in diameter; 2 circles of pre-stiffened light pink felt 1½" (3.8 cm) in diameter using smaller circular template; needle and sewing thread to match felt; headband.

FLOWER MOTIF (Make 1)

With designated hook and MC, ch 8, sl st in first ch to form ring—8 ch-sts.

Rnd 1: Ch 1, 15 sc in ring, sl st in first sc of round to join—15 sts.

Rnd 2: Ch 5, sk next 2 sc, [sc flp in next sc, ch 5, sk next 2 sc] 4 times, sc in flp of sl st from previous rnd—5 ch-5 sps. (**Note:** You will work in the unused back loops of the 5 sc stitches when you work Round 4.)

Rnd 3: [Sl st, ch 1, sc, hdc, 5 dc, hdc, sc] in the first ch-5 sp, [sc, hdc, 5 dc, hdc, sc] in each of next 4 ch-5 sps, sl st in the first sc of round—5 petals.

Rnd 4: Ch 1; working behind each of the petals made in the previous round (just bend them forward, out of the way), 1 sc in the unused back loop of the sl st (left after working Round 2), [ch 7, 1 sc in next unused back loop behind sc (left after working Round 2)] 4 times, ch 7, sl st to first sc of rnd—5 ch-7 sts.

Rnd 5: Sl st in the first ch-7 st, ch 1, [1 sc, 1 hdc, 8 dc, 1 hdc, 1 sc] in same ch-7 st and in each of the next 4 ch-7 sts, sl st to first sc of round—5 petals made.

Rnd 6: Ch 2; working behind the last set of petals made in previous round, bpslst around post of first sc from Rnd 4, ch 10, [bpslst around post of next sc from Rnd 4, ch 10] 4 times, do not join—5 ch-10 sps.

Rnd 7: Sl st in the first ch-10 sp, ch 1, 15 sc sts in each ch-10 sp around, sl st in the first sc of round—5 sets of 15 sc around.

Rnd 8: Sl st in following st, *[ch 4, sk next sc, sl st in next sc] 6 times, turn, 2 sl sts in closest ch-4 sp, [ch 4, sl st in next ch-4 sp] 5 times, turn, 2 sl sts in closest ch-4 sp, [ch 4, sl st in next ch-4 sp] 4 times, turn, 2 sl sts in closest ch-4 sp, [ch 4, sl st in next ch-4 sp] 3 times, turn, 2 sl sts in closest ch-4 sp, [ch 4, sl st in next ch-4 sp] 2 times, turn, 2 sl sts in closest ch-4 sp, ch 4, sl st in next ch-4 sp, fasten off**. [With RS facing, sk next 2 sc and join MC to following st by pulling up a loop and ch 1. Rep from * to **] 4 more times. On last lace petal, do not fasten off.

EDGING

As you work this round, try to crochet around each of the yarn tails as you come to them. This will reduce the amount of weaving in you need to do later. Ch 1, turn

TECHNIQUE TIDBIT

In the mid-eighteen hundreds, Irish crochet became a much-needed way for poor, young Irish women to make money. In response to the poverty caused by the potato famine, clergymen's wives invited Irish crochet makers to teach those in their community how to create this kind of lace. Selling this new kind of lace became a lifeline to many and allowed some families to immigrate to America.

BLOOM LEAF

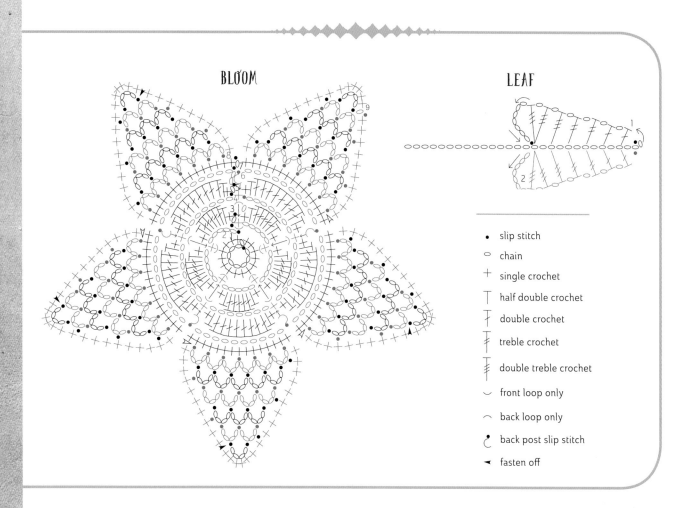

- • slip stitch
- ◦ chain
- + single crochet
- ⊤ half double crochet
- ⊤ double crochet
- ⊤ treble crochet
- ⊤ double treble crochet
- ⌣ front loop only
- ⌢ back loop only
- ↄ back post slip stitch
- ◄ fasten off

(RS facing), *6 sc in the tip ch-4 sp, 2 sc in each of the 5 ch-sts along the side edge of the petal, 2 sc in each of the 5 ch-sts up to the top of the next petal; rep from * 4 more times, sl st in first sc of this round. Fasten off. Weave in all ends.

LEAVES (for Fascinator only) (Make 2)

Using CC and larger hook, ch 29; working in the bottom bar of the chs, sl st in 2nd ch from hook, sk next ch, [1 dc in next ch, sk next ch, ch 1] twice, [1 tr in next ch, sk next ch, ch 1] twice, 1 dtr in next ch, sk next ch, ch 1, (dtr, ch 1, dtr, ch 7, sl st) in next ch; rotate to work in opposite side of foundation chain, leaving rem chs unworked, ch 7, (dtr, ch 1, dtr) in same ch, ch 1, sk next ch, dtr in following ch, [ch 1, sk next ch, tr in next ch] 2 times, [ch 1, sk next ch, dc in next ch] 2 times, sk next ch, sl st in following ch, fasten off.

BLOCKING AND SEAMING
BLOCKING THE LEAVES

Weave in all ends, except the beginning yarn tail of leaves (the yarn tail at the stem end of leaf).
Weave a piece of black wire through the stem of each leaf all the way to the tip of the leaf. Bend the end of the wire (about ½" [1.3 cm] from the end) back on itself and weave it through the stem once again. Make sure that the sharp end is not sticking out of the leaf. This wire will stay in place after you have stiffened the leaf. Place leaves on plastic wrap and using the paintbrush, fully saturate each leaf with fabric stiffener. Squeeze leaf between two pieces of plastic wrap to get rid of any excess stiffener. Place a new piece of plastic wrap on a folded-up old towel or cardboard box. Place leaves on plastic wrap and pin all of the points of the leaf in place—gently stretching outward from the center of motif. Allow Leaves to dry completely.

BLOCKING THE FLOWER

Place Flower motif on plastic wrap and using paintbrush, saturate just the large lacy petals with the fabric stiffener, but avoid getting too much on the first row of the lace petals. You will have to stitch felt to the back of this later, and it is difficult to sew through crochet that has been stiffened. (Do not apply any fabric stiffener to the center small petals of flower). If you have made the smaller motif for the headband, you will not need to stiffen the flower quite as much, since the motif is lighter. You can just saturate the underside (WS) of the lacy petals. Don't worry about the crochet thread being fully saturated (top and bottom) on a headband flower. Squeeze saturated petals between two clean pieces of plastic wrap or wax paper to remove any excess fabric stiffener. Inflate a balloon to about 4" (10 cm) in diameter and place the Flower motif upside down on the balloon so that the petals will be able to dry in a slightly concave shape. Place the balloon in a coffee mug to keep it from rolling around. Stretch the petals outward with your fingers to open up the lace pattern a bit and allow the motif to dry completely on the balloon.

ASSEMBLING THE FASCINATOR

Using needle and thread, whipstitch the outer edge of one of the circular felt pieces to the center back of the

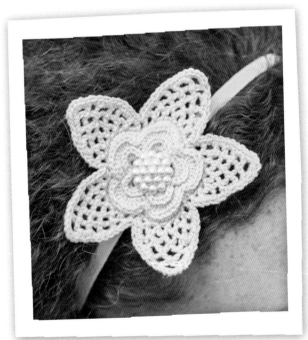

flower motif. The circle should just fit inside of the center back of the flower, trim the circle down if necessary. Using needle and thread, sew the button through the center of the RS of the flower in the felt piece behind. Gather your goose biot feathers together and tie a piece of CC around them about 3/4" (2 cm) from the bottom end of the feathers. Make sure you like how they are arranged before moving on (adjust if needed). Wrap the same piece of CC around the feathers a few times and tie tightly in a knot. Use a small amount of glue to adhere the ends of these feathers together so they cannot slip out of the CC tie. Set aside. To attach the leaves, coil the wire that comes out of the stem of each leaf in a circular shape (no larger than 1" [2.5 cm] in diameter) so that it will lay flat, but can be stitched to the wrong side of the felt-backed motif. Keep in mind that you want the leaves to stick out past the edge of the flower. Pin both leaves to the wrong side of the felt. Check the placement by looking at the flower motif from the right side. When you are happy with the placement, use needle and thread and stitch leaves in place all the way around the circular wire shape. After the glue has dried, pin feathers in place on the wrong side of the felt-backed motif. This should be placed between the two leaves. When you are happy with the placement of the feathers, stitch the tied end of the feathers to the wrong side of the felt-backed motif using needle and thread. Be careful not to stitch through the spines of the feathers, as that may cause them to break, but rather stitch between the feathers above where they are tied together, and stitch around all of the stems below the tie.

PREPARE FRENCH NETTING AS FOLLOWS:

Lay the 26" (66 cm) piece of netting on the table in front of you. Take a ruler and measure up along the short side of each end of netting and mark at 5" (12.5 cm). From this point cut the corner off each end of netting, following along the diagonal line of the net. This diagonal cut should be about 6" (15 cm) long. Using needle and a long piece of doubled thread, create a line of stitching that goes up one end, across the diagonal, across the top of the netting, down the next diagonal, and down the opposite end of the netting. To begin your stitches,

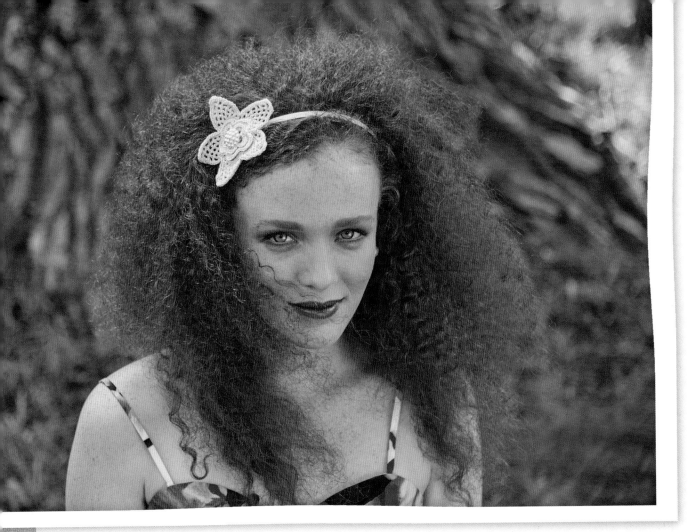

make sure that your thread is doubled with a sturdy knot tying the two ends together. Slide your needle through the little dot nearest the bottom corner and pull through until there is about 1/2"(1.3 cm) of thread left. Slide needle through the two pieces of thread, between the knot and the dot in the netting. Now you can finish pulling the thread through. This will anchor the thread. Continue to pass needle through each dot in the netting closest to the edge of the net along the path shown in the diagram. When you have ended at the opposite side of the netting, pull on the thread to gather the top and sides of net until it just fits along the edge of felt between the two leaves. Using needle and thread, stitch gathered edge of netting in place just inward from the edge of the felt. Place second circle of felt over this piece of felt and stitch the edges of the two felt layers together using needle and thread. Stitch alligator clip or comb to the outer felt layer, being careful to position it in a useful place.

ASSEMBLING THE HEADBAND

Using needle and thread, whipstitch the outer edge of one of the circular felt pieces to the center back of the flower motif. The circle should fit just inside of the center back of the flower; trim the circle down if necessary. Using needle and thread, sew the button through the center of the RS of the flower in the felt piece behind. Check placement of the Flower motif on the headband and mark where the center of the flower should be attached. Glue or stitch the wrong side of the felt circle to the headband. If at all possible, it is sturdiest if you can glue and stitch the felt to the headband. Even if you just catch a small amount of fabric from the headband with your needle and thread, it is better than none at all. Allow glue to dry, then glue the center of the other piece of felt to the first piece of felt, sandwiching the headband between. Be careful to keep the edge of the felt pieces away from the glue. After the glue has dried and using a needle and thread, whipstitch the edges of the felt together.

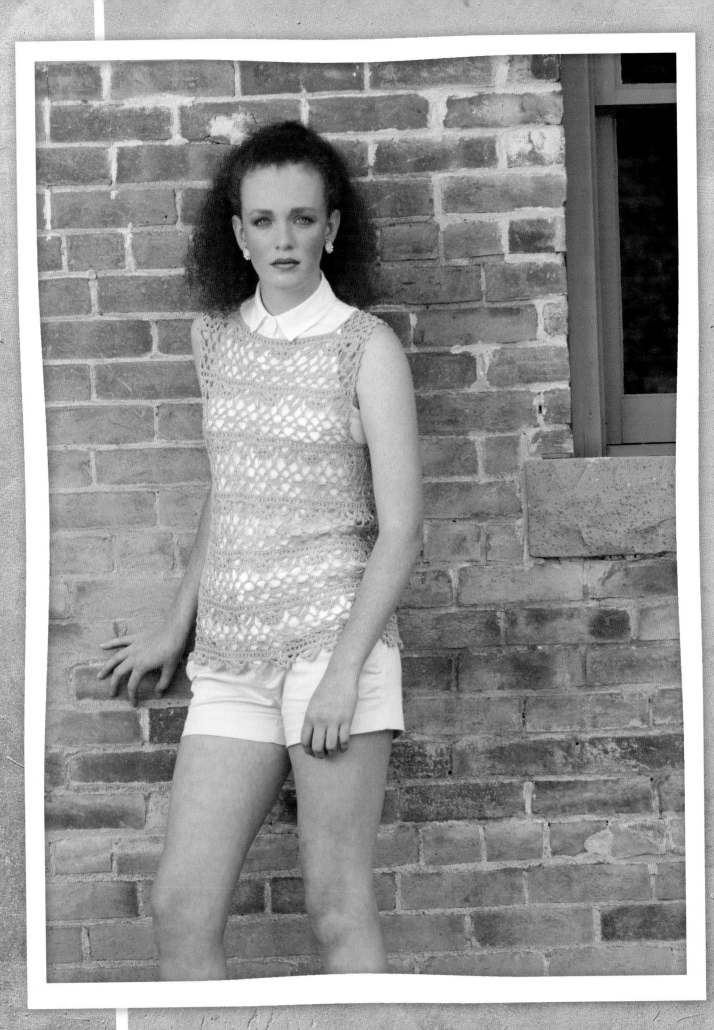

Guipure top

NATASHA ROBARGE

◆◆◆◆◆◆◆◆◆◆◆◆◆

Irish crochet lace's striking effect is created by the contrast between solid elements and delicate mesh lace. This top features the netting of Irish crochet as the star and not just a background to place motifs.

FINISHED MEASUREMENTS

35 (38½, 42, 45½, 49)" 89 [98, 106.5, 115.5, 124.5] cm with a close fit (0-1" [0, 2.5] cm ease) measured after blocking. Sized for S (M, L, XL, 2XL). Size shown is S.

YARN

Sportweight (#2 Fine).

Shown here: Nazli Gelin Garden 5 (100% mercerized cotton; 174 yd [159 m]/ 1.76 oz [50 g]): #500-73, 5 (6, 6, 7, 7) balls.

HOOK

Size C-2 (2.75 mm). *Adjust hook size if necessary to obtain the correct gauge.*

NOTIONS

Locking stitch marker; tapestry needle for assembly and weaving in the ends.

GAUGE

SR = stitch repeat: leaf and flower motif together,

RR = row repeat: main pattern repeat of 8 rows.

24 sts (1 SR) by 8 rows (1 RR) = 3½" × 3¼" (8.9 cm × 8.3 cm) in stitch pattern.

STITCH GUIDE

Double crochet cluster (3dc-cl): [Yo, insert hook in indicated st, yo and pull up a loop, yo and draw through 2 loops on hook] 3 times, yo and draw through all 4 loops on hook.

Picot: Ch 3, sl st in st at base of ch-3, under 2 horizontal bars at the top of prev st.

Quintuple crochet (qc): Yo 5 times, insert hook in indicated st, yo, pull up a loop, [yo and draw through 2 loops on hook] 6 times.

Double treble quintuple crochet together (dtr-qc-tog): Yo 3 times, insert hook in indicated st, yo, draw up a loop, [yo, draw through 2 sts on hook] 3 times, yo 5 times, insert hook in next indicated st, yo draw up a loop, [yo, draw through 2 sts on hook] 5 times, yo, draw through rem 3 loops.

Main body st patt swatch (multiple of 24 sts + 2)

For swatch ch 50, turn.

Row 1: (RS) Sc in 2nd ch from hook and each ch across, turn.

Row 2: Ch 4, dc in 3rd sc, *ch 1, sk 1 sc, dc in next sc; rep from * across, turn.

Row 3: Ch 1.

a) [Sc in next dc, sc in next ch-1 sp] 6 times, ch 4, turn (as if flipping a page of a book backward), sk 5 sc just made (counting first sc with ch), (3dc-cl, ch 3, 3dc-cl, ch 3, 3dc-cl) in next sc, ch 4, sk 5 sc, sl st in next sc, turn (as if flipping a page of a book forward), (3 sc, picot, 2 sc) in ch-4 sp, (2 sc, picot, 2 sc) in each of next 2 ch-3 sps, (2 sc, picot, 3 sc) in next ch-4 sp, sc in next dc in base row, (flower motif completed).

b) [Sc in next ch-1 sp, sc in next dc] 4 times, ch 9, turn (as if flipping a page of a book backward), sl st in 7th sc (counting first sc with ch), turn (as if flipping a page of a book forward), 2 sc blp in each of next 3 ch, sc blp in each of next 6 ch., sc in next ch-1 sp of base row, sc in next dc, ch 9, turn (as if flipping a page of a book backward), sl st in 8th sc (counting first sc with ch), turn (as if flipping a page of a book forward), 2 sc blp in each of next 3 ch, sc blp in each of next 6 ch, sc in next ch-1 sp of base row, (double leaf motif completed).

[Rep a) and b)] across. Sc in 3rd beg ch, turn.

Row 4: Ch 8, sk 5 sc, dtr in next sc, *ch 7, sk 4 sc, sc in next (sc, picot), ch 7, sk 3 sc on upper leaf and 2 sc on lower leaf, dtr2tog with first leg in next sc and sec-

ond leg in sc after next picot on flower, picot, ch 7, sk 3 (sc, picot), dc in next (sc, picot), ch 7, sk (2 (sc, picot)**, dtr2tog with first leg in next sc and second leg in 6th sc after next picot, picot; rep from * across, ending final rep at **, dtr-qc-tog with dtr in next sc and qc in last sc, beside sl st, turn.

Row 5: Ch 9, (sc, picot) in ch-7 sp, *ch 7, (sc, picot) in next ch-7 sp; rep from * across, ending with ch 3, dtr in dtr, turn.

Row 6: Ch 1, sc in dtr, ch 7, (sc, picot) in next ch-7 sp, *ch 3, 7 dc in next ch-7 sp, ch 3, (sc, picot) in next ch-7 sp; rep from * across, ending with ch-7, sc in 6th beg ch, turn.

Row 7: Ch 9, (sc, picot) in ch-7 sp, *ch 7, (sc, picot) in next dc, ch 7, sk 5 dc, (sc, picot) in next dc; rep from * across to last ch-7 sp, ch 7, (sc, picot) in last ch-7 sp, ch 3, dtr in beg sc, turn.

Row 8: Ch 1, sc in dtr, *ch 5, sc in next ch-7 sp; rep from * across, ending with sc in 6th beg ch, turn.

Row 9: Ch 1, sc in first sc, *5 sc in ch-5 sp, sc in next sc; rep from * across, turn.

Repeat Rows 2–9 for main patt.

Block swatch by ironing on cotton setting through wet cheesecloth and check gauge.

NOTES

Back and Front are worked separately from neckline down, then connected at the underarm and worked in body rounds. Shoulder mesh is worked last allowing neckline and armhole- depth adjustments.

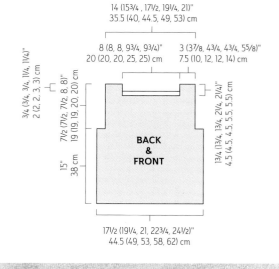

14 (15¾ , 17½, 19¼, 21)"
35.5 (40, 44.5, 49, 53) cm

8 (8, 8, 9¾, 9¾)"
20 (20, 20, 25, 25) cm

3 (3⅞, 4¾, 4¾, 5⅝)"
7.5 (10, 12, 12, 14) cm

¾ (¾, ¾, 1¼, 1¼)"
2 (2, 2, 3, 3) cm

7½ (7½, 7½, 8, 8)"
19 (19, 19, 20, 20) cm

1¾ (1¾, 1¾, 2¼, 2¼)"
4.5 (4.5, 4.5, 5.5, 5.5) cm

15"
38 cm

BACK & FRONT

17½ (19¼, 21, 22¾, 24½)"
44.5 (49, 53, 58, 62) cm

BACK AND FRONT (Make 2)

Note: For sizes S, L, 2XL, Row 3 ends with a leaf and sc in 3rd beg ch. For sizes Medium and XL, Row 3 ends with a flower and working last sc of flower in 3rd beg ch.

Sizes M and XL only:

Row 4: Ch 8, sk (2 sc, picot, 2 sc) of flower, dtr in next sc, *ch 7, sk (2 sc, picot), (dc, picot) in next sc, ch 7, sk (2 sc, picot)**, dtr2tog with first leg in next sc and second leg in 6th sc after next picot, picot, ch 7, sk 4 sc, (sc, picot) in next sc, ch 7, sk 3 on upper leaf and 2 sc on lower leaf, dtr2tog with first leg in next sc and second leg in sc after next picot on flower, picot, rep from * across, ending at **, dtr-qc-tog with dtr in next sc and qc in beg sc, turn.

All sizes:

Ch 98 (110, 122, 134, 146).
Work Rows 1–9 and then Rows 2–7 of main pattern, working alternate Row 4 for sizes M and XL (see Note). Fasten off Back. Do not fasten off Front.
Note: Row 8 of main pattern joins Back and Front and adds underarm stitches.
Work Row 8 (WS) of Front, ch 23, sc in first sc of Back (WS), omitting beg ch 1, work Row 8 of Back, ch 23, sl st in beg sc, turn, sl st in each of 12 chains. Mark the 12th sl st for side seam.

BODY

Note: For sizes S, L, 2XL, add a flower and a leaf motif for the underarm; for sizes Medium and X-Large, add 2 leaf motifs for the underarm.
Rnd 1 (RS): Ch 1, sc in each of next 11 ch, sc in next sc, [5 sc in ch-5 sp, sc in next sc] across Back, sc in each of next 23 ch, sc in next sc, [5 sc in ch-5 sp, sc in next sc] across Front, sc in each of next 12 sl sts, sl st in beg ch 1, turn.
Rnd 2: Ch 4, sk one sc, verifying that dc align with dc of Row 2 of the previous section, *dc in next sc, ch 1, sk 1 sc; rep from * around, sl st in 3rd beg ch, turn.
Rnd 3: Ch 1, sc in first st, place marker in sc just made, work in established pattern ensuring motifs align above motifs of previous section and join rnd with sc in marked sc of rnd, move marker up, turn.

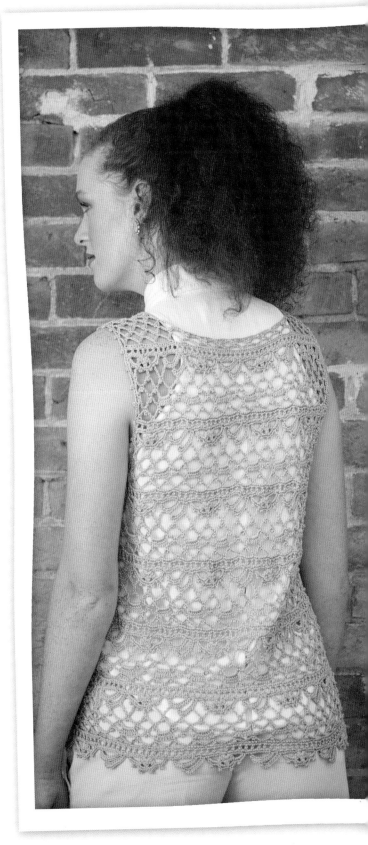

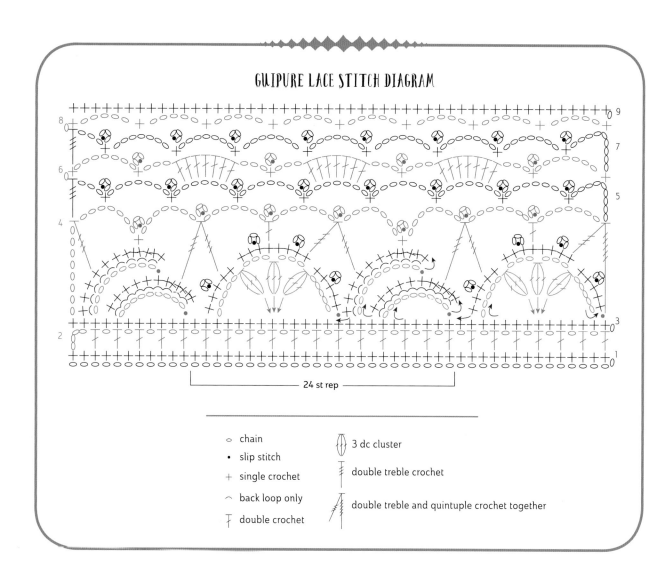

GUIPURE LACE STITCH DIAGRAM

Legend:
- ○ chain
- • slip stitch
- + single crochet
- ⌢ back loop only
- ┬ double crochet
- ⬙ 3 dc cluster
- ⨏ double treble crochet
- ⨏ double treble and quintuple crochet together

24 st rep

Note: For sizes S, L, 2XL, Rnd 3 ends with a flower motif where a last sc of the flower is in the marked seam sc; for sizes Medium and XL, Rnd 3 ends with a leaf motif and a sc in the marked seam sc.

Rnds 4–9: Work in established pattern, but join with sc in top of first st of round, turn.

Rnd 10: Ch 4, sk one sc, *dc in next sc, ch 1, sk 1 sc; rep from * around, sl st in 3rd beg ch, turn. Verify that dc align with dc row of the previous section.

Repeat Rnds 3–10 three more times. Work Rnd 3 once more. Fasten off.

RIGHT SHOULDER

Note: You will make shorter turning chains or end sts on the arm side and longer turning chains or end sts on the neck side to shape the shoulder.

Row 1: (RS) Attach yarn to first sc in top right-hand corner of Back, sc in same sc, [ch 7, sk 5 sc, sc in next sc] across, turn—16 (18, 20, 22, 24) ch-7 sps.

Row 2: Ch 7, (sc, picot) in ch-7 sp, [ch 7, (sc, picot) in next ch-7 sp] across, ch 3, tr in last sc, turn.

Row 3: Ch 1, sc in tr, [ch 7, (sc, picot) in next ch-7 sp] 3 (4, 5, 5, 6) times, ch 3, dtr in next sc, turn.

Row 4: Ch 1, sc in dtr, [ch 7, (sc, picot) in next ch-7 sp] 3 (4, 5, 5, 6) times, ch 3, tr in last sc, turn.

TECHNIQUE TIDBIT

Irish crochet lends itself to endless creative possibilities. Historically, Irish crafters specialized in individual motifs that were assembled in beautiful garments and accessories. To make solid parts stand out against the mesh, the crafters reinforced the outlines with cord or multiple threads that were held together and then crocheted around them.

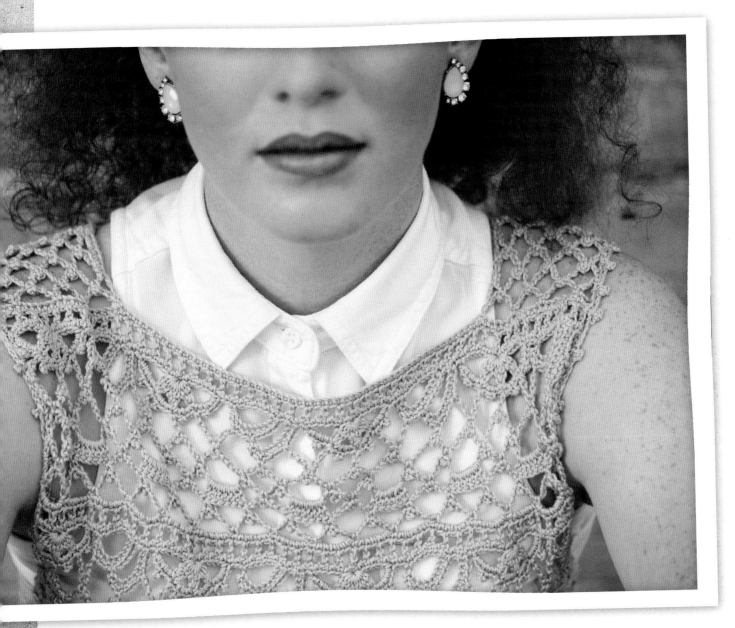

Rows 5–8 (8, 8, 10, 10): Repeat Rows 3 and 4.

Note: Shoulder height can be adjusted to allow for a longer or shorter armhole.

Note: In the next row, you will connect Back to Front. Align the Front with Back so that Back RS and shoulder rows are below and the Front top edge meets the hook above.

Row 9: Inserting hook from back to front, tr in first sc of Front, ch 3, sk 3 sc on Front, inserting hook from back to front, sc in next sc on Front, ch 3, (sc, picot) in next ch-7 sp of Back, [ch 3, sk 5 sc on Front, sc in next sc on Front, ch 3, (sc, picot) in next ch-7 sp of Back] 2 (3, 4, 4, 5) times, ch 3, sk 5 sc of Front, sc in next sc of Front, tr in last sc of Back. Fasten off.

LEFT SHOULDER

Row 3: With RS facing, sk 7 (7, 7, 9, 9) ch-7 sps from edge of Right Shoulder, in next ch-7 sp, sl st to join, ch 8, (sc, picot) in next ch-7 sp**, ch 7] across, ending with sc in last ch-7 sp, turn.

Row 4: [Ch 7, (sc, picot) in next ch-7 sp] across, ending with sc in 5th ch of beg ch-8, turn.

Row 5: Ch 9, (sc, picot) in ch-7 sp, [ch 7, (sc, picot) in next ch-7 sp] across, ending with ch 7, sc in 4th beg ch, turn.

Row 6: [Ch 7, (sc, picot) in next ch-7 sp] across, ch 7, sc in 5th beg ch, turn.

Rows 7–8 (8, 8, 10, 10): Rep Rows 5 and 6.

Note: In the next row, you will connect Back to Front. Align Front with Back so that Back RS and shoulder rows are below and Front top edge meets hook above.

Row 9: Ch 5, inserting hook from back to front, sc in 22nd (28th, 34th, 34th, 40th) sc from left edge of Front, ch 3, (sc, picot) in ch-7 sp of Back, [ch 3, sk 5 sc of Front, sc in next sc of Front, ch 3, (sc, picot) in next ch-7 sp of Back] 2 (3, 4, 4, 5) times, ch 3, sk 5 sc of Front, sc in next sc of Front, ch 3, sc in 4th beg ch of Back, ch 3, sc in first sc of Front. Fasten off.

Armhole Trim

With RS facing, join yarn with sl st in side of Row 2 of Front (for left armhole) and of Back (for right armhole), ch 1, (sc, picot) in same st, ch 5, (sc, picot) in first ch-sp, [ch 5, sc in next sp] across to bottom of armhole, ch 5, sk 4 sc at bottom of armhole, sc in next sc, [ch 2, sk 1 sc, sc in next sc] along the bottom of armhole until 4 sc left, [ch 5, (sc, picot) in next sp] to shoulder mesh, [ch 3, (sc, picot) in next shoulder mesh sp] across to last shoulder sp, ch 3, sl st in beg sc. Fasten off.

BLOCKING

Weave in the ends and iron the top on the cotton setting through wet cheesecloth.

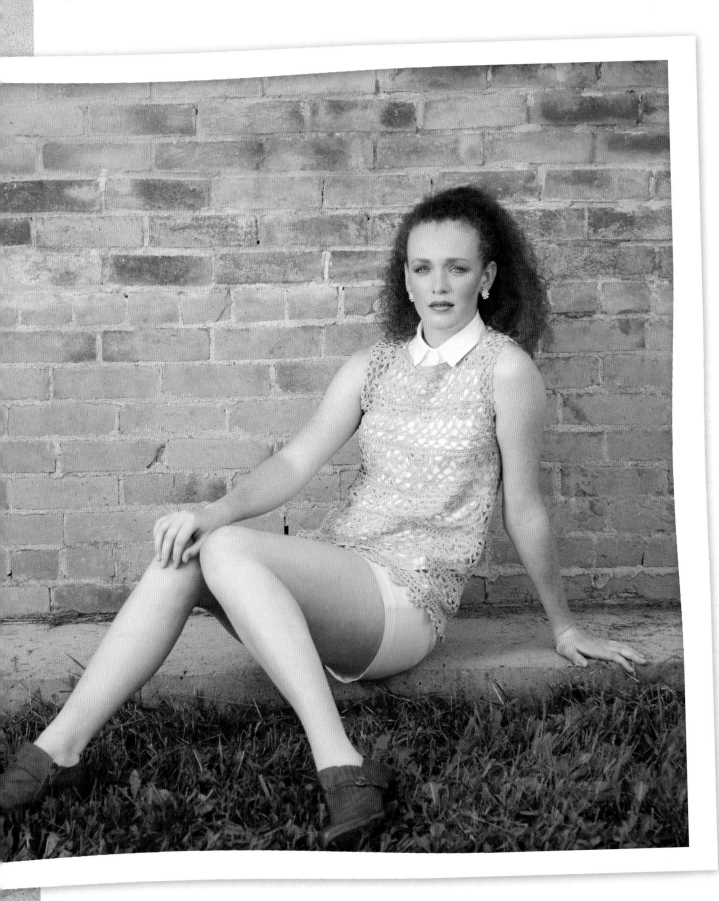

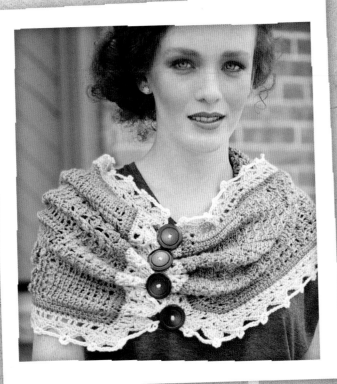

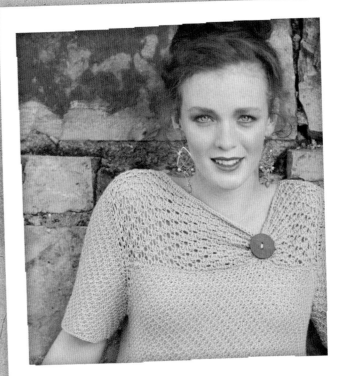

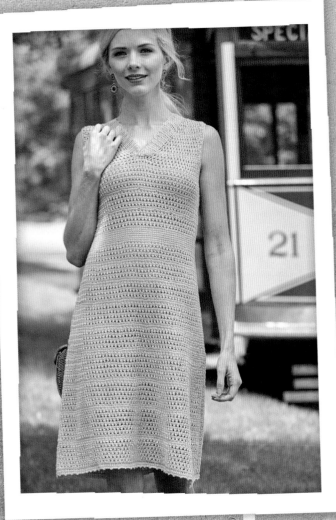

TUNISIAN CROCHET

Some scholars believe that Tunisian crochet was the craft that birthed knitting and crochet as we know it today . . . and there are others who think that is completely wrong. This style has had many names over the years, which helps with the confusion: It has been called Tunisian crochet (most think this was coined by French publications); the Afghan Stitch, extremely popular in America for making backgrounds in needlework afghans; Railway Knitting, named for the craft many made in the 1800s on the way to work; Idiot's Knitting, since the basic simple stitch is so simple; Tricot Crochet, which translates to "knitting hook" in French; Shepard's Knitting, named for the warm clothes made from the stitch. With so many names, the histories can all get interwoven and confusing. What we *do* know is it has always been a richly loved craft that has come in and out of popularity.

My personal love of Tunisian crochet is for the chameleon it can be. Some patterns look exactly like knitting, others crochet, others weaving, and others needlepoint. With its wide array of fabric choices, it can make the most varying laces. This book is going to focus in on three ways to make lace in Tunisian, but keep in mind there are more. We focus on lace made with yarn overs similar to how you make lace in knitting; lace made with chain spaces similar to crochet lace; and lace made with extended stitches. Each technique makes patterns that are unique to that style; but again, they are just the tip of the amazing wealth of stitches out there.

Yarn-over stitch patterns are made by skipping stitches in the forward pass or pulling through two or more stitches at the same time and adding a yarn over in its place. The return pass is worked off in the usual manner. This makes for small holes in the fabric, since the return pass has a solid line of stitches. The Cleves Lace Stitch Pattern in the Priya Cowl is the perfect example of yarn overs

in your stitch pattern. The lace is exaggerated by working the simple stitch around the horizontal bars, thus extending the hole in the fabric.

Chain-stitch patterns are made by pulling up stitches or a group of stitches in each one across the forward pass. Then, chaining one or many stitches while passing through a number of loops at the same time in the return pass. The fabric can mimic classic crochet very easily without the pesky problem of how huge lace crochet can creep. Tunisian fabric is stiffer and denser, and in this crochet technique, it comes in handy to help stop your project from huge growth. The Peronell Stitch Pattern in Priya Cowl shows off this technique with double crochet clusters in its center. Even though the stitch pattern is impressively similar to a cluster lace, you can see hints of the classic uniform stitches of Tunisian crochet.

Extended stitch patterns are made by tall stitches in the forward pass. This could be from true extended stitches, which are regular stitches with a chain or two extra, or tall classic stitches such as double or treble crochets. These stitch patterns hark back to more of a hybrid of woven fabric with an almost dropped stitch look between each row. The extended stitches in the Priya Cowl show how this technique really highlights the beauty of fiber by exaggerating the strands.

If you want to test out all of these techniques in one piece, then either the **Priya Cowl**, for a more uniform block-by-block layout, or the stunning **Yasmine Shawl**, with amazingly unique stitches, are the projects for you. If you want to just dip your toe into Tunisian lace, then give the **Syrah Cuffs**, with or without the beads and wire, a try. The **Fleur Swing Top** and **Cyrine Striped Dress** are perfect examples of how Tunisian lace makes extremely wearable garments. Since each project highlights a different technique, it's probably best to crochet them all!

Syrah cuffs

ROBYN CHACHULA

These simple cuffs make great gifts and use up the thread and beads you have lingering in your craft room. You can grab almost any thread or wire and some beads and turn them into a great cuff. I love mixing crafts, so adding a touch of beading on the edge of the cuff slightly steps up the polished look. Anyway you decide to cook up your own, I know they will look great.

FINISHED MEASUREMENTS

Wire Version: 2" (5 cm) wide × 7½" (19 cm) long.

Aqua Version: 2¼" (5.5 cm) wide × 8" (20.5 cm) long.

Pumpkin Version: 2" (5 cm) wide × 8" (20.5 cm) long.

YARN

Thread Weight, Size 10.

Wire Version Shown: Artistic Wire, 30-gauge wire (bare copper; 50 yd [46 m]/ spool]): 25 yd [23 m].

Aqua Version Shown: Nazli Gelin, Garden 10 Metallic (99% Egyptian giza mercerized cotton, 1% glitter yarn; 306 yd [280 m]/ 1.75 oz [50 g]): #702-25 Mint with Turquoise, 1 ball.

Pumpkin Version Shown: Nazli Gelin, Garden 10 Metallic (99% Egyptian giza mercerized cotton, 1% glitter yarn; 306 yd [280 m]/ 1.75 oz [50 g]): #702-20 Caramel with Bronze, 1 ball.

HOOK

Size. 0 (2.55 mm) steel hook for wire version; F-5 (3.75 mm) for aqua version; E-4 (3.5 mm) for pumpkin version. *Adjust hook size if necessary to obtain the correct gauge.*

NOTIONS

Wire Version: 0.006" Wildfire black beading thread; size 10 beading needle; (34) 6/0 transparent frosted rosaline round seed beads (B); 3 g 11/0 matte opaque gray round seed beads (A); black 5-loop magnetic slide clasp.

Aqua Version: sixty-three 4 mm jet recycled glass rondelle beads; fabric stiffener; rust-proof pins; wax paper; 0.006" Wildfire black beading thread; size 10 beading needle; 2 g 11/0 matte opaque bronze round seed beads (C); antique brass 5-loop magnetic slide clasp.

Pumpkin Version: ninety-four 3 mm gold lustered African sunset magatama seed beads (E); one hundred eighty-eight 11/0 alabaster with copper lining round seed beads (D); fabric stiffener; rust-proof pins; wax paper; ten 4 mm gold jump rings; gold 5-loop magnetic slide clasp; needle-nose pliers.

GAUGE

Wire Version: 11 sts by 16 rows = 1¾" × 6¾" (4.5 × 17 cm) in wire stitch pattern.

Aqua Version: 11 sts by 16 rows = 2") × 7¼" (5 × 18.5 cm) in aqua stitch pattern.

Pumpkin Version: 13 sts by 18 rows = 2" × 7¼" (5 × 18.5 cm) in pumpkin stitch pattern.

STITCH GUIDE

Tunisian Simple Stitch (TSS): Insert hook from right to left into front vertical bar of next st and pull up a loop.

Tunisian Knit Stitch (TKS): Insert hook from front to back between front and back vertical bar of next st (under horizontal bars), yo, and pull up a loop.

"Work lps off as normal": Yo, pull through 1 loop on hook, *yo, pull through 2 loops on hook; rep from * to end.

Tunisian Extended Stitch (TES): TSS in next st, ch 1.

Tunisian Double Extended Stitch (TDES): TSS in next st, ch 2.

Tunisian Double Extended Knit Stitch (TDEKS): TKS in next st, ch 2.

WIRE VERSION

With Size 0 (2.55 mm) hook and wire, ch 11.

Row 1: (RS) : (Fwd) Pull up loop in 2nd ch from hook and ea ch across. Rtn: Work loops off normally—11 sts.

Row 2: (Fwd) Ch 1 (counts as first st), *TSS in next st, ch 1; rep from * across. Rtn: Work loops off normally.

Row 3: (Fwd) Ch 2 (counts as first st), *TSS in next st, ch 1; rep from * across. Rtn: Work loops off normally.

Rep Rows 2–3 six times, Rep Row 2 once more.

Last Row: Sl st in vert bar of next st and ea st across, fasten off.

AQUA VERSION

Thread on all recycled seed beads onto aqua thread, ch 11 with F-5 (3.75 mm) hook.

Row 1: (RS) (Fwd) Pull up loop in 2nd ch from hook and ea across. Rtn: Work loops off normally—11 sts.

Row 2: (Fwd) Ch 2 (counts as 1st st), *TKS in next st, ch 1, slide bead to hook, ch 1 (**Note:** sometimes you might have to help the bead pop onto the larger strand by gently pushing it forward after you chain. Most will naturally fall into place.), tdeks in next st; rep from * across to last 2 sts, TKS in next st, ch 1, slide bead up, ch 1, tdes in last st. Rtn: Work loops off normally.

Row 3: (Fwd) Ch 2 (counts as 1st st), *Tdkes in next st, TKS in next st, ch 1, slide bead up, ch 1; rep from * across to last 2 sts, tdeks in next st, tdes in last st. Rtn: Work loops off normally.

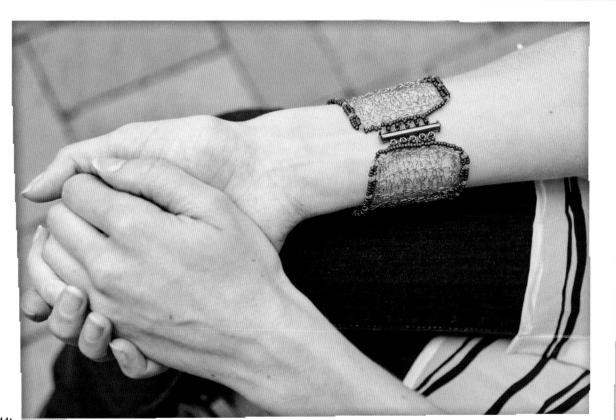

Rep Rows 2–3 six times, Rep Row 2 once more.

Last Row: Sl st in vert bar of next st and ea st across, do not fasten off.

PUMPKIN VERSION

Thread on all seed beads onto pumpkin thread in multiples of 1 E and 2 D, ch 13 with E/4 hook.

Row 1: (WS) Fwd Pull up loop in 2nd ch from hook and ea ch across. Rtn: Work loops off normally — 13sts.

Row 2: (Fwd) Ch 2 (counts as 1st st), *slide bead to hook, tdeks in next 2 sts; rep from * across to last 2 sts, slide bead up, tdeks in next st, tdes in last st. Rtn: Work loops off normally..

Row 3: (Fwd) Ch 2 (counts as 1st st), *Tdkes in next st, slide bead up, TDEKS in next st; rep from * across to last 2 sts, TDEKS in next st, TDES in last st. Rtn: Work loops off normally.

Rep Rows 2–3 seven times, Rep Row 2 once more.

Last Row: Sl st in vert bar of next st and ea st across, do not fasten off.

TECHNIQUE TIDBIT

Tunisian lace made with extended stitches can vary wildly by just changing your hook size, as you can see between the aqua and pumpkin cuffs. It can change by the material of your hook as well. If your hook is plastic or bamboo, sometimes the lace can be tighter because friction is making your thread cling to the hook a fraction more than if your hook is aluminum. With all that said, do not get frustrated. Look at it instead as a fun experiment with lots of possibilities for new avenues and project potential. Extended stitches in Tunisian lace are one of my favorites for using those truly unique hanks of yarn, too, since the single strand of yarn is really the star of the resulting fabric. Just imagine the stitch pattern for the cuff with a larger hook, beads, and bulky yarn; sounds like a recipe for an amazing shawl to me!

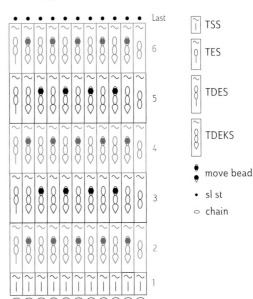

WIRE STITCH

PUMPKIN STITCH

AQUA STITCH

TSS	
TES	
TDES	
TDEKS	
move bead	
sl st	
chain	

ASSEMBLY
WIRE VERSION

Edge cuff with seed beads by joining beading thread to edge of cuff.

Rnd 1: Thread on 1 B, pass through edge of cuff and back through B, *thread on 5 A 1 B, pass through edge of cuff and back through B, rep from * evenly along long edge. Thread on 4 A, pass through edge of cuff and back through last A; rep across short edge. Rep around cuff.

Rnd 2: Pass through B, *thread on 5 A, pass through B; rep from * across long edge. Pass through 7 A on short edge, **thread on 2 A, pass through 1 clasp loop, thread on 2 A, pass through 1 A on short edge, pass through all once more, pass through 2 A on short edge; rep from ** for all clasp loops, pass through rest of A on short edge. Rep from the beginning around the remaining cuff. Fasten off and weave in the end.

AQUA VERSION

Edge cuff with sc by sc evenly along long edge, 3 sc in corner, sc in ea sc across short edge, 3 sc in corner, rep around, sl st to first sc, fasten off. Pin cuff to schematic size on top of wax paper, gently spray cuff with fabric stiffener to block and allow to dry.

Edge cuff with seed beads by joining beading thread to edge of cuff.

Rnd 1: Thread on 1 C, pass through edge of cuff and back through C, *thread on 4 C, pass through edge of cuff and back through last C, rep from * evenly along long edge. Rep around cuff.

Rnd 2: Pass through 4 C, *thread on 3 C, skip 1 C below, pass through 7 C; rep from * across long edge. Thread on 4 C at corner, skip 1 C at corner, pass through 4 C on short edge, thread on 3 C, skip 1 C below, pass through 3 C, **thread on 2 C, pass through 1 clasp loop, thread on 2 C, pass through 1 C on short edge, pass through all once more, pass through 2 C on short edge; rep from ** for all clasp loops, pass through 3 C on short edge, thread on 3 C, skip 1 C below, pass through 4 C, thread on 4 C at corner, skip 1 C at corner. Rep from the beginning around the remaining cuff. Fasten off and weave in the end.

PUMPKIN VERSION

Edge cuff with sc by sc evenly along long edge, 3 sc in corner, sc in ea sc across short edge, 3 sc in corner, rep around, sl st to first sc, fasten off. Pin cuff to schematic size on top of wax paper, gently spray cuff with fabric stiffener to block and allow to dry. Join slide clasp to short edge with jump rings.

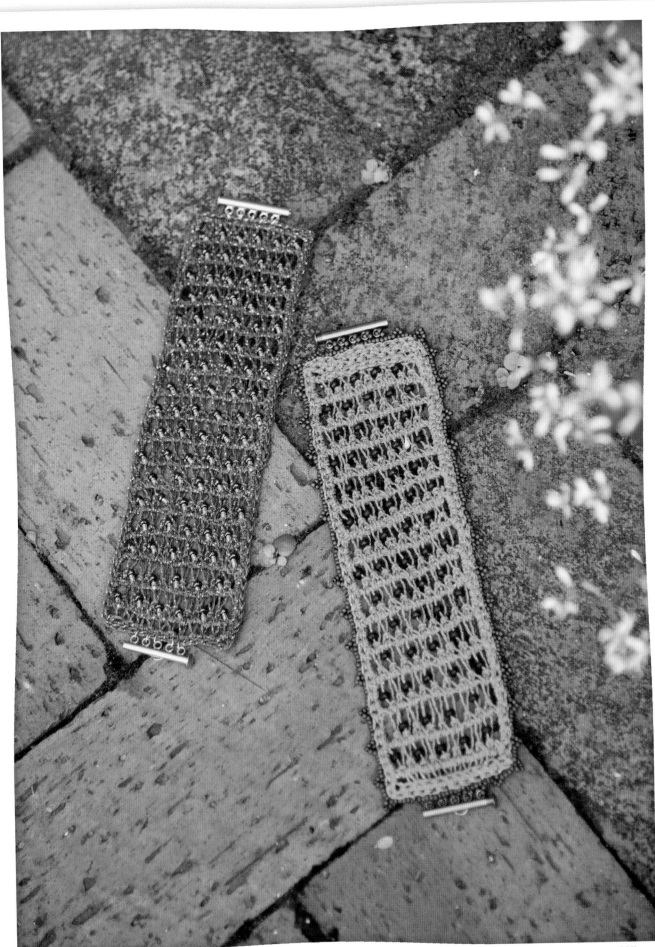

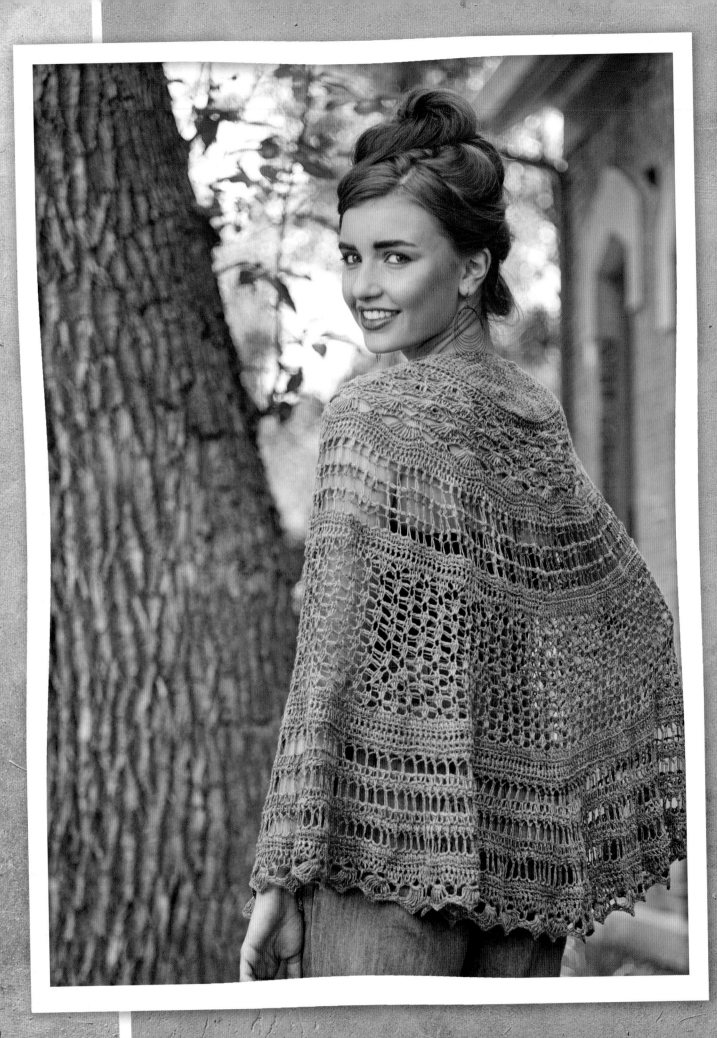

Yasmine shawl

REBECCA VELASQUEZ

This "sampler" shawl was born from my desire to test the limits of Tunisian lace. Not designed to be easy, this shawl includes short-row shaping, multiple lace patterns, and increases within the lace stitches. Push your limits with this challenging and gratifying shawl.

FINISHED MEASUREMENTS
66" (168 cm) wide and 28" (71 cm) long.

YARN
Fingering Weight (#0 Lace).

Shown here: Anzula Breeze (65% silk, 35% linen; 750 yd [686 m]/ 4 oz [113 g]): Prudence, 1 hank.

HOOK
Size I-9 (5.5 mm) Tunisian hook with 18" (45.5 cm) cable and J-10 (6 mm) hook. *Adjust hook size if necessary to obtain the correct gauge.*

NOTIONS
Locking stitch markers; tapestry needle for assembly and weaving in the ends.

GAUGE
Not essential for this pattern

STITCH GUIDE

Extended cluster (Ecl): [yo, insert hook into st indicated as if to TKS, pull up a loop] twice, yo, draw through 4 lps on hook.

Extended cluster increase (Eclinc): [yo, insert hook into st indicated as if to TKS, pull up a loop] twice, yo, draw through 4 lps on hook, ch 1, [yo, insert hook into same st as Ecl just made as if to TKS, pull up a loop] 2 times, yo, draw through 4 lps on hook, (2 lps made).

Edge stitch (ES): Insert hook into vertical bar and second vertical strand of last st, pull up a loop.

Extended tunisian knit stitch (eTKS): Insert hook into stitch indicated as if to TKS, pull up a loop, yo, draw through 1 loop on hook.

Inc: draw up a loop in space indicated.

Tunisian simple stitch (TSS): see Techniques.

Tunisian knit stitch: see Techniques.

Tunisian knit stitch (TKS): see Techniques.

Tunisian purl stitch (TPS): see Techniques.

Tunisian simple stitch 2 together (TSS-2Tog): Insert hook under next 2 vertical bars and draw up a loop.

Tunisian simple Single crochet (TSSc): insert hook under two horizontal bars before next vertical bar, pull up a loop.

7-loop fan (7fan): Insert hook as if to TSS into stitch indicated, pull up a loop, yo, draw through loop [insert hook as if to TSS into same st as prev st, pull up a loop, yo, draw through loop] 6 times, (7 lps made).

7-extended TKS fan (7eTKSfan): Insert hook as if to TKS into stitch indicated, pull up a loop, yo, draw through loop [insert hook as if to TKS into same st as prev st, pull up a loop, yo, draw through loop] 6 times, (7 lps made).

5-extended TKS fan (5eTKSfan): Insert hook as if to TKS into stitch indicated, pull up a loop, yo, draw through loop [insert hook as if to TKS into same st as prev st, pull up a loop, yo, draw through loop] 4 times, (5 lps made).

double eyelet increase (5W): Insert hook into stitch indicated, pull up a loop, [yo, insert hook into same st as prev st, pull up a loop] twice (5 lps made).

single eyelet increase (3W): Insert hook into stitch indicated, pull up a loop, yo, insert hook into same st as prev st, pull up a loop (3 lps made).

9-loop fan (9fan): Insert hook as if to TSS into stitch indicated, pull up a loop, yo, draw through loop [insert hook as if to TSS into same st as prev st, pull up a loop, yo, draw through loop] 8 times, (9 lps made).

"Work Lps off as normal": Yo, pull through 1 loop on hook, *yo, pull through 2 lps on hook; rep from * to end.

NOTES

The first vertical bar below the live loop at the beginning of the row is not worked into, but it is counted in the total stitch count.

SECTION A

Row 1: (Fwd) Ch 31, TSS in 2nd ch from hook and in each ch across. Rtn: Yo, pull through 1 loop, [yo, pull through 2 lps] 13 times, [ch 1, yo, draw through 2 lps] 4 times, [yo, draw through 2 lps] 13 times.

Row 2: (Fwd) TSS in next vertical bar (2 lps on hook), leave rem sts unworked; Rtn: Work lps off normally.

Row 3: ES in first st, TSS in next st of row below (3 lps on hook), leave rem sts unworked; Rtn: Work lps off normally.

Row 4: TSS in next st, ES in next st, TSS in next st of row below (4 lps on hook), leave rem sts unworked; Rtn: Work lps off normally.

Row 5: TSS in next 2 sts, ES in next st, TSS in next st of row below (5 lps on hook), leave rem sts unworked; Rtn: Work lps off normally.

Row 6: TSS in next 3 sts, ES in next st, TSS in next st of row below (6 lps on hook), leave rem sts unworked; Rtn: Work lps off normally.

Row 7: TSS in next 4 sts, ES in next st, TSS in next st of row below (7 lps on hook), leave rem sts unworked; Rtn: Work lps off normally.

Row 8: TSS in next 5 sts, ES in next st, TSS in next st of row below (8 lps on hook), leave rem sts unworked; Rtn: Work lps off normally.

Row 9: TSS in next 6 sts, ES in next st, TSS in next st of row below (9 lps on hook), leave rem sts unworked; Rtn: Work lps off normally.

Row 10: TSS in next 7 sts, ES in next st, TSS in next st of row below (10 lps on hook), leave rem sts unworked; Rtn: Work lps off normally.

Row 11: TSS in next 8 sts, ES in next st, TSS in next st of row below (11 lps on hook), leave rem sts unworked; Rtn: Work lps off normally.

Row 12: TSS in next 9 sts, ES in next st, TSS in next st of row below (12 lps on hook), leave rem sts unworked; Rtn: Work lps off normally.

Row 13: TSS in next 10 sts, ES in next st, TSS in next st of row below (13 lps on hook), leave rem sts unworked; Rtn: Work lps off normally.

Row 14: TSS in next 5 sts, (6 lps on hook), leave rem sts unworked; Rtn: Work lps off normally.

Row 15: TSS in next 4 sts, ES in next st, TSS in next st of row below (7 lps on hook), leave rem sts unworked; Rtn: Work lps off normally.

Row 16: TSS in next 5 sts, ES in next st, TSS in next st of row below (8 lps on hook), leave rem sts unworked; Rtn: Work lps off normally.

Row 17: TSS in next 6 sts, ES in next st, TSS in next st of row below (9 lps on hook), leave rem sts unworked; Rtn: Work lps off normally.

Row 18: TSS in next 7 sts, ES in next st, TSS in next st of row below, TSS in next 2 sts, ES in next st, TSS in next st of row below (14 lps on hook), leave rem sts unworked; Rtn: Work lps off normally.

Row 19: TSS in next 12 sts, sk ES, inc in ch-1 sp, (14 lps on hook), leave rem sts unworked; Rtn: Work lps off normally.

Row 20: TSS in next 3 sts, (4 lps on hook), leave rem sts unworked; Rtn: Work lps off normally.

Row 21: TSS in next 2 sts, ES in next st, TSS in next st of row below (5 lps on hook), leave rem sts unworked; Rtn: Work lps off normally.

Row 22: TSS in next 3 sts, ES in next st, TSS in next st of row below (6 lps on hook), leave rem sts unworked; Rtn: Work lps off normally.

Row 23: TSS in next 4 sts, ES in next st, TSS in next st of row below (7 lps on hook), leave rem sts unworked; Rtn: Work lps off normally.

Row 24: TSS in next 5 sts, ES in next st, TSS in next st of row below, TSS in next 5 sts, sk ES, inc in same ch-1 sp as previous inc, (14 lps on hook), leave rem sts unworked; Rtn: Work lps off normally.

Row 25: TSS in next 12 sts, sk ES, TKS in next st of row below (14 lps on hook), leave rem sts unworked; Rtn: Work lps off normally.

Row 26: TSS in next 12 sts, sk ES, inc in next ch-1 sp of row below (14 lps on hook), leave rem sts unworked; Rtn: Work lps off normally.

Row 27: TSS in next 6 sts, (7 lps on hook), leave rem sts unworked; Rtn: Work lps off normally.

Row 28: TSS in next 5 sts, (6 lps on hook), leave rem sts unworked; Rtn: Work lps off normally.

Row 29: TSS in next 4 sts, (5 lps on hook), leave rem sts unworked; Rtn: Work lps off normally.

Row 30: TSS in next 3 sts, (4 lps on hook), leave rem sts unworked; Rtn: Work lps off normally.

Row 31: TSS in next 2 sts, ES in next st, [ES in row below] 3 times, TSS in next st of row below, TSS in next 5 sts, sk ES, inc in same ch-1 sp as previous inc, (14 lps on hook), leave rem sts unworked; Rtn: Work lps off normally.

Row 32: TSS in next 12 sts, sk ES, TKS in next st of row below (14 lps on hook), leave rem sts unworked; Rtn: Work lps off normally.

Row 33: TSS in next 12 sts, sk ES, inc in next ch-1 sp, (14 lps on hook), leave rem sts unworked; Rtn: Work lps off normally.

Row 34: TSS in next 3 sts, (4 lps on hook), leave rem sts unworked; Rtn: Work lps off normally.

Row 35: TSS in next 2 sts, ES in next st, TSS in next st of row below (5 lps on hook), leave rem sts unworked; Rtn: Work lps off normally.

Row 36: TSS in next 3 sts, ES in next st, TSS in next st of row below (6 lps on hook), leave rem sts unworked; Rtn: Work lps off normally.

Row 37: TSS in next 4 sts, ES in next st, TSS in next st of row below (7 lps on hook), leave rem sts unworked; Rtn: Work lps off normally.

TECHNIQUE TIDBIT

Borrowing elements from both knitting and crochet, Tunisian crochet is a fun and unique experience. The ease and speed of crochet with the ability to create knit-like fabrics, makes Tunisian crochet a very useful and enjoyable skill. Personally, I have found the most interesting attribute of Tunisian crochet to be the ability to alter the look of each stitch with subtle changes in either the "forward" or "return" pass. The traditional afghan stitch is only the beginning of this amazing technique. Tunisian Simple Stitch. These are classic stitches that give you a modern style.

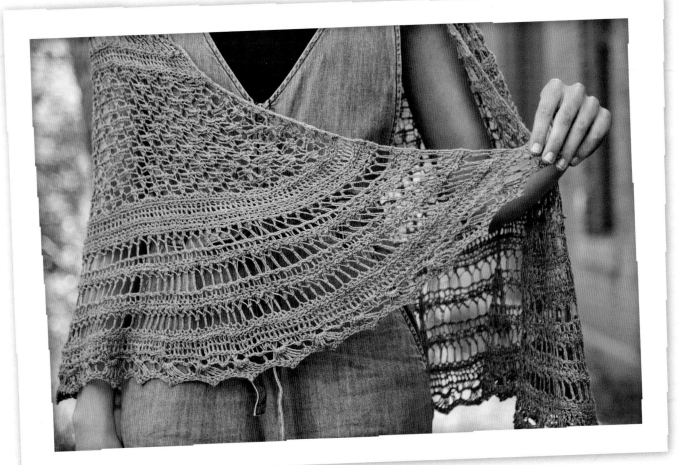

Row 38: TSS in next 5 sts, ES in next st, TSS in next st of row below, TSS in next 5 sts, sk ES, inc in same ch-1 sp as prev inc, (14 lps on hook), leave rem sts unworked; Rtn: Work lps off normally.

Row 39: TSS in next 12 sts, TKS in next st of row below (14 lps on hook), leave rem sts unworked; Rtn: Work lps off normally.

Row 40: TSS in next 12 sts, sk ES, inc in next ch-1 sp of row below (14 lps on hook), leave rem sts unworked; Rtn: Work lps off normally.

Row 41: TSS in next 6 sts, (7 lps on hook), leave rem sts unworked; Rtn: Work lps off normally.

Row 42: TSS in next 5 sts, (6 lps on hook), leave rem sts unworked; Rtn: Work lps off normally.

Row 43: TSS in next 4 sts, (5 lps on hook), leave rem sts unworked; Rtn: Work lps offnormally.

Row 44: TSS in next 3 sts, (4 lps on hook), leave rem sts unworked; Rtn: Work lps off normally.

Row 45: TSS in next 2 sts, ES in next st, (ES in next st of row below) 3 times, TSS in next st of row below, TSS in next 5 sts, inc in same ch-1 sp as previous inc, (14 lps on hook), leave rem sts unworked; Rtn: Work lps off normally.

Row 46: TSS in next 12 sts, sk ES, TSS in next st of row below (14 lps on hook), leave rem sts unworked; Rtn: Work lps off normally.

Row 47: TSS in next 8 sts, (9 lps on hook), leave rem sts unworked; Rtn: Work lps off normally.

Row 48: TSS in next 7 sts, (8 lps on hook), leave rem sts unworked; Rtn: Work lps off normally.

Row 49: TSS in next 6 sts, (7 lps on hook), leave rem sts unworked; Rtn: Work lps off normally.

Row 50: TSS in next 5 sts, ES in next st, (ES in next st of row below) 2 times, TSS in next st of row below, TSS in next 3 sts, sk ES, TSS in next st of row below (14 lps on hook), leave rem sts unworked; Rtn: Yo, pull through 1 loop, yo, pull through 2 lps (13 times).

Row 51: TSS in next 12 sts, sk ES, TSS in next st of row below = 14 lps; Rtn: Work lps off normally.

Row 52: TSS in next 10 sts, TSS2Tog, sk ES, TSS in next st of foundation row, (13 lps on hook); Rtn: [yo, pull through 2 lps] 12 times.

Row 53: TSS in next 9 sts, TSS2Tog, sk ES, TSS in next st of foundation row, (12 lps on hook); Rtn: [yo, pull through 2 lps] 11 times.

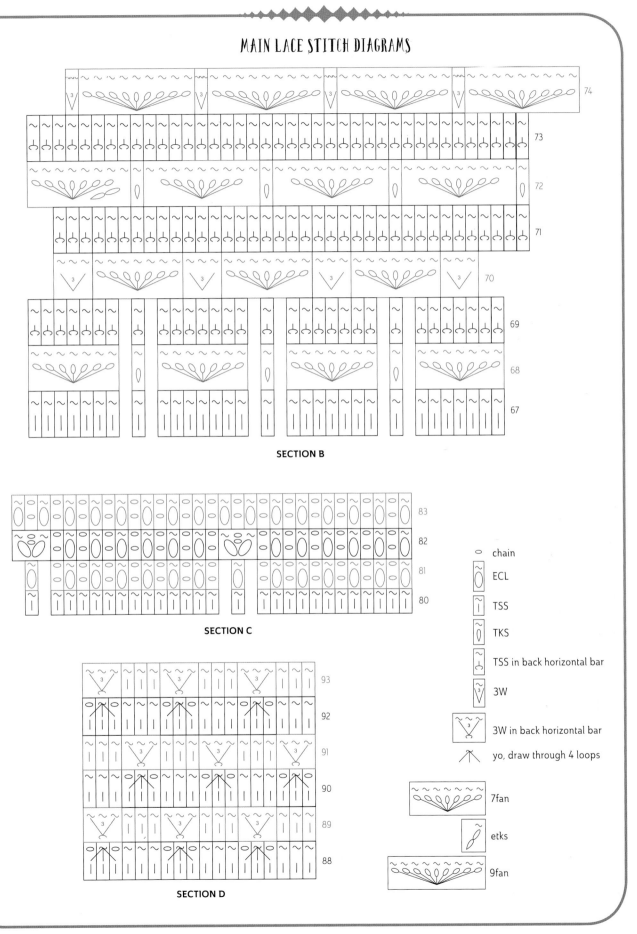

SECTION B

SECTION C

SECTION D

⬭	chain
⬓	ECL
~ / I	TSS
~ / ⬭	TKS
~ / ∪	TSS in back horizontal bar
~ / ₃V	3W
⌄₃	3W in back horizontal bar
⋏	yo, draw through 4 loops
7fan	7fan
etks	etks
9fan	9fan

Row 54: TSS in next 8 sts, TSS2Tog, sk ES, TSS in next st of foundation row, (11 lps on hook); Rtn: [yo, pull through 2 lps] 10 times.

Row 55: TSS in next 7 sts, TSS2Tog, sk ES, TSS in next st of foundation row, (10 lps on hook); Rtn: [yo, pull through 2 lps] 9 times.

Row 56: TSS in next 6 sts, Ts2Tog, sk ES, TSS in next st of foundation row, (9 lps on hook); Rtn: [yo, pull through 2 lps] 8 times.

Row 57: TSS in next 5 sts, TSS2Tog, sk ES, TSS in next st of foundation row, (8 lps on hook); Rtn: [yo, pull through 2 lps] 7 times.

Row 58: TSS in next 4 sts, TSS2Tog, sk ES, TSS in next st of foundation row, (7 lps on hook); Rtn: [yo, pull through 2 lps] 6 times.

Row 59: TSS in next 3 sts, TSS2Tog, sk ES, TSS in next st of foundation row, (6 lps on hook); Rtn: [yo, pull through 2 lps] 5 times.

Row 60: TSS in next 2 sts, TSS2Tog, sk ES, TSS in next st of foundation row, (5 lps on hook); Rtn: [yo, pull through 2 lps] 4 times.

Row 61: TSS in next 1 sts, TSS2Tog, sk ES, TSS in next st of foundation row, (4 lps on hook); Rtn: [yo, pull through 2 lps] 3 times.

Row 62: TSS2Tog, TSS in next st of foundation row, (3 lps on hook); Rtn: Yo, pull through 2 lps [twice].

Row 63: TSS2Tog by inserting hook as if to TSS in next st, insert hook as if to ES in last st of foundation row, draw up a loop, (2 lps on hook); Rtn: Yo, pull through 2 lps.

Row 64: ES into foundation chain, (2 lps on hook); Rtn: Yo, pull through 2 lps, turn.

SECTION B

Row 65: (WS facing you) Pull up loop in flp of each st across, TSS in edge st, (65 lps on hook); Rtn: Work lps off normally.

Row 66: (WS) Ch 1, sc in 2 horizontal strands before next st, sc between front and back vertical lps of next st, [sc in 2 horizontal strands before next st] 63 times, sc between vertical lps of last st = 66 sc, turn.

Row 67: (RS) Insert hook under both lps of sc, TSS in each sc across, (67 lps on hook); Rtn: Work lps off normally.

Row 68: TSS in vertical bar of first edge stitch, TSS in next st, [sk 3 sts, 7fan in next st, sk 3 sts, TKS in next st] 7 times, sk 3 sts, 7fan in next st, sk 3 sts, TSS, ES in next st, TSS into side of same st as ES just made, (69 lps on hook); Rtn: Work lps off normally.

Row 69: TSS in next 2 sts, [with RS facing, insert hook in top of back bar on WS of work, pull up a loop] 63 times across to last 3 sts, TSS in next 2 sts, ES in next st, (69 lps on hook); Rtn: Work lps off normally.

Row 70: TSS in next 2 sts, 5W in space before next st, [sk 3 sts, 3W in next st, sk 3 sts, 7fan in next st] 7 times, sk 3 sts, 3W in next st, sk 3 sts, 5W in space before next st, TSS2Tog, ES in next st, TSS into side of same st as ES just made, (89 lps on hook); Rtn: Work lps off normally.

Row 71: TSS in next 2 sts, [with RS facing, insert hook in top of back bar on WS of work, pull up a loop] 83 times, TSS2Tog, ES in next st, TSS into side of same st as ES just made, (89 lps on hook); Rtn: Work lps off normally.

Row 72: TSS in next 2 sts, TKS in next st, sk next st, TKS in next st, sk 2 sts, [eTKS in next st, 7 fan in next st, eTKS in next st, sk 3 sts, TKS, sk 3 sts] 7 times, eTKS in next st, 7fan in next st, eTKS in next st, sk 2 sts, TKS in next st, sk next st, TKS in next st, TSS2Tog, ES in next st, TSS into side of same st as ES just made, (89 lps on hook); Rtn: Work lps off normally.

Row 73: TSS in next 2 sts [with RS facing, insert hook in top of back bar on WS of work, pull up a loop] 83 times, TSS2Tog, ES in next st, TSS into side of same st as ES just made, (89 lps on hook); Rtn: Work lps off normally.

Row 74: TSS in next 2 sts, sk next st, 5fan in next st, (sk 4 sts, 3W in next st, sk 4 sts, 9fan in next st) 7 times, sk 4 sts, 3W in next st, sk 4 sts, 5fan in next st, sk next st, TSS2Tog, ES in next st, TSS into side of same st as ES just made, (103 lps on hook); Rtn: Work lps off normally.

Row 75: TSS in next 2 sts, [with RS facing, insert hook in top of back bar on WS of work, pull up a loop] 97 times, TSS2Tog, ES in next st, TSS into side of same st as ES just made, (103 lps on hook); Rtn: Work lps off normally.

Row 76: TSS in next 2 sts, [5W in next st, sk 4 sts, eTKS in next st, 9fan in next st, eTKS in next st, sk 4 sts] 8 times, 5W in next st, TSS2Tog, ES in next st, TSS into side of same st as ES just made, (139 lps on hook); Rtn: Work lps off normally.

Row 77: TSS in next 2 sts, [with RS facing, insert hook in top of back bar on WS of work, pull up a loop] 132 times, TSS2Tog, ES in next st, TSS into side of same st as ES just made, (139 lps on hook); Rtn: Work lps off normally.

SECTION C

Switch to traditional J-10 (6 mm) hook.

Row 78: Sl st in each front vertical loop across, turn—138 sts. Use I-9 (5.5 mm) Tunisian hook.

Row 79: Ch 1, sc in flp of each slst across, turn.

Row 80: Pull up a loop in each sc across and in last ch (140 lps on hook); Rtn: Work lps off normally.

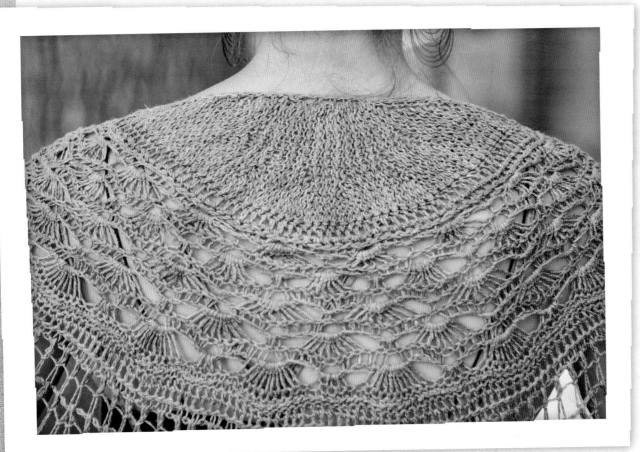

Row 81: Ch 2, Ecl in first st, ch 1, [sk next st, Ecl in next st, ch 1] 69 times, yo, insert hook in side edge of last st, pull up a loop, yo, pull through 2 lps, ch 1, (71 lps on hook); Rtn: Yo, pull through 1 loop, [yo, pull through 2 lps, ch 1] 70 times, yo, pull through 2 lps.

Row 82: Ch 2, Ecl in first st, ch 1, [sk ch-1 sp, Ecl in next st, ch 1] 5 times, Eclinc in next st,
*[sk ch-1 sp, (Ecl in next st, ch 1) 6 times, Eclinc in next st, ch 1] 3 times**,
[sk ch-1 sp, Ecl in next st, ch 1] 7 times, Ecl into ch-1 sp, ch 1, [Ecl in next st, ch 1, sk ch 1 sp] 7 times, Eclinc in next st, ch 1, rep from * to **, [sk ch-1 sp, Ecl in next st, ch 1] 5 times, yo, insert hook in side edge of last st, pull up a loop, yo, pull through 2 lps, ch 1, (81 lps on hook); Rtn: Yo, pull through 1 loop, [yo, pull through 2 lps, ch 1] 79 times, yo, pull through 2 lps.

Row 83: Ch 2, Ecl in first st, ch 1, [sk ch-1 sp, Ecl in next st, ch 1] 77 times, yo, insert hook in side edge of last st, pull up a loop, yo, pull through 2 lps, ch 1, (80 lps on hook); Rtn: Yo, pull through 1 lp, [yo, pull through 2 lps, ch 1] 79 times, yo, pull through 2 lps.

SECTION D

Row 84: TKS in vertical bar of first edge stitch, [TSS in next st, pull up a lp in back horizontal strand before next st] 78 times, ES in last st, (159 lps on hook); Rtn: Work lps off normally. Use traditional J-10 (6 mm) hook.

Row 85: Ch 1, sl st in each vertical loop across, turn—158 sts. Use I-9 (5.5 mm) Tunisian hook.

Row 86: Ch 1, sc in flp of each sl st across, turn—158 sc.

Row 87: Pull up a lp each sc across, insert hook in side edge of last st, pull up a lp (159 lps on hook); Rtn: Work lps off normally.

Row 88: TSS in each st across to last st, ES in next st, TSS into side of same st as ES just made, (159 lps on hook); Rtn: Ch 1, [yo, pull through 2 lps] 5 times, [ch 1, yo, pull through 4 lps, ch 1, (yo, pull through 2 lps) 3 times] 24 times, ch 1, yo, pull through 4 lps, ch 1, [yo, pull through 2 lps] 6 times.

Row 89: TSS in first vertical bar (increase made), TSS in next 5 sts, [sk ch 1, 3W in back horizontal strand of next st, sk ch 1, TSS in each of next 3 sts] 24 times, sk ch 1, 3W in back horizontal strand of next st, sk ch 1, TSS in next 5 sts, ES in next st, TSS into side of the same st as ES just made(inc made, 161 lps on hook); Rtn: Ch 1, [yo, pull through 2 lps 6 times, [ch 1, yo, pull through 2 lps) 3 times, ch 1, yo, pull through 4 lps] 24 times, ch 1, (yo, pull through 2 lps) 3 times, ch 1, [yo, pull through 2 lps] 7 times.

Row 90: TSS in next 6 sts, 3W in ch-1 sp, TSS in next 3 sts, [3W in back horizontal strand of next st, TSS in next 3 sts] across to last ch sp, 3W in ch-1 sp, TSS in each st across to last 3 sts, TSS-2Tog, ES in next st, TSS into side of same st as ES just made, (167 lps on hook); Rtn: Yo, pull through 1 lp, ([yo, pull through 2 lps] 3 times, [ch 1, yo, pull through 4 lps, ch 1, (yo, pull through 2 lps) 3 times] across, ending with yo, pull through last 2 lps.

Row 91: TSS in first vertical bar (inc made), TSS in next 4 sts, [3W in back horizontal strand of next st, TSS in next 3 sts] 26 times, 3W in next st, TSS in next 3 sts, ES in next st, TSS into side of same st as ES just made (inc made, 169 lps on hook); Rtn: Yo, pull through 1 loop, [yo, pull through 2 lps] 4 times, ch 1, [yo, pull through 2 lps] 3 times, [ch 1, yo, pull through 4 lps, ch 1, (yo, pull through 2 lps) 3 times] across to last 5 sts, ch 1, [yo, pull through 2 lps] 5 times.

Row 92: TSS in next 4 sts, 3W in next ch sp, TSS in next 3 sts, [sk ch sp, 3W in next st, sk ch sp, TSS in next 3 sts] across to last ch sp, 3W in ch sp, TSS in next 2 sts, TSS2Tog, ES in next st, TSS into side of same st as ES just made(175 lps on hook); Rtn: Yo, pull through 1 lp, [yo, pull through 2 lps] 8 times, ch 1, yo, pull through 4 lps, ch 1, [(yo, pull through 2 lps) 3 times, ch 1, yo, pull through 4 lps, ch 1] across to last 8 sts, [yo, pull through 2 lps] 8 times.

Row 93: TSS in first vertical bar (inc made), TSS in next 8 sts, [sk ch sp, 3W in next st, sk ch sp, TSS in next 3 sts] across to last 5 sts, TSS in next 2 sts, TSS2Tog, ES in last st, TSS in side of same st as ES just made (inc made, 177 lps on hook); Rtn: Yo, pull through 1 loop, [yo, pull through 2 lps] 2 times, [ch 1, (yo, pull through 2 lps) 3 times, ch 1, yo, pull through 4 lps] across to last 6 sts, [yo, pull through 2 lps] 3 times, ch 1, [yo, pull through 2 lps] 3 times.

Row 94: TSS in next 2 sts, 3W in first ch sp, [TSS in next 3 sts, sk ch sp, 3W in next st, sk ch sp] across to last 6 sts, TSS in next 3 sts, 3W in last ch sp, TSS2Tog, ES in last st, TSS in side of same st as ES just made (183 lps on hook); Rtn: Ch 1, [yo, pull through 2 lps] 5 times, ch 1, yo, pull through 4 lps, ch 1, [(yo, pull through 2 lps) 3 times, ch 1, yo, pull through 4 lps, ch 1] across to last 6 sts, [yo, pull through 2 lps] 6 times.

Row 95: TSS in first vertical bar (inc made), TSS in next 3 sts, 3W under horizontal bars before next st, TSS in next 3 sts, [sk ch sp, 3W in next st, sk ch sp, TSS in next 3 sts] across to last 3 sts, 3W under horizontal bars before nest st, TSS in next 2 sts, ES in last st, TSS in side of same st as ES just worked (inc made, 191 lps on hook); Rtn: [Ch 1, (yo, pull through 2 lps) 3 times] twice, [ch 1, yo,

pull through 4 lps, ch 1, (yo, pull through 2 lps) 3 times] across to last 4 sts, ch 1, [yo, pull through 2 lps] 4 times.

Row 96: TSS in first vertical bar (inc made), TSS in next 4 sts, 3W in next ch sp, TSS in next 3 sts, [sk ch sp, 3W in next st, sk ch sp, TSS in next 3 sts] across to last ch sp, 3W in last ch sp, TSS in next 3 sts, ES in last st, TSS in side of same st as ES just worked (inc made, 199 lps on hook); Rtn: Ch 1, [yo, pull through 2 lps] 4 times, ch 1, [yo, pull through 2 lps] 3 times, [ch 1, yo, pull through 4 lps, ch 1, (yo, pull through 2 lps) 3 times] across to last 5 sts, ch 1, [yo, pull through 2 lps] 5 times.

Row 97: TSS in first vertical bar (inc made), TSS in next 2 sts, 3W under horizontal bars before next st, TSS in next 3 sts, 3W in first ch sp, [TSS in next 3 sts, sk ch sp, 3W in next st, sk ch sp] across, ending with 3W in last ch sp, TSS in next 3 sts, 3W under horizontal bars before next st, TSS in next st, ES in last st, TSS in side of same st as ES just worked (inc made, 205 lps on hook); Rtn: Ch 1, [yo pull through 2 lps] 5 times, [ch 1, yo, pull through 4 lps, (yo, pull through 2 lps) 3 times] across to last 6 lps, [yo, pull through 2 lps] 6 times.

Row 98: TSS in first 5 sts, [sk ch sp, 3W in next st, sk ch sp, TSS in next 3 sts] across to last 3 sts, TSS2Tog, ES in last st, TSS in side of same st as ES just worked; Rtn: Ch 1, [yo, pull through 2 lps] 5 times, ch 1, [[yo, pull through 2 lps] 3 times, ch 1, yo, pull through 4 lps, ch 1] across to last 6 sts, ch 1, [yo, pull through 2 lps] 6 times.

Row 99: TSS in first vertical bar (inc made), TSS in next 6 sts, 3W in first ch sp, [TSS in next 3 sts, sk ch sp, 3W in next st, sk ch sp] across ending with 3W in last ch-2, TSS in next 5 sts, ES in last st, TSS in side of same st as ES just worked (inc made, 213 lps on hook); Rtn: Ch 1 [yo, pull through 2 lps] 3 times, [ch 1, yo, pull through 4 lps, ch 1, (yo, pull through 2 lps) 3 times] across, ending with yo, pull through last 2 lps.

Row 100: TSS in next 2 sts, 3W under horizontal bars before next st, TSS in next st, TSS in back horizontal strand of next 2 sts, 3W in next ch sp, [TSS in next 3 sts, sk ch sp, 3W in next st, sk ch sp] across to last 10 sts, TSS in next 3 sts, 3W in next ch sp, TSS in back horizontal strand of next 2 sts, TSS in next st, 3W under horizontal bars before next st, TSS2Tog, ES in last st, TSS in side of same st as ES just worked (225 lps on hook); Rtn: Ch 1, [yo, pull through 2 lps] 5 times, [ch 1, yo, pull through 4 lps, ch 1, (yo, pull through 2 lps) 3 times] across to last 3 sts, [yo, pull through 2 lps] 3 times.

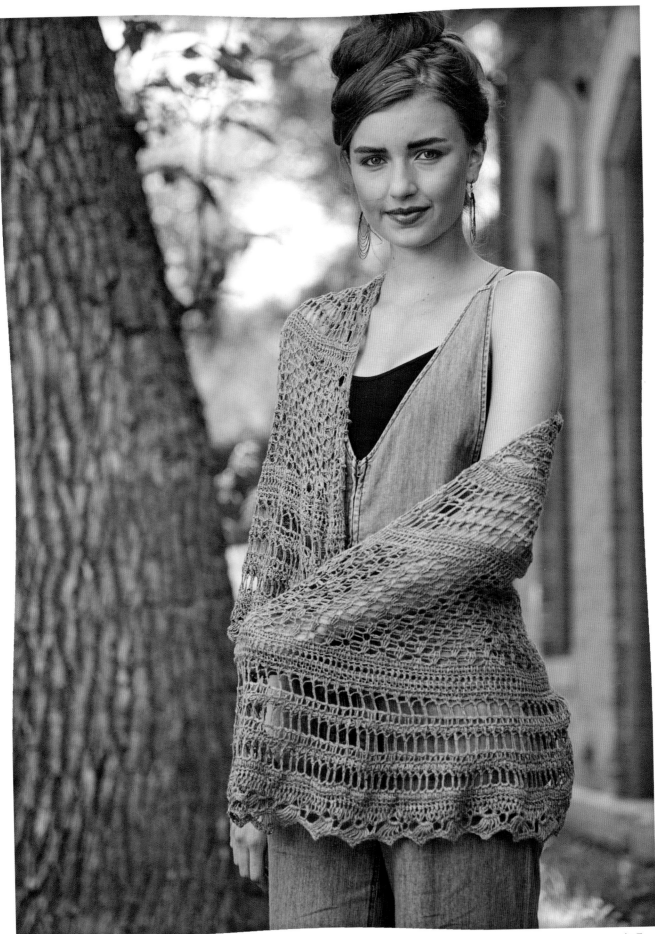

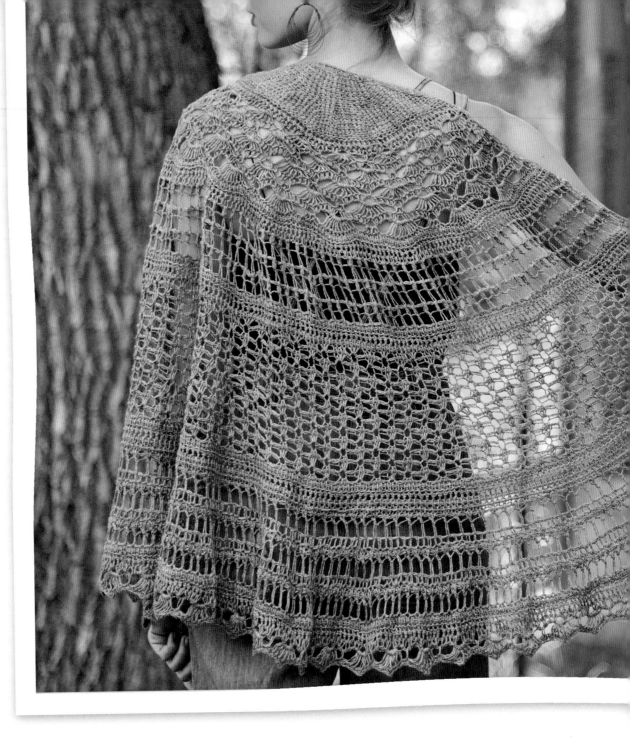

SECTION E

Row 101: TSS in next 3 sts, [TSS in next 3 sts, pull up a loop in back bar of next 3 sts] across to last 6 sts, TSS in next 3 sts, TSS2Tog, ES in next st, TSS into side of same st as ES just made (225 lps on hook); Rtn: Work lps off normally. Use traditional J-10 (6 mm) hook.

Row 102: Ch 1, sl st in first vertical loop and in each across, to last st, sl st in 2 side edge lps of last st, turn—225 sts. Use 1 Tunisian hook.

Row 103: With WS facing, ch 1, sc in flp of each sl st across to last st, sc in 2 side edge lps of last st, turn—226 sc.

Row 104: With RS facing, TSS in each sc across, (227 lps on hook); Rtn: Work lps off normally.

Row 105: TSS in first vertical loop, TSS across to last st, ES in last st, TSS into side of same st as ES just made, (229 lps on hook); Rtn: Work lps off normally.

Row 106: [TPS in next 56 sts, TPS under horizontal bars before next stitch, TPS in next st, TPS under horizontal bars before next st] 3 times, TPS in next 54 sts, TPS2tog, ES in next st, TSS into side of same st as ES just made, (235 lps on hook); Rtn: Work lps off normally.

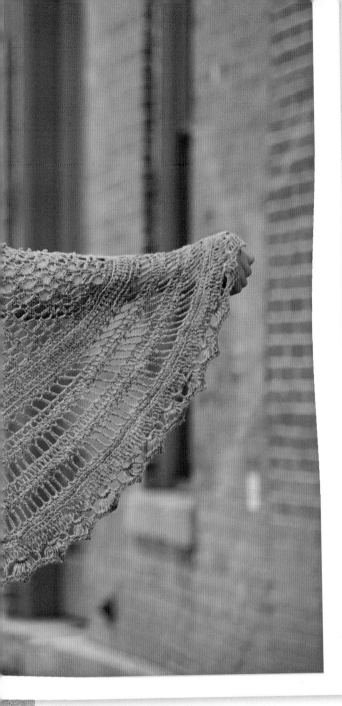

in back bar of next 2 sts, ES in last st (311 lps on hook); Rtn: Work lps off normally.

Row 110: Ch 2, [TSS2Tog, ch 2] 155 times, (156 lps on hook); Rtn: [yo, pull through 2 lps, ch 1] across, ending with yo, pull through 2 lps.

Row 111: [Pull up a loop in back bar of next ch, TSS in next st] across ending with ES in last st (311 lps on hook); Rtn: Work lps off normally.

Row 112: [Pull up a loop in back bar of next 4 sts, TSS in front vertical loop of same st as prev st used] 103 times, ES in next st, TSS in side of same st as ES just made, (415 lps on hook); Rtn: Work lps off normally.

Row 113: Ch 2, [TSS2Tog, ch 2] 207 times, (208 lps on hook); Rtn: [yo, pull through 2 lps, ch 1] across, ending with yo, pull through 2 lps.

Row 114: Pull up a loop in back bar of each st across, ES in next st, (415 lps on hook); Rtn: Work lps off normally.

SECTION F
Use traditional J-10 (6 mm) hook.

Row 115: Ch 1, sl st in each vertical loop across, to last st, ES in last st, turn—414 sl sts

Use I-9 (5.5 mm) Tunisian hook.

Row 116: With WS facing, ch 1, sc in flp of each sl st across, turn—414 sc.

Row 117: With RS facing, TSS in each sc across, ES in next st, TSS into side of same st as ES just made, (415 lps on hook); Rtn: Work lps off normally.

Row 118: Ch 2, TSS in next st, ch 1, 5 eTKSfan in next st, [sk 3 sts, 7 eTKSfan in next st, sk 3 sts, TKS in next st] 50 times, sk 3 sts, 7 eTKSfan, sk 3 sts, 5 eTKSfan in next st, TSS2Tog, ch 1, ES in last st (423 lps on hook); Rtn: Work lps off normally.

Row 119: Ch 1, sc in first vertical bar and in each of next 3 sts, 3 sc in next st, sc in next st, sc2tog over next 2 sts, sc in each of next 2 sts,[3 sc in next st, sc in each of next 2 sts, sc3tog over next 3 sts, sc in each of next 2 sts] 50 times, 3 sc in next st, sc in each of next 2 sts, sc2tog, sc in next st, 3 sc in next st, sc in each rem st. Fasten off.

BLOCKING
Weave in the ends carefully. Wet the block and pin for best results.

Row 107: Ch 2, [TSS2Tog, ch 2] 117 times, (118 lps on hook); Rtn: [yo, pull through 2 lps, ch 1] across, ending with yo, pull through 2 lps.

Row 108: Pull up a loop in back bar of next ch, TSS in next st, [(Pull up a loop in back bar of next ch, TSS in next st) 19 times, 3W in back bar of next ch, TSS in next st] 5 times, [Pull up a loop in back bar of next ch, TSS in next st] 18 times (244 lps on hook); Rtn: Work lps off normally.

Row 109: Pull up a loop in back bar of next 3 sts, [TSS in front vertical bar of same st as last st used, pull up a loop in back bar of next 4 sts, TSS in front vertical bar of same st as last st used, pull up a loop in back bar of next 3 sts] 34 times, pull up a loop

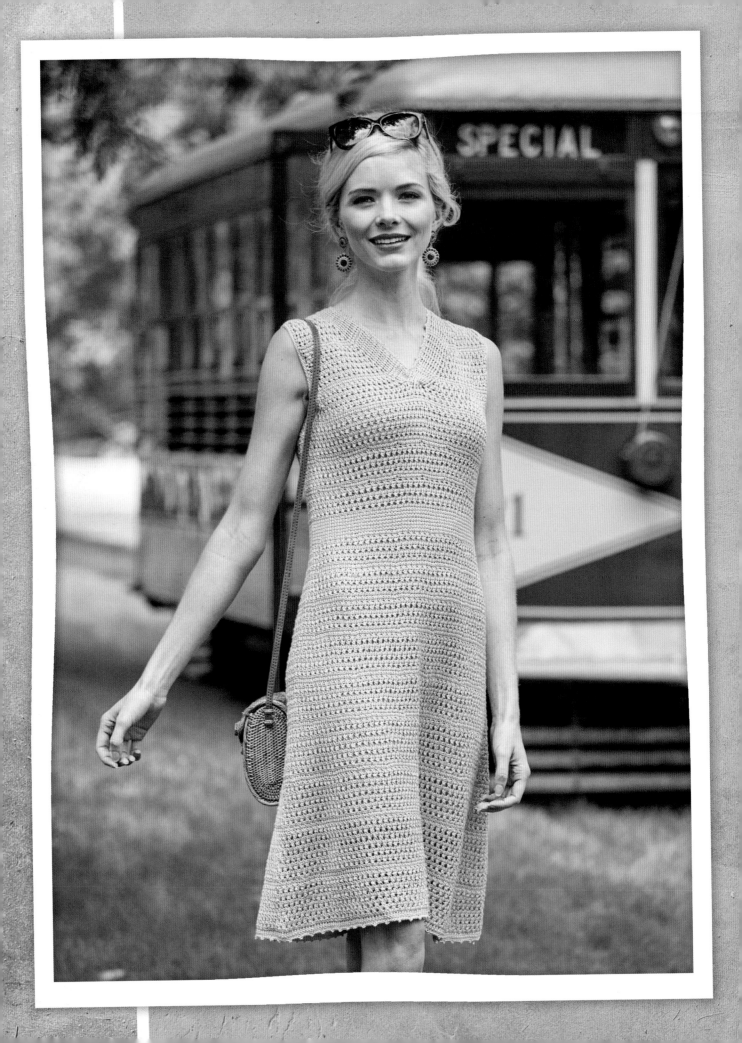

Cyrine Striped dress

MOON ELDRIDGE

This beautiful gold-color yarn gives the dress a fresh and summery feeling. The dress is based on Tunisian Double Crochet cross-stitch, and it is striped with Tunisian Simple Stitch. Classic stitches but they provide a modern style.

FINISHED MEASUREMENTS

Bust measurement is 36 (39, 42, 45, 48)" (91.5 [99, 106.5, 114.5, 122] cm) with a tight fit. Sized for XS (S, M, L, XL). Size shown is XS.

YARN

Fingering Weight (#1 Super fine.)

Shown here: Nazli Gelin Garden 5 (100% mercerized cotton; 174 yd [160 m]/ 1.75 oz [50 g]): #500-53 yellow: 9 (10, 11, 13, 15) balls.

HOOKS

Size G-6 (4 mm) Tunisian crochet single-ended cable hook 24" (1 cm) or longer; size G-6 (4 mm) standard crochet hook; size C-3 (2.75 mm) standard crochet hook. *Adjust hook size if necessary to obtain the correct gauge.*

NOTIONS

Locking stitch marker; tapestry needle for assembly and weaving in ends.

GAUGE

Diagonally across motif trefoil to trefoil = 4" (10 cm) with size G-6 (4 mm) hook.

16 sc by 20 rows= 4" × 4" (10 × 10 cm) with size G-7 (4.50 mm) hook.

22 sts by 10 rnds = 4" × 4" (10 × 10 cm) with size G-6 (4 mm) hook in TDCC sts.

STITCH GUIDE

Main body pattern (multiple of 4 sts)
Work TSS across foundation row.

Row 1: Ch 1 (counts as first TDC here and throughout), *TDCC in next 2 sts; rep from * across to last st, TDC in last st.

Row 2: Ch 1, TDC in next st, *TDCC in next 2 sts; rep from * across to last 2 sts, TDC in each of last 2 sts.

Rep Rows 1 and 2 the number of times indicated.

Row 3: *TSSC in next 2 sts; rep from * across to last st, TSS in last st.

Row 4: TSS across.

Make 1 increase (M1): Insert hook in horizontal strand between current and next vertical bars, yo, draw up a loop.

Picot (picot): Ch 3, sl st in front loop and Left Front vertical leg of stitch below first ch.

Tunisian Simple Stitch (TSS): Insert hook from right to left into front vertical bar of next st and pull up a loop.

Tunisian Double Crochet (TDC): Yo, insert hook from right to left into front vertical bar of next st and pull up a loop, [yo, pull through 2 loops on hook] twice.

Tunisian Simple Stitch 2 together (TSS2tog): Insert hook from right to left under next 2 vertical bars and pull up a loop.

Tunisian Double Crochet 2 together (TDC2Tog): Yo, insert hook from right to left under next 2 vertical bars and pull up a loop, [yo, pull through 2 loops on hook] twice.

Crossed Tunisian Simple Stitch (TSSC): Worked across 2 stitches; skip next vertical bar, insert hook from right to left into following front vertical bar, yo, pull up loop, bring hook in front of stitch just worked, insert hook from right to left in skipped vertical bar, yo, pull up loop.

Crossed Tunisian Double Crochet (TDCC): Worked across 2 stitches; skip next vertical bar, yo, insert hook from right to left into following front vertical bar, yo, pull up loop, [yo, pull through 2 loops] twice, reaching in front of stitch just worked, yo, insert hook from right to left in skipped vertical bar, [yo, pull through 2 loops] twice.

Tunisian Cable Join (TCJ): Bring end of cable to position parallel with hook and lay on front of work, yo around the end of the cable, from back to front, yo the hook, draw through a lp, yo around the end of the cable from back to front, leaving 2 lps on cable, *yo the hook, draw though 2 lps on hook, rep from* to last 5 lps on hook, sk the first 2 lps, with fingers, pinch 3rd lp and lift over last 2 lps to the right, making it the 5th lp on hook, hold in place so it does not return to 3rd position, yo, draw through first 4 lps on hook, yo, draw through last 2 lps. The loop with the stitch marker in it is the vertical bar of the next st for the following row.

NOTES

The dress is worked in the round from the skirt hem to the armhole shaping where it is divided and worked in rows. When working in the round, place locking stitch marker in the loop on the hook after you have worked the first st every round; this does not mean the live loop that is on the hook at the end of each return pass. All return passes on rounds are worked with a Tunisian Cable Join. **All return passes on rows are worked as:** Ch 1, *yo, pull through 2 loops on hook; rep from * across until 1 loop rems on hook; return passes are not explicitly mentioned unless there is a change. If stitch count does not allow for a clear multiple of 4 sts, follow established pattern at the beginning of rounds.

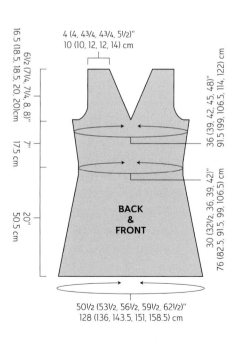

16.5 (18.5, 18.5, 20, 20)cm

6½ (7¼, 7¼, 8, 8)"

4 (4, 4¾, 4¾, 5½)"
10 (10, 12, 12, 14) cm

36 (39, 42, 45, 48)"
91.5 (99, 106.5, 114, 122) cm

7"
17.5 cm

30 (32½, 36, 39, 42)"
76 (82.5, 91.5, 99, 106.5) cm

20"
50.5 cm

BACK & FRONT

50½ (53½, 56½, 59½, 62½)"
128 (136, 143.5, 151, 158.5) cm

SKIRT

Set-up rnd: With size G hook, work 278 (294, 312, 328, 344) foundation hdc, being careful not to twist, sl st into first hdc to join in rnd; change to Tunisian Cable Hook.

Rnd 1: TSS across, TCJ.

Rnd 2: (Dec) Ch1, TDC2tog in next 2 sts, *TDCC in next 2 sts; rep from * across to last 2 sts, TDC in last 2 sts— 277 (293, 311, 327, 343) sts rem, TCJ.

Rnd 3: Rep Main body pattern Row 1, TCJ.

Rnd 4: Rep Main body pattern Row 2, TCJ.

Rnds 5–7: Rep Rnds 3 and 4, ending with Rnd 3.

Rnd 8: Rep Main body pattern Row 3, TCJ.

Rnd 9: (Dec) TSS2tog in next 2 sts, TSS across, TCJ—276 (292, 310, 326, 342) sts rem.

Rnds 10–17: Rep last 8 rnds—274 (290, 308, 324, 340) sts rem.

Rnd 18: (Dec) TSS in next 10 (13, 12, 15, 18) sts, [TSS2tog in next 2 sts, TSS in next 23 (24, 26, 27, 28) sts] 10 times, TSS2tog in next 2 sts, TSS across, TCJ—263 (279, 297, 313, 329) sts rem.

Rnds 19–23: Rep Rnds 3 and 4, ending with Rnd 3.

Rnd 24: Rep Rnd 8.

TECHNIQUE TIDBIT

Tunisian crochet is also known as Afghan crochet. It originated in Central Asia. It is a mixture of knitting and crochet. The fabrics created by Tunisian crochet can be thicker and heavier than normal knitting and crochet, and it also can be lacy and airy when made with lightweight yarn and a lace-stitch pattern. This design is based on Tunisian Double Crochet cross-stitch and is striped with Tunisian Simple Stitch. These are classic stitches that give you a modern style.

Rnd 25: (Dec) TSS in next 6 (14, 10, 12, 13) sts, [TSS2tog in next 2 sts, TSS in next 17 (17, 19, 20, 21) sts] 13 times, TSS2tog in next 2 sts, TSS across, TCJ—249 (265, 283, 299, 315) sts rem.

Rnd 26: (Dec) Ch1, TDC2tog in next 2 sts, *TDCC in next 2 sts; rep from * across, ending with TDC in last st, TCJ—248 (264, 282, 298, 314) sts rem.

Rnds 27–30: Work in established TDCC pattern across, TCJ.

Rnd 31: Work TSC across, TCJ.

Rnd 32: (Dec) TSS in next 8 (10, 13, 15, 11) sts, [TSS2tog in next 2 sts, TSS in next 17 (18, 19, 20, 22) sts] 12 times, TSS2tog in next 2 sts, TSS across, TCJ—235 (251, 269, 285, 301) sts rem.

Rnd 33: (Dec) Rep Rnd 26—234 (250, 268, 284, 300) sts rem.

Rnds 34–36: Work in established TDCC pattern across, TCJ.

Rnd 37: Work TSC across, TCJ.

Rnd 38: (Dec) TSS in next 7 (9, 12, 14, 10) sts, [TSS2tog in next 2 sts, TSS in next 16 (17, 18, 19, 21) sts] 12 times, TSS2tog in next 2 sts, TSS across, TCJ—221 (237, 255, 271, 287) sts rem.

Rnd 39: (Dec) Rep Rnd 26—220 (236, 254, 270, 286) sts rem.

Rnds 40–42: Work in established TDCC pattern across, TCJ.

Rnd 43: Work TSC across, TCJ.

Rnd 44: (Dec) TSS in next 6 (8, 11, 13, 9) sts, [TSS2tog in next 2 sts, TSS in next 15 (16, 17, 18, 20) sts] 12 times, TSS2tog in next 2 sts, TSS across, TCJ—207 (223, 241, 257, 273) sts rem.

Rnd 45: (Dec) Rep Rnd 26—206 (222, 240, 256, 272) sts rem.

Rnds 46 and 47: Work in established TDCC pattern across, TCJ.

Rnd 48: Work TSC across, TCJ.

Rnd 49: (Dec) TSS in next 11 (7, 10, 12, 8) sts, [TSS2tog in next 2 sts, TSS in next 13 (15, 16, 17, 19) sts] 12 times, TSS2tog in next 2 sts, TSS across, TCJ—193 (209, 227, 243, 259) sts rem.

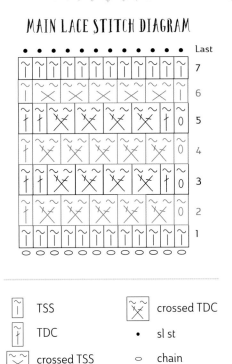

MAIN LACE STITCH DIAGRAM

Symbol	Meaning		
⎸	TSS	⤬	crossed TDC
⫮	TDC	•	sl st
⤬	crossed TSS	○	chain

Rnd 50: (Dec) Rep Rnd 26—192 (208, 226, 242, 258) sts rem.

Rnds 51 and 52: Work in established TDCC pattern across, TCJ.

Rnd 53: Work TSC across, TCJ.

Rnd 54: (Dec) TSS in next 10 (6, 9, 11, 13) sts, [TSS2tog in next 2 sts, TSS in next 12 (14, 15, 16, 17) sts] 12 times, TSS2tog in next 2 sts, TSS across, TCJ—179 (195, 213, 229, 245) sts rem.

Rnd 55: (Dec) Rep Rnd 26—178 (194, 212, 228, 244) sts rem.

Rnds 56 and 57: Work in established TDCC pattern across, TCJ.

Rnd 58: Work TSC across, TCJ.

Rnd 59: (Dec) TSS in next 9 (5, 8, 10, 12) sts, [TSS2tog in next 2 sts, TSS in next 11 (13, 14, 15, 16) sts] 12 times, TSS2tog in next 2 sts, TSS across, TCJ—165 (181, 199, 215, 231) sts rem.

Rnd 60: (Dec) Rep Rnd 26—164 (180, 198, 214, 230) sts rem.

Rnds 161–165: Work in TSS across, TCJ.

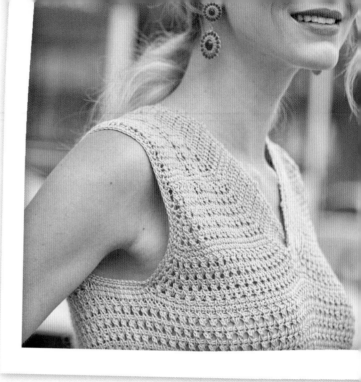

UPPER BODY

Rnd 1: Work Main body pattern Row 1, TCJ.

Rnd 2: Work Main body pattern Row 2, TCJ.

Rnd 3: Work Main body pattern Row 1, TCJ.

Rnd 4: Work Main body pattern Row 3, TCJ.

Rnd 5: (Inc) TSS in next 5 (4, 5, 4, 12) sts, [M1, TSS in next 9 (10, 11, 12, 12) sts] 17 times, M1, TSS across, TCJ—182 (198, 216, 232, 248) sts rem.

Rnds 6–9: Rep Rnds 1–4.

Rnd 10: (Inc) TSS in next 5 (5, 10, 10, 11) sts, [M1, TSS in next 10 (11, 13, 14, 15) sts] 17 times, M1, TSS across, TCJ—200 (216, 232, 248, 264) sts rem.

Rnds 11–13: Rep Rnds 1–3.

Rnd 14: Rep Rnd 2.

Rnd 15: Work Main body pattern Row 3, TCJ.

Rnd 16: TSS across, TCJ. Fasten off.

SHAPE ARMHOLE

Now working in Rows.

Row 1: Sk 44 (47, 51, 54, 58) sts from marked st; remove marker; sl st in next 13 (15, 15, 17, 17) sts, ch 1, TDCC across next 87 (93, 101, 107, 115) sts—88 (94, 102, 108, 116) sts rem.

Row 2: Ch 1, TDC in next st, TDC2tog in next 2 sts, TDCC across to last 4 sts, TDC2tog in next 2 sts, TDC in each of last 2 sts—86 (92, 100, 106, 114) sts rem.

LEFT FRONT

Row 1: Ch 1, TDC in next st, TDC2tog in next 2 sts, TDCC across next 34 (38, 42, 44, 48) sts, TDC in each of next 9 (8, 8, 9, 9) sts; work return pass, leaving rem sts unworked— 46 (49, 53, 56, 60) sts rem.

Row 2: Ch 1, TDC in next st, TDC2tog in next 2 sts, TDCC across next 32 (36, 40, 42, 46) sts, TDC2tog in next 2 sts, TDC in each rem st—44 (47, 51, 54, 58) sts rem.

Row 3: TSS in next st, TSS2tog in next 2 sts, TSSC across next 30 (34, 38, 40, 44) sts, TSS2tog in next 2 sts, TSS in each rem st—42 (45, 49, 52, 56) sts rem.

Row 4: TSS2tog in next 2 sts, TSS in next 29 (33, 37, 39, 43) sts, TSS2tog in next 2 sts, TSS in each rem st—40 (43, 47, 50, 54) sts rem.

Row 5: Ch 1, TDC in next st, TDC2tog in next 2 sts, TDCC across next 26 (30, 34, 36, 40), TDC2tog in next 2 sts, TDC in each rem st—38 (41, 45, 48, 52) sts rem.

Size 36 only:

Row 6: Ch 1, TDC in next st, TDCC across next 26 sts, TDC2tog in next 2 sts, TDC in each rem st—37 sts rem.

Row 7: Ch 1, TDC2tog in next 2 sts, TDCC across next 24 sts, TDC2tog in next 2 sts, TDC in each rem st—35 sts rem.

Size 39 (42, 45, 48) only:

Row 6: Ch 1, TDC in next st, TDC2tog in next 2 sts, TDCC across next (28 32, 34, 38) sts, TDC2tog in next 2 sts, TDC in each rem st—39 (43, 46, 50) sts rem.

Row 7: Ch 1, TDC in next st, TDC2tog in next 2 sts, TDCC across next (26, 30, 32, 36) sts, TDC2tog in next 2 sts, TDC in each rem st—37 (41, 44, 48) sts rem.

All sizes:
Row 8: Ch 1, work in established TDCC pattern to last 10 (9, 9, 10, 10) sts, TDC2tog in next 2 sts, TDC in each rem st—34 (36, 40, 43, 47) sts rem.

Size 36 (39, 42) only:
Row 9: Ch 1, work in established TDCC pattern to last 10 (9, 9) sts, TDC2tog in next 2 sts, TDC in each rem st—33 (35, 39) sts rem.

Sizes (45 and 48) only:
Row 9: Ch 1, TDC2tog in next 2 sts, work in established TDCC pattern to last 10 sts, TDC2tog in next 2 sts, TDC in each rem st—(41, 45) sts rem.

All sizes:
Row 10: Work in established TSSC pattern to last 10 (9, 9, 10, 10) sts, TSS2tog in next 2 sts, TSS in each rem st—32 (34, 38, 40, 44) sts rem.
Row 11: TSS across to last 10 (9, 9, 10, 10) sts, TSS2tog in next 2 sts, TSS in each rem st—31 (33, 37, 39, 43) sts rem.
Rows 12–17: Ch 1, work in established TDCC pattern to last 10 (9, 9, 10, 10) sts, TDC2tog in next 2 sts, TDC in each rem st—25 (27, 31, 33, 37) sts rem after Row 17.
Row 18: Rep Row 10—24 (26, 30, 32, 36) sts rem.
Row 19: Rep Row 11—23 (25, 29, 31, 35) sts rem.

Size 36 only:
Row 20: Rep Row 11—22 sts rem.
Row 21: Sl st in each vertical bar across to bind off. Fasten off.

Sizes 39 and 42 only:
Rows 20 and 21: Ch 1, work in TDCC across to last 9 sts, TDC2tog in next 2 sts, TDC in each rem st—(23, 27) sts rem after Row 21.
Row 22: Rep Row 11—(22, 26) sts. rem.
Row 23: Sl st in each vertical bar across to bind off. Fasten off.

Sizes 45 and 48 only:
Rows 20–23: Ch 1, work in TDCC across to last 9 sts, TDC2tog in next 2 sts, TDC in each rem st—(27, 31) sts rem after Row 23.
Row 24: Rep Row 11—(26, 30) sts.
Row 25: Sl st in each vertical bar across to bind off. Fasten off.

RIGHT FRONT
With WS of the Left Front facing, sl st to join in vertical bar below last st of Left Front, sl st loosely in each of 8 (7, 7, 8, 8) vertical bars that are below the collar sts of the Left Front, turn.

Row 1 (RS): Ch 1 TDC in next 8 sl sts, TDCC across next 34 (38, 42, 44, 48) sts, TDC2tog in next 2 sts, TDC in next 2 (1, 1, 2, 2) st(s), work return pass leaving rem sts unworked—46 (49, 53, 56, 60) sts rem.
Row 2: Ch 1, TDC in next 7 sts, TDC2tog in next 2 sts, TDCC across next 32 (36, 40, 42, 46) sts, TDC2tog in next 2 sts, TDC in each rem st—44 (47, 51, 54, 58) sts rem.
Row 3: TSS in next 7 sts, TSS2tog in next 2 sts, TSSC across next 30 (34, 38, 40, 44) sts, TSS2tog in next 2 sts, TSS in each rem st—42 (45, 49, 52, 56) sts rem.
Row 4: TSS in next 7 sts, TSS2tog in next 2 sts, 29 (33, 37, 39, 43) TSS, TSS2tog in next 2 sts, TSS in each rem st—40 (43, 47, 50, 54) sts rem.
Row 5: Ch 1, TDC in next 7 sts, TDC2tog in next 2 sts, TDCC across next 26 (30, 34, 36, 40), TDC2tog in next 2 sts, TDC in each rem st—38 (41, 45, 48, 52) sts rem.

Size 36 only:
Row 6: Ch 1, TDC in next 7 sts, TDC2tog in next 2 sts, TDCC across next 26 sts, TDC in each rem st—37 sts rem.
Row 7: Ch 1, TDC in next 7 sts, TDC2tog in next 2 sts, TDCC across next 24 sts, TDC2tog in next 2 sts, TDC in each rem st—35 sts rem.

Sizes (39, 42, 45, 48) only:
Row 6: Ch 1, TDC in next 7 sts, TDC2tog in next 2 sts, TDCC across next (28 32, 34, 38) sts, TDC2tog in next 2 sts, TDC in each rem st—39 (43, 46, 50) sts rem.
Row 7: Ch 1, TDC in next 7 sts, TDC2tog in next 2 sts, TDCC across next (26, 30, 32, 36) sts, TDC2tog in next 2 sts, TDC in each rem st—37 (41, 44, 48) sts rem.

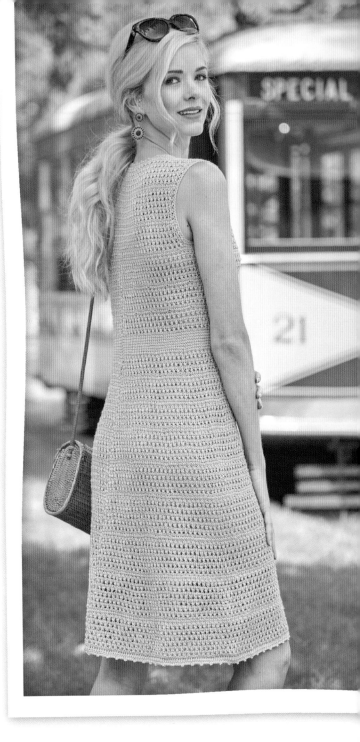

All sizes:

Row 8: Ch 1, TDC in next 7 sts, work in established TDCC pattern to last 3 sts, TDC2tog in next 2 sts, TDC in rem st—34 (36, 40, 43, 47) sts rem.

Size 36 (39, 42) only:

Row 9: Ch 1, TDC in next 7 sts, work in established TDCC pattern to last 3 sts, TDC2tog in next 2 sts, TDC in rem st—33 (35, 39) sts rem.

Sizes (45 and 48) only:

Row 9: Ch 1, TDC in next 7 sts, TDC2tog in next 2 sts, work in established TDCC pattern to last 3 sts, TDC2tog in next 2 sts, TDC in rem st—(41, 45) sts rem.

All sizes:

Row 10: TSS in next 7 sts, work in established TSSC pattern to last 3 sts, TSS2tog in next 2 sts, TSS in rem st—32 (34, 38, 40, 44) sts rem.

Row 11: TSS across to last 3 sts, TSS2tog in next 2 sts, TSS in rem st—31 (33, 37, 39, 43) sts rem.

Rows 12–17: Ch 1, TDC in next 7 sts, work in established TDCC pattern to last 3 sts, TDC2tog in next 2 sts, TDC in rem st—25 (27, 31, 33, 37) sts rem after Row 17.

Row 18: Rep Row 10—24 (26, 30, 32, 36) sts rem.

Row 19: Rep Row 11—23 (25, 29, 31, 35) sts rem.

Size 36 only

Row 20: Rep Row 11—22 sts rem.

Row 21: Sl st in each vertical bar across to bind off. Fasten off.

Sizes 39 and 42 only:

Rows 20 and 21: Ch 1, TDC in next 7 sts, work in TDCC as established across to last 3 sts, TDC2tog in next 2 sts, TDC in rem st—23 (27) sts rem after Row 21.

Row 22: Rep Row 11—22 (26) sts rem.

Row 23: Sl st in each vertical bar across to bind off. Fasten off.

Sizes 45 and 48 only:

Rows 20–23: Ch 1, TDC in next 7 sts, work in TDCC as established across to last 3 sts, TDC2tog in next 2 sts, TDC in each rem st—27 (31) sts rem after Row 23.

Row 24: Rep Row 11—26 (30) sts rem.

Row 25: Sl st in each vertical bar across to bind off. Fasten off.

BACK

With RS of the right under arm facing.

Row 1: With RS facing, join with sl st in last st of Right Shoulder shaping, sl st in each of next 12 (14, 14, 16, 16) sts, ch1, work TDCC in established pattern across next 87 (93, 101, 107, 115) sts across to Left Shoulder shaping—88 (94, 102, 108, 116) sts rem.

SHAPE ARMHOLES

Row 2: Ch 1, TDC, TDC2tog in next 2 sts, work in established TDCC pattern across to last 4 sts, TDC2tog in next 2 sts, TDC in each of last 2 sts—86 (92, 100, 106, 114) sts rem.

Row 3: Rep Row 2—84 (90, 98, 104, 112) sts rem.

Row 4: Rep Row 2—82 (88, 96, 102, 110) sts rem.

Row 5: TSS, TSS2tog in next 2 sts, work in TSSC across to last 4 sts, TSS2tog in next 2 sts, TSS in each of last 2 sts—80 (86, 94, 100, 108) sts rem.

Row 6: TSS, TSS2tog in next 2 sts, TSS across to last 4 sts, TSS2tog in next 2 sts, TSS in each of last 2 sts—78 (84, 92, 98, 106) sts rem.

Row 7: Ch 1, TDC, TDC2tog in next 2 sts, TDCC across to last 4 sts, TDC2tog in next 2 sts, TDC in each of last 2 sts—76 (82, 90, 96, 104) sts rem.

Row 8: Rep Row 7—74 (80, 88, 94, 102) sts rem.

Sizes (39, 42, 45, 48) only:

Row 9: Rep Row 2—78 (86, 92, 100) sts rem.

Sizes (45 and 48) only

Row 10: Rep Row 2—90 (98) sts rem.

All sizes:

Work rem rows to correspond the stripes of lace and TSS rows to the Fronts without shaping until the Back measures the same as the Fronts. Sl st in each st across to bind off.

ASSEMBLY

Sew shoulder and side seams. Weave in loose ends. Block.

NECK EDGING

With standard hook and RS front facing, join to Right Front collar at overlap, ch 1.

Row 1: Work 34 (38, 38, 42, 42) sc evenly along Right Neck, work 32 (36, 36, 40, 40) sc evenly across Back sts, work 35 (39, 39, 43, 43) sc evenly along Left Neck, turn—101 (113, 113, 125, 125) sts.

Row 2: Ch 1, sc in first sc, picot, *sc in next 4 sc, picot; rep from * around.

ARMHOLE EDGING

With standard hook and RS facing, join with sl st in side seam under arm.

Rnds 1 and 2: Ch 1, work 82 (90, 90, 98, 98) sc evenly around sl st in first ch. Fasten off.

HEM EDGING

With standard hook and RS facing, join with sl st in center Back.

Rnd 1: Ch 1, sc in same st as join, work 275 (291, 311, 327, 343) sc evenly around, join with sl st in first sc.

Rnd 2: Ch 1, sc, *picot, sc in next 4 sts; rep from * around. Fasten off.

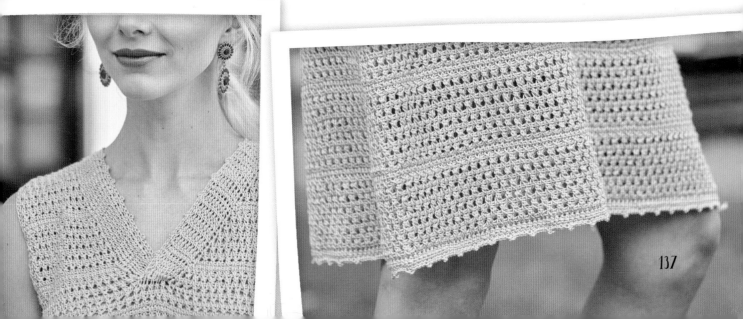

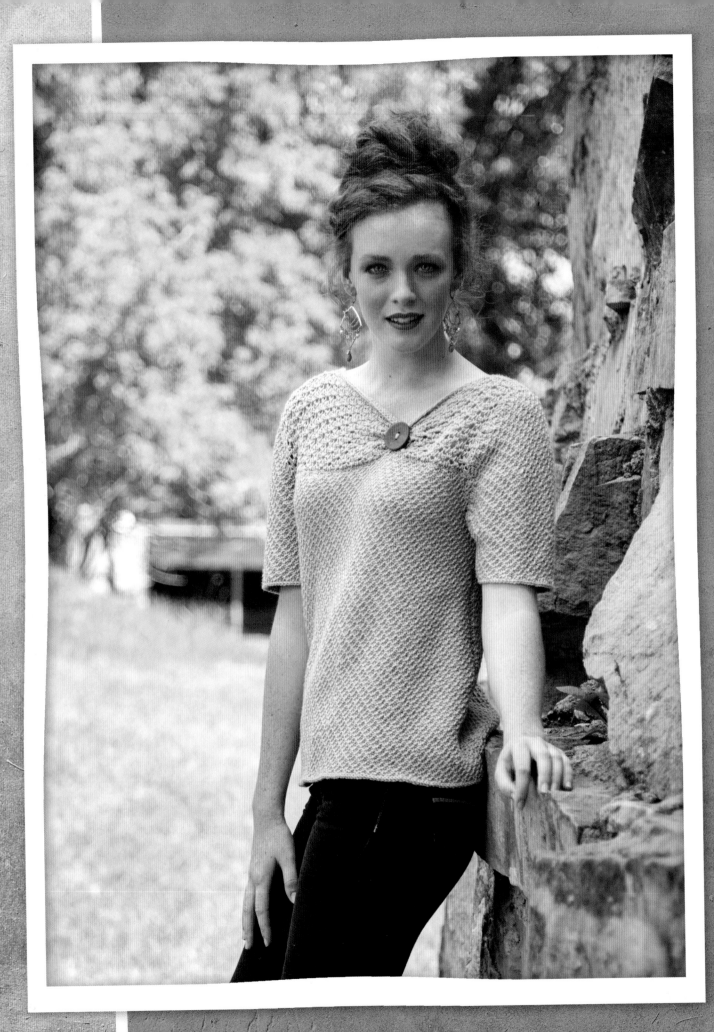

Fleur Swing top

MEGAN GRANHOLM

Tunisian is great for making tailored, almost knit-like sweaters, but it can also produce beautiful lace. This sweater, with its gentle shaping, can help ease you into Tunisian lace. It has just a bit of Tunisian lace at the neck of a structured but swingy pullover.

FINISHED MEASUREMENTS
Bust measurement is 29 (33, 37, 41, 45)" (73.5 [84, 94, 104, 114.5] cm) with negative ease in the bust and a loose fit in the hips. Sized for XS (S, M, L, XL). Size shown is M.

YARN
Fingering weight (#1 Super fine).

Shown here: Cascade Heritage Silk (85% merino superwash wool, 15% mulberry silk; 437 yd [400 m] /3.5 oz [100 f]):#5660 Grey, 4 (4, 4, 5, 6) skeins.

HOOK
Size J-10 (6 mm) Tunisian with adjustable length. *Adjust hook size if necessary to obtain the correct gauge.*

NOTIONS
Locking stitch markers; tapestry needle for assembly and weaving in ends; 13/4" (40 mm) button.

GAUGE
Neom: 21 sts by 20 rows = 4"× 4" (10 × 10 cm) with size J-10 (6 mm) hook.

Emmeline Lace: 25 sts by 12 rows = 4" × 4" (10 × 10 cm) with size J-10 (6 mm) hook.

STITCH GUIDE

Tunisian Simple Stitch (TSS): Insert hook from right to left into front vertical bar of next st and pull up a loop.

Tunisian Purl Stitch (TPS): Move yarn to front of work, insert hook from right to left into front vertical bar of next st, yo and pull up a lp.

Tunisian Foundation Stitch (Tfs): Ch 2, insert hook in 2nd ch from hook, ch 2, leave last ch on hook. Rep across as indicated.

Increase (Inc): Insert hook through fabric between st and next vertical bar and pull up a loop. On return pass, work loops off as normal unless otherwise indicated.

"Work Loops off as normal": Yo, pull through 1 loop on hook, *yo, pull through 2 loops on hook; rep from * to end.

Neom (used for body of sweater)
Ch a multiple of 4 sts plus 2.

Row 1 : (Fwd) Pull up lp in 2nd ch from hook and each ch across. Rtn: Work loops off normally.

Row 2 : (Fwd) (Lp on hook counts as 1st st here and throughout) *TPS in each of next 2 sts, sk next st, TSS in next st, TSS in skipped st; rep from * across to last st, TSS in last st. Rtn: Work loops off normally.

Row 3 : (Fwd) TPS in next st, *sk next st, TSS in next st, TSS in skipped st, TPS in next 2 sts; rep from * across to last 4 sts, sk next st, TSS in next st, TSS in skipped st, TPS in next st, tsp in last st. Rtn: Work loops off as normal.

Row 4 : (Fwd) *Sk next st, TSS in next st, TSS in skipped st, TPS in next 2 sts; rep from * across to last st, TSS in last st. Rtn: Work loops off normally.

Row 5 : (Fwd) (Lp on hook counts as 1st st.) TPS in next 3 sts, *sk next st, TSS in next st, TSS in skipped st, TPS in next 2 sts; rep from * across to last 2 sts, TPS in next st, TSS in last st. Rtn: Work loops off normally.

Rep Rows 2–5 for pattern.

Incorporate increases into established stitch pattern at ends of rows as necessary.

Emmeline Lace Stitch (ELS) (used for lace neckline)
Ch a multiple of 6 sts plus 5.

Row 1 : (Fwd) Pull up lp in 2nd ch from hook and each ch across. Rtn: Work lps off normally.

Row 2 : (Fwd) (Lp on hook counts as first st here and throughout.) TSS in each st across. Rtn: Yo, pull through 2 lps on hook, *ch 1, yo, pull through 4 lps on hook (sh made), ch 1, [yo, pull through 2 lps on hook] 3 times; rep from * to end.

Row 3 : (Fwd) *Insert hook into top horizontal bar of sh and pull up lp, yo, insert hook into same horizontal bar and pull up lp, TSS in next 3 sts; rep from * across, TSS in last st. Rtn: Yo, pull through 1 lp on hook, *[yo, pull through 2 lps on hook] 3 times**, ch 1, yo, pull through 4 lps on hook (sh made), ch 1; rep from * across, ending at **, yo, pull through 2 lps on hook.

Row 4 : (Fwd) *TSS in next 3 sts, insert hook into top horizontal bar of sh and pull up lp, yo, insert hook into same horizontal bar and pull up lp; rep from * across, TSS in last 4 sts. Rtn: Yo, pull through 1 lp on hook, *ch 1, yo, pull through 4 lps on hook (sh made), ch 1**, [yo, pull through 2 lps on hook] 3 times; rep from * across, ending at **, yo, pull through 2 lps on hook. Rep Rows 3 and 4 for pattern.

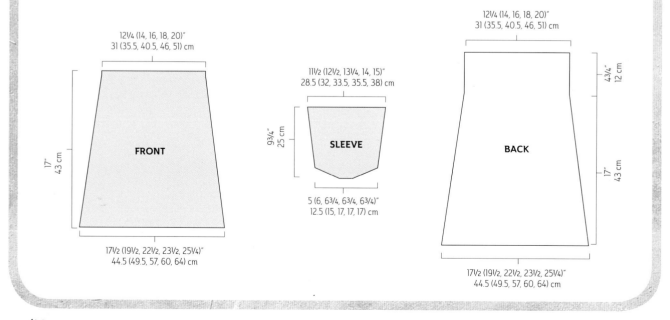

FRONT
12¼ (14, 16, 18, 20)"
31 (35.5, 40.5, 46, 51) cm
17"
43 cm
17½ (19½, 22½, 23½, 25¼)"
44.5 (49.5, 57, 60, 64) cm

SLEEVE
11½ (12½, 13¼, 14, 15)"
28.5 (32, 33.5, 35.5, 38) cm
9¾"
25 cm
5 (6, 6¾, 6¾, 6¾)"
12.5 (15, 17, 17, 17) cm

BACK
12¼ (14, 16, 18, 20)"
31 (35.5, 40.5, 46, 51) cm
4¾"
12 cm
17"
43 cm
17½ (19½, 22½, 23½, 25¼)"
44.5 (49.5, 57, 60, 64) cm

GATHERED NECKLINE

Ch 77 (77, 83, 89, 95).

Rows 1–16: Work in Emmeline Lace pattern.

Row 17: Sl st evenly across. Fasten off and set aside.

FRONT

Row 1: Ch 66 (76, 86, 97, 107) sts and work first row of Neom st.

Row 2 : (Fwd) Inc between first and second vertical bars, work in established pattern across to last st, inc 1, TSS in last st. Rtn: Work lps off normally.

Row 3: Work evenly in Neom st.

Rows 4–11: [Rep Rows 2 and 3] 4 times—68 (78, 94, 99, 109) sts after Row 11.

Row 12: Rep Row 3.

Row 13: Ch 1, TSS in first vertical bar below ch-1, inc 1 (2 inc made), work across to second to last st, inc 1, insert hook in front

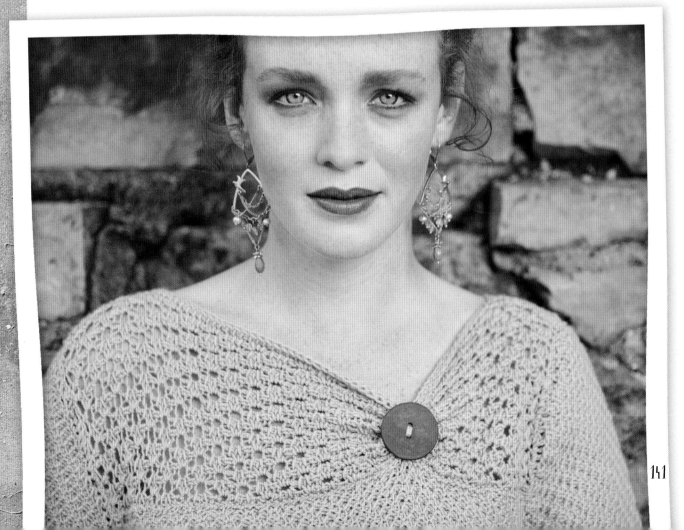

EMMELINE LACE STITCH DIAGRAM

NEOM STITCH DIAGRAM

Symbol	Meaning	Symbol	Meaning
o	chain	⊡	TPS
•	sl st	⊠	crossed TSS
⊡	TSS	⋀	yo, draw through 4 loops
⋁	(TSS, yo, TSS) in back loop of stitch		

lp of last st of prev row and pull up st, insert hook in back lp of last st of prev row and pull up st (2 inc made). Rtn: Work lps off normally 72 (82, 98, 103, 113) sts.

Row 14: Rep Row 3.

Rows 15–17: Rep Rows 12–14—76 (86, 102, 107, 117) sts.

Rows 18–21: Work evenly in Neom st.

Row 22: Rep Row 2—78 (88, 104, 109 119) sts.

Rows 23–29: Work evenly in Neom.

Row 30: Rep Row 2—80 (90, 106, 111, 121) sts.

Rows 31–78: [Rep Rows 23–30] 6 times—92 (102, 118, 123, 133) sts.

Rows 79–85: Work evenly in Neom st. Fasten off.

BACK

Ch 64 (74, 84. 95, 105).

Rows 1–23: Work evenly in Neom st.

Rows 24–108: Work as for Rows 2–85 of Front.

SLEEVES (Make 2)

Ch 6 (12, 16, 16, 16).

Row 1: Work evenly in Neom st.

Row 2: Ch 1, TSS in first vertical bar below ch-1, inc 1 (2 inc made), work across to second to last st, inc 1, insert hook in front lp of last st of prev row and pull up st, insert hook in back lp of last st of prev row and pull up st (2 inc made). Rtn: Work lps off normally—10 (16, 20, 20, 20) sts.

Rows 3–6: [Rep Row 2] 4 times—26 (32, 36, 36, 36) sts after Row 6.

Size XS (S, M) only:

Row 7 : (Fwd) Inc between first and second vertical bars, work in established pattern across to last st, inc 1, TSS in last st. Rtn: Work lps off normally—28 (34, 38) sts.

Rows 8–12: [Rep Row 7] 5 times—38 (44, 48) sts after Row 12.

Row 13: Work evenly in Neom st.

Row 14: Rep Row 7—40 (46, 50) sts.

Rows 15–28: [Rep Rows 13 and14] 7 times—54 (60, 64) sts.

Rows 29–30: Work evenly in Neom st.

Row 31: Rep Row 7—56 (62, 66) sts.

Rows 32–37: [Rep Rows 29–31] twice—60 (66, 70) sts. Place marker on this row to mark the underarm.

Rows 38–48: Work evenly in Neom st.

Row 49: Sl st loosely across. Fasten off

Size L (XL) only:

Rows 7–9: [Rep Row 2] 3times (48, 48) sts.

Rows 10–13 : (Fwd) Inc between first and second vertical bars, work in established pattern across to last st, inc 1, TSS in last st. Rtn: Work lps off normally—(56, 56) sts after Row 13.

Size L only:

Row 14: Work evenly in Neom st.

Row 15 : (Fwd) Inc between first and second vertical bars, work in established pattern across to last st, inc 1, TSS in last st. Rtn: Work lps off normally—(58) sts.

Rows 16–23: [Rep Rows 14 and 15] 4 times—(66) sts.

Rows 24–25: Work evenly.

Row 26: Rep Row 15—(68) sts.

Rows 27–35: [Rep Rows 24–26] 3 times—(74) sts.

Rows 36–37: Work evenly in Neom st. Place marker on this row to mark the underarm.

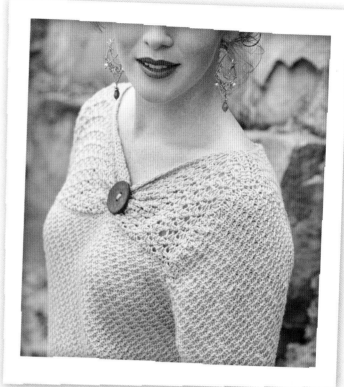

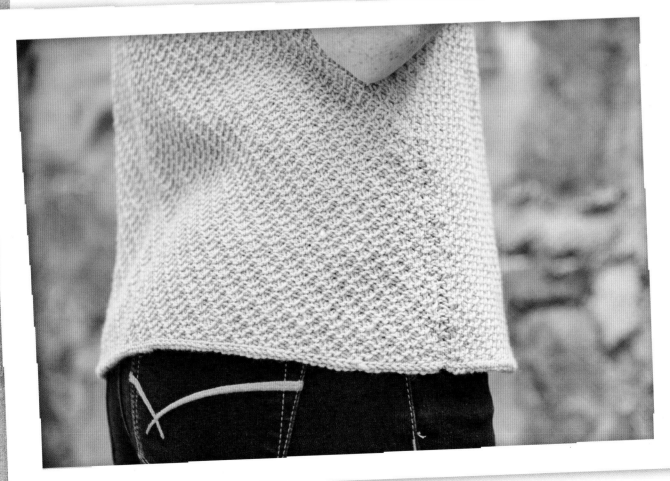

Rows 38–48: Work evenly in Neom st.

Row 49: Sl st loosely across. Fasten off.

Size XL only:

Rows 14–17 : (Fwd) Inc between first and second vertical bars, work in established pattern across to last st, inc 1, TSS in last st. Rtn: Work lps off normally—(64) sts.

Row 18: Work evenly in Neom st.

Row 19: Rep Row 14—(66) sts.

Rows 20–25: [Rep Rows 18 and 19] 3times—(72) sts

Rows 26–27: Work evenly in Neom.

Row 28: Rep Row 14—(74) sts.

Rows 29–37: [Rep Rows 26–28] 3 times—(80) sts. Place marker on this row to mark the underarm.

Rows 38–48: Work evenly in Neom.

Row 49: Sl st loosely across. Fasten off.

BLOCKING AND SEAMING

Weave in the ends. Block pieces before assembly. Block lace collar to 15 (15, 16, 17, 18)" 38 [38, 40.5, 43, 45.5] cm across. Sew lace to top of front piece; sew lace to back at the shoulder seams, leaving 7¾ (9½, 11, 12½, 14)" 19.5 [24, 28, 31.5, 35.5] cm for the neck opening. Sew the sleeves to the body centering the shoulder seams on the top sleeve edge. Sew the front and back side seams together at the sides. About ⅓ of the way across the lace piece, gather the lace and secure it with a couple of whipstitches to the top edge of the neckline. Sew a decorative button to the lace gathering or use a brooch or shawl pin

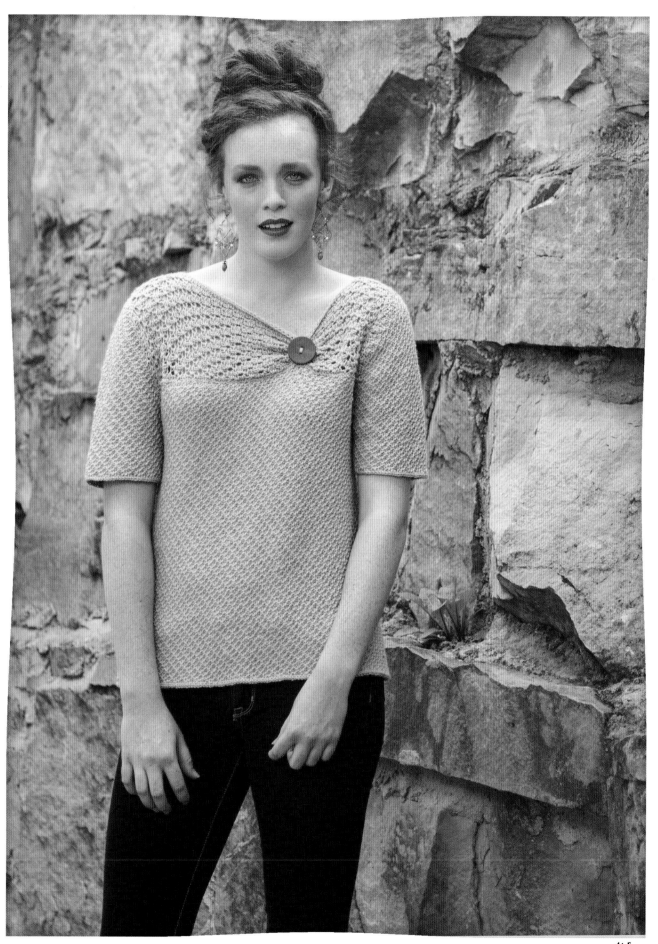

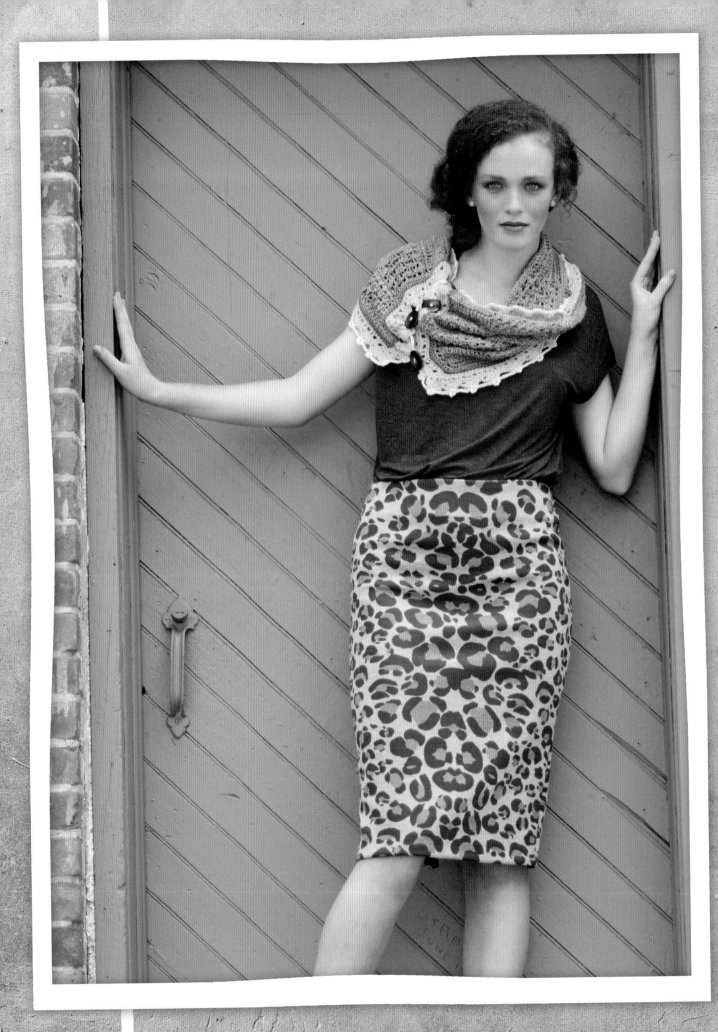

Priya cowl

Robyn Chachula

Cowls are a great way to test a new technique without having to worry about shaping, since they are just large rectangles. This cowl is no exception, because you can test all three ways to make Tunisian lace in one project. Priya is also versatile in how you can wear it. By playing with how you button the cowl, you can get completely different looks, from a small shawl or cape to a wrapping scarf.

FINISHED MEASUREMENTS
Cowl is 17" (43 cm) wide × 35" (89 cm) long.

YARN
Fingering Weight (#1 Super fine).

Shown here: Anzula Yarns Cloud (80% merino, 10% cashmere, 10% nylon; 575 yd [526 m]/4 oz [114 g]): #Toffee (MC), 1 hank; #Elephant (CC1), 100 yd [91 m], #Seaside (CC2), 300 yd [274 m], #Au Natural (CC3), 50 yd [46 m].

HOOK
Size J-10 (6 mm) Tunisian Hook and F-5 (3.75 mm) hook. *Adjust hook size if necessary to obtain the correct gauge.*

NOTIONS
Tapestry needle for weaving in the ends; rust-proof pins; spray bottle; four 1" [2.5 cm] diameter buttons.

GAUGE
Block = 3¼" (8.5 cm) width × 3½" (9 cm) tall.

STITCH GUIDE

Tunisian Simple Stitch (TSS): Insert hook from right to left into front vertical bar of next st and pull up a loop.

Tunisian Purl Stitch (TPS): Move yarn to front of work, insert hook from right to left into front vertical bar of next st, yo, and pull up a loop.

Tunisian Knit Stitch (TKS): Insert hook from front to back between front and back vertical bar of next st (under horizontal bars), yo, and pull up a loop.

Two Double Crochet Cluster (2 dc-cl): *yo, insert hook into vertical bar, yo, and pull loop up, yo, and draw through 2 lps; rep from * once in same stitch, yo, and draw through 3 lps on hook.

"Work lps off as normal": Yo, pull through 1 loop on hook, *yo, pull through 2 lps on hook; rep from * to end.

NOTES
The cowl is built block by block, with each block connected at either the left side or bottom edge.

BLOCK 1
EXTENDED LACE STITCH PATTERN

Ch 12 with MC and J-10 (6 mm) Tunisian hook.

Row 1: (Fwd) Pull up loop in 2nd ch from hook and ea ch across. Rtn: Work lps off normally—12 sts.

Row 2: (Fwd) Ch 1 (counts as 1st st), *TSS in next st, ch 1; rep from * across. Rtn: Work lps off normally.

Row 3: (Fwd) Ch 1 (counts as 1st st), *TKS in next st, ch 1; rep from * across to last st, TSS in last st, ch 1. Rtn: Work lps off normally.
Rep Rows 2–3 twice.

Last Row: Sl st in vert bar of next st and ea st across, fasten off.

BLOCKS 2, 11, 23
PERONELL LACE STITCH PATTERN

Join MC to right bottom corner of Block 1 (7, 19) with sl st, ch 13.

Row 1: (RS) : (Fwd) Pull up loop in 3rd ch from hook (sk ch count as first st), ch 1, *2dc-cl in next ch, sk next ch, TPS in next ch, sk next ch; rep from * once, 2dc-cl in next ch, TSS in last ch, ch 1, pull up loop in edge of adjoining block. Rtn: Yo and draw through 2 lps on hook, *yo and draw through 2 lps on hook, ch 1; rep from * across to last 3 sts, [yo and draw through 2 lps on hook] 3 times—12sts.

Row 2: (Fwd) Ch 1 (counts as first st), TSS in next st, ch 1, *TPS in next st, sk next st, 2 dc-cl in next st, sk next st; rep from * once, TPS in next st, TSS in last st, ch 1, pull up lp in edge of adjoining block. Rtn: Yo and draw through 2 lps on hook, *yo and draw through 2 lps on hook, ch 1; rep from * across to last 3 sts, [yo and draw through 2 lps on hook] 3 times.

Row 3: (Fwd) Ch 1 (counts as first st), TSS in next st, ch 1, *2 dc-cl in next st, sk next st, TPS in next st, sk next st, rep from * once, 2dc-cl in next st, TSS in last st, ch 1, pull up lp in edge of adjoining block. Rtn: Yo and draw through 2 lps on hook, *yo and draw through 2 lps on hook, ch 1; rep from * across to last 3 sts, [yo and draw through 2 lps on hook] 3 times.
Rep Rows 2–3 once, end on Row 2.

Last Row: Sl st in vertical bar of next 2 sts, *sl st in horizontal bar of next st, sl st in vertical bar of next st; rep from * across to last st, sl st in vertical bar of last st, do not fasten off.

BLOCK 3

Row 1 (RS): (Fwd) Sl st to first st of last row of Block 1, ch 1, pull up lp in next st, ch 1, *2dc-cl in next st, sk next st, TPS in next st, sk next st; rep from * once, 2dc-cl in next st, TSS in last st, ch 1. Rtn: Yo and draw through 1 lp on hook, *yo and draw through 2 lps on hook, ch 1; rep from * across to last 3 sts, [yo and draw through 2 lps on hook] 3 times—12sts.

Row 2: (Fwd) Ch 1 (counts as first st), TSS in next st, ch 1, *TPS in next st, sk next st, 2 dc-cl in next st, sk next st; rep from * once, TPS in next st, TSS in last st, ch 1. Rtn: Yo and draw through 1 lp on hook, *yo and draw through 2 lps on hook, ch 1; rep from * across to last 3 sts, [yo and draw through 2 lps on hook] 3 times.

Row 3: (Fwd) Ch 1 (counts as first st), TSS in next st, ch 1, *2 dc-cl in next st, sk next st, TPS in next st, sk next st; rep from * once, 2dc-cl in next st, TSS in last st, ch 1. Rtn: Yo and draw through 1 lp on hook, *yo and draw through 2 lps on hook, ch 1; rep from * across to last 3 sts, [yo and draw through 2 lps on hook] 3 times.

Rep Rows 2–3 once, end on Row 2.

Last Row: Sl st in vertical bar of next 2 sts, *sl st in horizontal bar of next st, sl st in vertical bar of next st; rep from * across to last st, sl st in vertical bar of last st, fasten off.

BLOCKS 4, 15, 27
CLEVES LACE STITCH PATTERN

Join MC to right bottom corner of Block 2 (11, 23) with sl st, ch 13.

Row 1: (Fwd) Pull up lp in 2nd ch from hook and ea ch across, pull up lp in edge of adjoining block. Rtn: *Yo, pull through 2 lps on hook; rep from * to end—12sts.

Row 2: (Fwd) (Lp on hook counts as first st), *TSS in next 2 sts at once together, yo; rep from * across to last st, TSS in last st, pull up lp in edge of adjoining block. Rtn: *Yo, pull through 2 lps on hook; rep from * to end.

Row 3: (Fwd) (Lp on hook counts as first st), *TSS in next st, insert hook around horizontal bars on next st, yo and pull up a lp; rep from * across to last st, TSS in last st, pull up lp in edge of adjoining block. Rtn: *Yo, pull through 2 lps on hook; rep from * to end.

Rep Rows 2–3 four times ending with a Row 2.

Last Row: *Sl st in vertical bar of next st, sl st in horizontal bar of next st: rep from * across to last st, sl st in vertical bar of last st, do not fasten off.

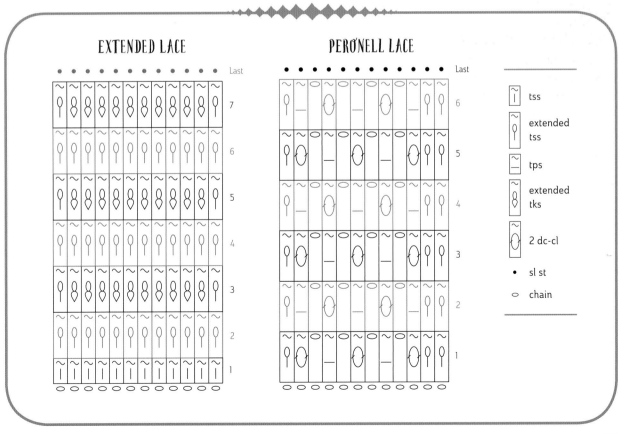

EXTENDED LACE

PERONELL LACE

tss	
extended tss	
tps	
extended tks	
2 dc-cl	
•	sl st
○	chain

BLOCKS 5, 16–18, 28–30, 38–39

Row 1: (Fwd) Sl st to first st on last row of Block 2 (11–13, 23–25, 35–36), pull up lp in ea st across, pull up lp in edge of adjoining block. Rtn: *Yo, pull through 2 lps on hook; rep from * to end—12sts.

Cont with directions for Block 4.

BLOCK 6

Row 1: (Fwd) Sl st to first st on last row of Block 3, pull up lp in ea st across, pull up lp in edge of adjoining block. Rtn: *Yo, pull through 2 lps on hook; rep from * to end—12 sts.

Row 2: (Fwd) (Lp on hook counts as first st), *TSS in next 2 sts at once, yo; rep from * across to last st, TSS in last st. Rtn: Work lps off normally.

Row 3: (Fwd) (Lp on hook counts as first st), *TSS in next st, insert hook around horizontal bars on next st, yo and pull up a lp; rep from * across to last st, TSS in last st. Rtn: Work lps off normally.

Rep Rows 2–3 four times, ending with a Row 2.

Last Row: *Sl st in vertical bar of next st, sl st in horizontal bar of next st: rep from * across to last st, sl st in vertical bar of last st, fasten off.

BLOCKS 7, 19, 31
EXTENDED LACE STITCH PATTERN

Join MC to right bottom corner of Block 4 (15, 27) with sl st, ch 12.

Row 1: (Fwd) Pull up lp in 2nd ch from hook and ea ch across, pull up lp in edge of adjoining block. Rtn: *Yo, pull through 2 lps on hook; rep from * to end—12sts.

Row 2: (Fwd) Ch 1 (counts as 1st st), *TSS in next st, ch 1; rep from * across, pull up lp in edge of adjoining block. Rtn: *Yo, pull through 2 lps on hook; rep from * to end.

Row 3: (Fwd) Ch 1 (counts as 1st st), *TKS in next st, ch 1; rep from * across to last st, TSS in last st, ch 1, pull up lp in edge of adjoining block. Rtn: *Yo, pull through 2 lps on hook; rep from * to end.

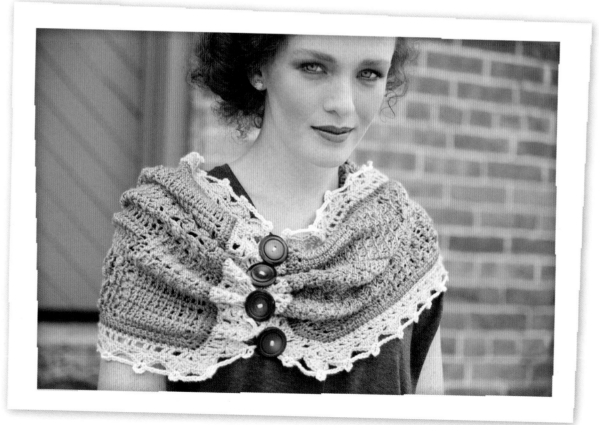

Rep Rows 2–3 twice.

Last Row: Sl st in vert bar of next st and ea st across, do not fasten off.

BLOCKS 8–9, 20–22, 32–34, 40

Join MC to right bottom corner of Block 4 (5, 15-17, 27–29, 38) with sl st, ch 12.

Row 1: (Fwd) Pull up lp in 2nd ch from hook and ea ch across, pull up lp in edge of adjoining block. Rtn: *Yo, pull through 2 lps on hook; rep from * to end—12 sts.

Cont in directions for Block 7.

BLOCK 10

Join MC to right bottom corner of Block 6 with sl st, ch 12.

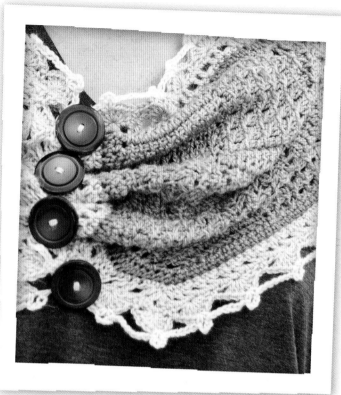

CLEVES LACE STITCH DIAGRAM

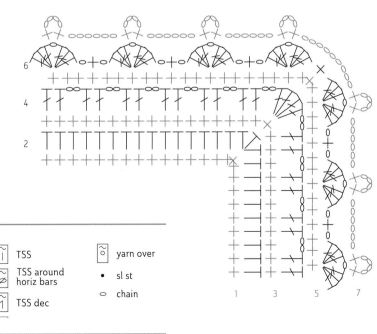

PRIYA EDGING

	TSS		yarn over
	TSS around horiz bars		sl st
	TSS dec		chain

CLEVES LACE STITCH DIAGRAM

35" (89 cm)

17" (43 cm)

10	14	18	22	26	30	34	37	39	40
6	9	13	17	21	25	29	33	36	38
3	5	8	12	16	20	24	28	32	35
1	2	4	7	11	15	19	23	27	31

Row 1: (Fwd) Pull up lp in 2nd ch from hook and ea ch across, pull up lp in edge of adjoining block. Rtn: *Yo, pull through 2 lps on hook; rep from * to end—12sts.

Cont in directions for Block 1.

BLOCKS 12–14, 24–26, 35–37
PERONELL LACE STITCH PATTERN

Join MC to right bottom corner of Block 7 (8–9, 19–21, 31–33) with sl st, ch 13.

Row 1 (RS): (Fwd) Pull up lp in 3rd ch from hook (sk ch count as first st), ch 1, *2dc-cl in next ch, sk next ch, TPS in next ch, sk next ch; rep from * once, 2dc-cl in next ch, TSS in last ch, ch 1, pull up lp in edge of adjoining block. Rtn: Yo and draw through 2 lps on hook, *yo and draw through 2 lps on hook, ch 1; rep from * across to last 3 sts, [yo and draw through 2 lps on hook] 3 times—12sts.

Cont in directions for Block 2.

EDGING

Join MC with F-5 (3.75 mm) hook to RS at corner.

Rnd 1: Ch 1, *sc evenly along edge of cowl in mult of 6 + 2, 3 sc in corner; rep from * around, sl st to first sc, fasten off, do not turn.

Rnd 2: Join CC1, ch 2 (counts as hdc), *hdc in ea sc to middle sc of corner, 3 hdc in corner sc; rep from * around, sl st to top of tch, fasten off, do not turn.

Rnd 3: Join CC2, ch 1, *sc in ea hdc to middle hdc of corner, 3 sc in corner; rep from * around, sl st to first sc, do not turn.

Rnd 4: Sl st to next sc, ch 3 (counts as dc), dc in next sc, *ch 2, sk 1 sc, dc in next 2 sc; rep from * to corner, ch 2, 4 dc in corner, ch 2, dc in next 2 sc; rep from * around; sl st to top of tch, do not turn.

Rnd 5: Ch 1, sc between tch and dc, *[2 sc in ch sp, sc between next 2 dc] rep to corner, 2 sc in ch sp, sc between next 2 dc, 3 sc between next 2 dc, sc between next 2 dc; rep from * around, sl st to first sc, do not turn.

Rnd 6: Ch 3, (2 dc, ch 1, 3 dc) in first sc, *sk 2 sc, ch 1, sc in next sc, sk 2 sc, ch 1, (3 dc, ch 1, 3 dc) (shell made) in next sc; rep from * to corner, sk 1 sc, sc in corner, sk 1 sc, (3 dc, ch 1, 3 dc) in next sc; rep from * around, ch 1, sk 2 sc, sc in next sc, ch 1, sl st to top of tch, fasten off, do not turn.

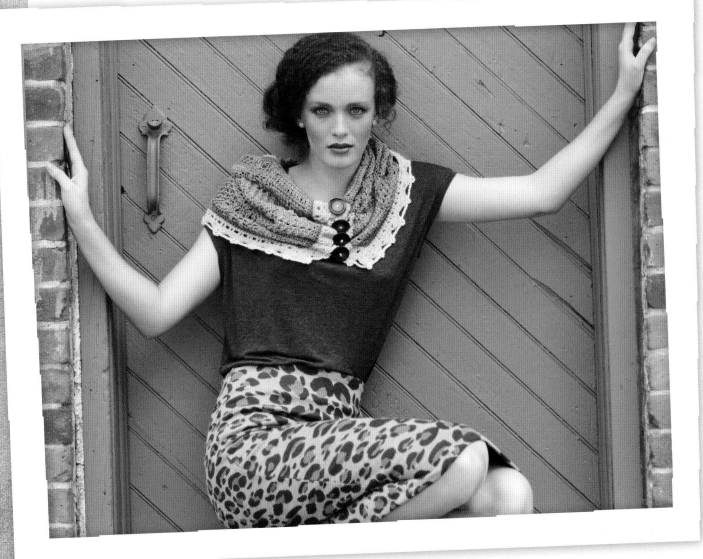

Rnd 7: Join CC3 to ch sp of shell, *(sc, ch 4, sc) in ch sp of shell, ch 6; rep from * to corner, (sc, ch 4, sc) in ch sp of shell, ch 9; rep from * around, sl st to first sc, fasten off.

BLOCKING AND BUTTONS

Block cowl to schematic size and pin in place. Spray with water and allow to dry. Sew buttons to the short edge of the cowl across from the chain spaces. Use the chain spaces as buttonholes.

ABBREVIATIONS

beg	beginning
bet	between
CC	contrasting color
cm	centimeter
ch-sp	chain space
dec	decrease
ea	each
est	established
flp	through front loop only
fsc	foundation single crochet
g	gram
incr	increase
lp	loop
MC	main color
m	marker
opp	opposite
pm	place marker
prev	previous
rem	remaining
rep	repeat
rnd	round
RR	row repeat
RS	right side
sh	shell
Sk	skip
SR	stitch repeat
st	stitch
tch	turning chain
tog	together
WS	wrong side
yd	yard
yo	yarn over
*	repeat instructions following asterisk as directed
**	repeat all instructions between asterisks as directed
()	alternate measurements and/or instructions
[]	work bracketed instructions specified number of times

TECHNIQUES

Single Crochet 2 Together (sc2tog)
[Insert hook into next indicated stitch, yarn over hook and draw up a loop] × times, yarn over hook, draw through all loops on hook—(x-1) decrease made.

Foundation Single Crochet (fsc)
Ch 2 (does not count as fsc), insert hook in 2nd ch from hook, yo and pull up lp, yo and draw through 1 lp (the "ch"), yo and draw through 2 lps (the "fsc"), * insert hook under 2 lps of the "ch" st of last fsc, yo and pull up lp, yo and draw through 1 lp, yo and draw through 2 lps, rep from * for length of foundation.

Adjustable Ring

Make a large loop with the yarn. Holding the loop with your fingers, insert hook into loop and pull working yarn through loop. Yarn over hook, pull through loop on hook. Continue to work indicated number of stitches into loop. Pull on yarn tail to close loop.

Half Double Crochet (hdc)

*Yarn over hook, insert hook into a stitch, yarn over hook and draw up a loop (3 loops on hook), yarn over hook and draw it through all loops on hook. Repeat from *.

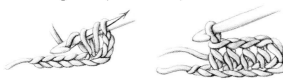

Half Double Crochet × Together (hdcxtog)

[Yarn over hook, insert hook into next indicated stitch, yarn over hook and draw up a loop] × times, yarn over hook and draw yarn through remaining loops on hook—(x-1) decrease made.

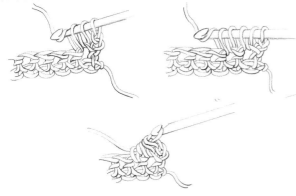

X Double Crochet Cluster (Xdc-cl)

[Yarn over hook, insert hook into indicated stitch, yarn over hook, draw up loop, yarn over hook, draw through 2 loops on hook] × times, yarn over hook, draw through remaining loops on hook.

Double Crochet × Together (dcxtog)

[Yarn over hook, insert hook into NEXT indicated stitch, yarn over hook and draw up a loop, yarn over hook and draw yarn through 2 loops] × times, yarn over hook and draw yarn through remaining loops on hook—(x-1) decrease made.

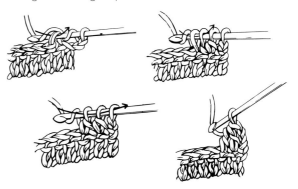

Front Post Double Crochet (FPdc)

Yo, insert hook from front to back to front, yo, pull up a lp, yo, draw through 2 lps on hook, yo, draw through last 2 lps on hook.

Back Post Double Crochet (BPdc)

Yo, insert hook from back to front to back, yo, pull up a lp, yo, draw through 2 lps on hook, yo, draw through last 2 lps on hook.

Treble Crochet (tr)

*Wrap yarn around hook twice, insert hook into next indicated stitch, yarn over hook and draw up a loop (4 loops on hook), yarn over hook and draw it through 2 loops, yarn over hook and draw it through the next 2 loops, yarn over hook and draw it through remaining 2 loops on hook. Repeat from *.

Front Post Treble Crochet (FPtr)

Yo twice, insert hook from front to back to front around post of stitch indicated, yo and pull up a lp, [yo, draw through 2 lps on hook twice, yo, draw through last 2 lps on hook.

Back Post Treble Crochet (BPtr)

Yo twice, insert hook from back to front to back around post of stitch indicated, yo and pull up a lp, [yo, draw through 2 lps on hook twice, yo, draw through last 2 lps on hook.

Double Treble Crochet (dtr)

*Wrap yarn around hook 3 times, insert hook into stitch, yarn over hook and draw up a loop (5 loops on hook), [yarn over hook and draw it through 2 loops] 4 times. Repeat from *.

Front Post Double Treble Crochet (Fpdtr)

Yarn over 3 times, insert hook from front to back to front around post of indicated stitch, yarn over and pull up a loop (5 loops on hook), [yarn over and draw through 2 loops] 4 times.

Back Post Double Treble Crochet (Bpdtr)

Yarn over 3 times, insert hook from back to front to back around post of indicated stitch, yarn over and pull up a loop (5 loops on hook), [yarn over and draw through 2 loops] 4 times.

Triple Treble Crochet (trtr)

*Wrap yarn around hook 4 times, insert hook into stitch, yarn over hook and draw up a loop (6 loops on hook), [yarn over hook and draw it through 2 loops] 5 times. Repeat from *.

Tunisian Simple Stitch (TSS)

Row 1 (RS) Pull up a loop in 2nd chain from hook and in each chain across. Yarn over and draw through 1 loop on hook, *yarn over and draw through 2 loops on hook; repeat from * to end.
Row 2 (loop on hook counts as first st) *Insert hook in vertical bar of next stitch and pull up a loop; rep from * across. Yarn over and draw through 1 loop on hook, *yarn over and draw through 2 loops on hook; repeat from * to end.
Repeat Row 2 to desired length.

Tunisian Purl Stitch (TPS)

Row 1 (RS) Pull up a loop in 2nd chain from hook and in each chain across. Yarn over and draw through 1 loop on hook, *yarn over and draw through 2 loops on hook; repeat from * to end.
Row 2 (loop on hook counts as first st): *Move yarn to front of work, insert hook in vertical bar of next stitch, yarn over and pull up a loop; repeat from * across. Yarn over and draw through 1 loop on hook, *yarn over and draw through 2 loops on hook; repeat from * to end.
Rep Row 2 to desired length.

Tunisian Knit Stitch (TKS)

Row 1 (RS) Pull up a loop in 2nd chain from hook and in each chain across. Yarn over and draw through 1 loop on hook, *yarn over and draw through 2 loops on hook; repeat from * to end.
Row 2 (loop on hook counts as first st): *Insert hook from front to back between front and back vertical bars and under all horizontal loops of designated stitch, yarn over and pull up a loop; rep from * across. Yarn over and draw through 1 loop on hook, *yarn over and draw through 2 loops on hook; repeat from * to end.
Rep Row 2 to desired length.

Mattress Stitch

With RS facing, use threaded needle to pick up one bar between first 2 stitches on one piece (Figure 1), then corresponding bar plus the bar above it on other piece (Figure 2). *Pick up next two bars on first piece, then next two bars on other (Figure 3). Repeat from * to end of seam, finishing by picking up last bar (or pair of bars) at the top of first piece.

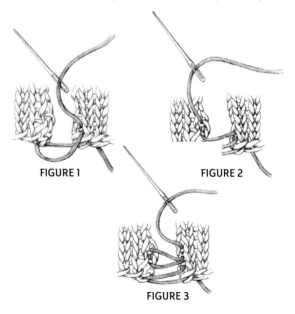

FIGURE 1 **FIGURE 2**

FIGURE 3

METRIC CONVERSION CHART

TO CONVERT:	TO:	MULTIPLY BY:
Inches	Centimeters	2.54
Centimeters	Inches	0.4
Feet	Centimeters	30.5
Centimeters	Feet	0.03
Yards	Meters	0.9
Meters	Yards	1.1

CONTRIBUTORS

Shelby Allaho holds a degree in fashion design and has worked as an art department director for an embroidery design firm. She has won numerous design awards and has exhibited her crochet work and taught crochet internationally. She is the coauthor of the book *Crocheting Clothes Kids Love,* and her designs have been published in popular crochet magazines and books such as *Interweave Crochet, Inside Crochet, Grannies (Vogue Knitting on the Go), 100 Purses to Knit and Crochet,* and *Runway Crochet.* Find her online at stitch-story.com.

Brenda K. B. Anderson is the author of *Beastly Crochet* and *Crochet Ever After.* Her designs have been published in numerous magazines, including *Interweave Crochet* and *Crochet Today.* She has contributed to several books, including *It Girl Crochet* and *Crochet at Home* (both by Interweave). Brenda is featured in the Interweave video *3D Crochet,* where she shares tips and tricks for creating adorable creatures. Whimsical accessories, amigurumi, and other small projects are her absolute favorite things to design.

Moon Eldridge got her master's degree in music composition at the Central Conservatory of Music in China and came to the United States in 2010. Currently living in North Carolina, she is interested in different cultural traditions around the world, the beauty in nature, and its amazing colors. She also translated the DVD of the *Knitted lace of Estonia* by Nancy Bush to Chinese (Henan Science and Technology Press, 2014).

Megan Granholm's Tunisian patterns have been featured in *Interweave Crochet* magazine, *Unexpected Afghans, Simply Crochet, Inside Crochet* magazine, and *Crochet Me.* She lives in a teensy town in Oregon's Willamette Valley, in a house where the curtains are always open.

Cristina Mershon is from Spain, where art and design are on display everywhere. A graphic designer and mom of four, she works in an advertising agency during the day and crochets at night

Kristin Omdahl has been involved in nearly every aspect of the fiber industry. She has been the crochet expert on *Knitting Daily TV* for ten seasons. She is also a sought-after instructor and guest presenter at yarn shops and industry events. Kristin has been designing for more than eleven years; she is the best-selling author of eleven how-to craft books and counting, and ownsKristin Omdahl Yarns, a growing yarn company, with yarns that Kristin dyes herself. Stay tuned at kristinomdahl.com for what Kristin's cooking up next!

Anastasia Popova is a contributor to Cooperative Press's *Fresh Design Crochet* book series. Her crochet career began when she designed and produced a line of kid's clothes and accessories for local boutiques. She enjoys sharing her passion for crochet with others and teaches crochet classes in central New Jersey and eastern Pennsylvania. See the schedule of classes at anastasiapopova.com.

Laurinda Reddig is the author of two books, including *Reversible Color Crochet: A New Technique* (Interweave/F&W, 2014). Her designs and articles have been published in numerous magazines, including *Interweave Crochet, Crochet Today, Crochet!,* and *Vogue Crochet.* Her children inspire many of her designs. Learn more about Laurinda's work at recrochetions.com.

Natasha Robarge explores traditional crochet techniques to create contemporary wearables. Her designs can be found at ravelry.com or crochetme.com.

Rebecca Velasquez's crochet and knit designs have been featured by multiple yarn companies and have been frequently published in numerous magazines. She is currently working on several designs for future publication. In addition, she creates knit and crochet designs for her own line, RV Designs. You can read more about Rebecca's world as a designer at rebeccavelasquez.com.

Acquisitions Editor: **KERRY BOGERT**

Editor: **ERICA SMITH**

Technical Editor: **CHARLES VOTH**

Cover & Interior Designer: **CHARLENE TIEDEMANN**

Photographer: **DONALD SCOTT**

Stylist: **JILL CARTER**

Hair/Makeup: **KATHY MACKAY**

fw

a content + ecommerce company

www.fwcommunity.com

19 18 17 16 15 5 4 3 2 1

DISTRIBUTED IN CANADA BY FRASER DIRECT
100 Armstrong Avenue
Georgetown, ON, Canada L7G 5S4
Tel: (905) 877-4411

DISTRIBUTED IN THE U.K. AND EUROPE BY F&W MEDIA INTERNATIONAL
Brunel House, Newton Abbot, Devon, TQ12 4PU, England
Tel: (+44) 1626 323200, Fax: (+44) 1626 323319
Email: enquiries@fwmedia.com

DISTRIBUTED IN AUSTRALIA BY CAPRICORN LINK
P.O. Box 704, S. Windsor NSW, 2756 Australia
Tel: (02) 4560 1600, Fax: (02) 4577 5288
Email: books@capricornlink.com.au

SRN: 16CR01
ISBN-13: 978-1-63250-162-2

We make every effort to ensure the accuracy of our instructions, but errors occasionally occur. Pattern corrections can be found at **crochetme.com/errata**.

ABOUT THE AUTHOR

Robyn Chachula is the author of *Blueprint Crochet Sweaters, Unexpected Afghans,* and *Crochet Stitches Visual Encyclopedia.* Her work has been featured in *Interweave Crochet, Crochet!, Love of Crochet, Vogue Crochet,* and more. She is one of the crochet experts on the PBS show *Knit and Crochet Now!* All of her crochet inspiration comes from her little "office assistants" while out and about in Pittsburgh, Pennsylvania. Stop by **crochetbyfaye.com** to see what she has recently cooked up.

ACKNOWLEDGMENTS

I am truly grateful for the brilliance of everyone who touched this book. This book has been an idea of mine for so long that I am excited to share it with you, the reader.

First, and foremost, I want to thank my fellow designers for sharing their talent with us. Their creative spirit shines through in each project.

All the yarns used in the book were graciously donated by the yarn companies: Anzula, Berroco, Bamboo So Fine, Cascade, Lizbeth, Lorna's Laces, Mrs Crosby Yarn, Red Heart, Shibui Knits, Universal Yarn, and Willow Yarn. I thank them for the support and quick response to all our needs.

Thank you to everyone at Interweave, especially Erica Smith and Charles Voth, for making my random ramblings into a cohesive book. Thank you Kerry Bogert, Bekah Thrasher, and Charlene Tiedemann, and the entire Interweave team for seeing my vision and making it happen. Thank you Diane Halpern and Virginia Boundy for being my hands and crocheting the garments for me so I could focus on the jewelry projects.

Most important, I thank my family and friends for their ongoing love and support as I took on each new challenge. I especially thank my husband, Mark, my best half, for his unwavering encouragement and help. Without him, this book never would have been possible.

Lastly, I thank you, the readers, for enjoying what I love to do so much. Please know that your enthusiasm for crochet keeps me energized to create and share designs.

DEDICATION

This book is dedicated to all my crochet students for keeping me inspired and excited, so I can come up with fresh and new designs.

INDEX

SOURCES FOR YARN

Anzula Luxury Fibers
740 H Street
Fresno, CA 93721
anzula.com
Vera, Breeze, Cloud

Berroco
1 Tupperware Drive, Suite 4
N. Smithfield, RI 02896-6815
(401) 769-1212
berroco.com
Ultra Alpaca Fine, Vintage DK

Bamboo So Fine
styledbykristin.com/yarn
Be So Fine

Cascade Yarns
1224 Andover Park E.
Tukwila, WA 98188
cascadeyarns.com
Longwood Sport, Heritage Silk

Handy Hands
578 N. 1800 E.
Paxton, IL 60957
(217) 379-3802
hhtatting.com
Lizbeth Size 20 Crochet Thread

Lorna's Laces
4229 N. Honore Street
Chicago, IL 60613
(773) 935-3803
lornaslaces.net
Lion and Lamb

Mrs Crosby Yarn
4229 N. Honore Street
Chicago, IL 60613
(872) 230-4713
mrscrosbyplays.com
Satchel, Hat Box

Red Heart
PO Box 12229
Greenville, SC 29612-0229
(800) 648-1479
redheart.com
Red Heart Fashion Crochet Thread,
Aunt Lydia's Classic 10

Shibui Knits
1500 NW 18th
Suite 110
Portland, OR 97209
(503) 595-5898
shibuiknits.com
Silk Cloud, Linen

Universal Yarn
5991 Caldwell Business Park Drive
Harrisburg, NC 28075
(877) UniYarn [864-9276]
universalyarn.com
Nazli Gelin Garden 3, Nazli Gelin Garden 5, Nazli Gelin Garden 10, , Nazli Gelin Garden 10 Metallic

Willow Yarns
2800 Hoover Road
Stevens Point, WI 54492
(855) 279-4701
willowyarns.com
Stream

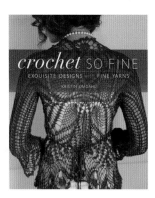